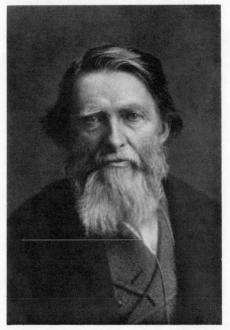

From a photograph by Elliott & Fry

J. Ruskin

RUSKIN AND HIS CIRCLE

BY

ADA EARLAND

"Through such souls alone
God stooping shows sufficient of His light
For us i' the dark to rise by."
The Ring and the Book.

*WITH 20 ILLUSTRATIONS INCLUDING
A PHOTOGRAVURE FRONTISPIECE*

AMS PRESS
NEW YORK

Reprinted from the edition of 1910, New York
First AMS EDITION published 1971
Manufactured in the United States of America

International Standard Book Number: 0-404-02232-4

Library of Congress Number: 71-129381

AMS PRESS INC.
NEW YORK, N.Y. 10003

To

THE DEAR MEMORY OF

MY MOTHER

PREFACE

UP to the present, although the Life of Ruskin has been most ably written by Mr. W. G. Collingwood and others, there has been no attempt (so far as I am aware) at an independent biography; nor any study of the direct relationship between the influences surrounding Ruskin's earlier years and his greatness, shortcomings, and inconsistencies. Ruskin was the victim of circumstances. The key to much that is contradictory or irritating in his writings is to be found in the story of his life. Hitherto, from a mistaken idea of respect for his memory, his married life has been slurred over by his biographers. At this distance of time, when all the principal actors in the drama are dead, reticence is neither necessary nor wise. Ruskin's character does not suffer by a true account of facts so much as by the concealment of them.

The task of selection has been no light one so far as the " circle " is concerned. Ruskin's friends were legion, and to include them all—even cursorily —would have lengthened the book beyond reasonable limits. I decided that it was better to confine my attention to those directly influencing his life,

or of sufficient note to interest my readers. These latter include Carlyle, Sir Henry Wentworth Acland, Burne-Jones, the Brownings, Mary Russell Mitford, Dr. John Brown, Lady Trevelyan, Lady Mount-Temple, Miss Susanna Beever, and Miss Kate Greenaway : proof, if any is needed, of the magnetic attraction Ruskin exercised over the best and noblest of his contemporaries.

It is a pleasant duty to acknowledge here the many kindnesses shown me by various publishers and authors during the preparation of this book. With hardly an exception, a prompt and courteous assent came in response to my request to include extracts from their publications. In several cases expressions of good-will and sympathetic encouragement were added : doubly precious because unexpected. Where the kindness has been so uniform to single out one name may seem invidious, but the Rev. A. G. L'Estrange has a special claim on me for his kindness in supplying, quite voluntarily, some very interesting reminiscences in addition to his permission to use a letter written by Ruskin to Miss Mitford. To Messrs. Bell & Sons I am indebted for permission to use extracts from the " Memorials of Edward Burne-Jones," by Lady Burne-Jones ; to Admiral Sir W. Acland, Bart., C.V.O., and Messrs. Smith, Elder & Co., for a like kindness in respect of " Sir Henry Wentworth Acland," by J. B. Atlay. In both these cases I trust that they will not think I have quoted too freely : my excuse must be the

interesting nature of the books in question and
their direct bearing on my subject. Mr. Alexander
Carlyle and Mr. John Lane kindly permitted me to
use extracts from the letters of Thomas Carlyle and
Jane Welsh Carlyle ; Messrs. Longmans, Green &
Co., from Froude's " Carlyle's Life in London " ; the
Proprietors of the *Times*, a letter written by Sir
H. W. Acland ; the Proprietors of *Punch*, lines on
the Hincksey Diggings, and the cartoon " An
Appeal to the Law " ; Messrs. Macmillan & Co.,
the comparison of Swift and Ruskin from Mr.
Frederic Harrison's " Ruskin." In each case a
footnote has been added acknowledging the source
of the quoted passage. A list of my authorities has
also been given. Should I have omitted, by any
oversight, to acknowledge the source of any material
I have used, I beg to tender my regrets and will
gladly rectify the mistake at the first opportunity.

ADA EARLAND.

January 1910.

CONTENTS

Contents

ILLUSTRATIONS

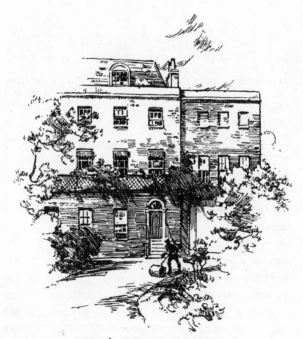

RUSKIN'S HOUSE AT HERNE HILL.

Ruskin and His Circle

CHAPTER I

THE HOME CIRCLE

" HE WAS AN ENTIRELY HONEST MERCHANT, AND HIS MEMORY IS TO ALL WHO KEEP IT DEAR AND HELPFUL. HIS SON, WHOM HE LOVED TO THE UTTERMOST, AND TAUGHT TO SPEAK TRUTH, SAYS THIS OF HIM."

EPITAPHS are not always trustworthy, but this in Shirley Church to the memory of John James Ruskin, placed there by the son he " taught to speak truth," is more accurate than most. An entirely honest man as well as merchant, for he began his career by paying off debts incurred by his father, working at the task for nine years without a holiday. The young Scot's honesty and attention to business did not go unrewarded. Mr. Peter Domecq, proprietor of vineyards in the best sherry district in Spain, offered him his London agency ; Mr. Henry Telford, an Englishman of some wealth, put the necessary capital into the business ;

both wisely agreeing to allow him uncontrolled management of their English business, with the position of senior partner in the firm of Ruskin, Telford, and Domecq.

Many years earlier, Margaret Cox, the sixteen-year-old daughter of the landlady of the Old King's Head in Market Street, Croydon, had gone to keep house for her uncle John Ruskin, of Edinburgh. She was a prudent, sensible girl ; well-educated after the standard of female education a hundred years ago ; good-looking, and a clever housewife. Thrown into constant companionship with her cousin John James Ruskin, he came to lean upon her for counsel and sympathy : little wonder that an attachment sprang up between them. An engagement followed : vague as to its termination on account of the young man's decision to make himself responsible for his father's debts.

The debts were paid at last, his feet were firmly planted on the social ladder, and the nine years' engagement ended in a quiet, almost secret wedding. It was a marriage founded on mutual respect and affection. Its course was placid and uneventful : never troubled by harsh words, quarrels, or bitterness. The husband's choice had been made calmly and without the disturbing influence of passion. If on the wife's side there was deeper attachment, she was not of a nature to give outward expression to it. She was a woman of inflexible will and held strict Evangelical opinions : her temperament

inclined to melancholy ; she was proud, made few friends, and shut herself up from any life outside her own household behind a barrier of impenetrable reserve. Perhaps an unacknowledged feeling of jealousy was at the bottom of her reluctance to admit any outside the family circle to intimacy, for she was her husband's senior by four years, and morbidly sensitive to the fact that she had moved in a lower social circle. Mr. Ruskin was of softer mould. Either from a firm belief in his wife's good judgment or submitting to the force of her stronger individuality, he allowed her influence to bias him in all the greater issues of life.

This staid couple set up housekeeping with a modest house in Hunter Street, Brunswick Square. There, on 8th February 1819, was born their only child—a son—named John after his father and grandfather. His parents being no longer young— his mother was thirty-eight when he was born—it might be supposed that in this case the rigid discipline customary in the nurseries of ninety years ago would be relaxed. Not so : Margaret Ruskin seems to have had little sympathy with children, and her only child was nurtured in the customary Spartan way ; whipped frequently, taught to keep in the background, fed on the plainest food, and even deprived by her rigid Puritanism of all but the simplest toys. Playthings, in the early days of the nineteenth century, were more expensive and less varied than now. It was not poverty, how-

ever, but principle which restricted the child John
Ruskin, to—first, a bunch of keys ; then, by suc-
cessive stages, adding a cart, a ball, two boxes of
wooden bricks, and, as a culminating treasure, a
fine model of a two-arched bridge.

On Sundays both toys and books were taken
away, and from a very early age, a visit to Beresford
Chapel, Walworth, was made an essential part of the
day's duties : one striking concession being allowed
there as a means of ensuring decorous quiet—he was
allowed to hold his mother's gold vinaigrette. Even
this special delight could not colour the tedium of
the rest of the day. Ruskin soon began to look
forward with dread to the approach of Sunday, and
could not enter with any enthusiasm into his parents'
ambition that he should be educated for the Church
with the sanguine hope of speedy preferment to a
bishopric.

Left to find amusement for himself, the child
obtained it by tracing the pattern of the carpet
with his chubby forefinger, or counting the bricks
in the opposite wall. As a purple patch in an other-
wise colourless existence, by a happy chance the
standpipe from which the water carts were filled
was outside their house, and afforded delicious
moments of too short-lived joy when water gushed
from the hose through a mysterious trap-door in
the cart's roof.

The same system of the simple life was extended
to his food. Fifty years afterwards he could re-

member a noteworthy occasion when three raisins had been given him by his mother in the forenoon from her store-cupboard at Hunter Street. His first taste of custard could also be dated : it was a portion of his father's, left unfinished, and brought him by his mother, evidently in some softened mood. Perhaps it harrowed her conscience afterwards, and she was thinking of this lapse into Epicurean ways when she told John in later life that he had been indulged too much. He was whipped when he did not instantly obey, but this was only part of his mother's stern educational system, for she guarded him all too carefully from danger, pain, or sorrow. She secluded him from all outer influence or example as carefully as if he had been shut in by convent walls. If we would understand John Ruskin, the man, his genius and its limitations, we must first recognise fully the exceptional nature of his early associations.

Aunt Bridget, of Croydon, a warm-hearted motherly woman, gave her lonely little nephew some of the store of affection left over from her own brood of healthy happy children, and in return received the boy's whole-hearted love. Her shop and bakehouse in Market Street were places of entirely pleasant memories for him, and he was never able to understand the subtle social distinction between the prosperous merchant's family and their shopkeeping relatives. In " Præterita " he lingers lovingly over every memory connected with

Mrs. Richardson, and in " Fors Clavigera " explains his fondness for the Sacristan's Cell at Assisi as originating in a fancied resemblance to the old Croydon bakehouse. He owed to this Aunt a brief moment of joy in the possession of a gaily clad Punch and Judy which she bought for him in Soho Bazaar. She showed him how to make the puppets dance, but he never saw it after that first exhibition. His mother, who seems to have regarded all gay or glittering toys as worldly snares to be avoided by the good Evangelical child, told him it was wrong for him to have it and took it away.

We hardly know which needs pity most, the mother trampling down all expressions of affection and depriving her son of innocent pleasures at the bidding of conscience, or the child reared to such unnatural habits of self-repression. Ruskin confesses that as a child his father and mother were too far removed from him for love to enter into their relationship. As far as his mother was concerned we have seen that she made no effort to take part in his joys and sorrows. His father, better capable of understanding a child's mind, was from home the greater part of the day, and was content to let his wife have absolute control over their son. It speaks well for the lovable nature of Ruskin that he never resented his mother's hardness, and of his insight that he recognised the depth and intensity of her strong, silent nature ; repaying her with a filial devotion so touching and complete that he

seems to have submitted to her in manhood with the same unquestioning obedience which she had exacted from him as a child. Her iron will kept him in subjection until past middle life, and her mistaken love led to all the unhappiness that laid life waste for him, but all his sorrow in age was that obedience had sometimes been given so grudgingly.

The Hunter Street household had another inmate, who played an important part in Ruskin's childhood. This was Anne, his nurse, who had come into service in the Ruskins' Edinburgh home as a barefooted lassie of fifteen. She was devoted to John and his father, and remained in their service until she died at the age of seventy-two. Anne had the Scotch dourness to an uncommon degree, and, even as a young woman, must have been harsh and unattractive. Like many old family servants she was entirely trustworthy and pre-eminently disagreeable. Contradiction came natural to her, and she appears to have taken a perverse delight in acting as a wet blanket on every possible occasion. In illness she was invaluable, and no more faithful creature ever lived, but she must have been an unsympathetic nurse. Any idea of foolish baby-talk and caresses on her part approaches the ludicrous.

When the boy John was out of the nursery and the family travelled on the Continent, he declared that all across France she looked forward to their arrival at the Hôtel de la Cloche, Dijon, because

there she could enter his room by a little secret door which opened above his pillow, and watch over or awaken him at her pleasure. It is easy to believe that her delight would increase proportionally with her nursling's growth of independence and dislike of this system of espionage.

But, in spite of Anne's queer and contradictory ways, she was a faithful servant of the old school, making her master's interests her own. Her ears were always open to pick up any words of commendation when Ruskin first began to publish, and not even his parents felt more pride in his genius. The door of old Mr. Ruskin's room was locked when he was seized with his fatal illness, and it was Anne who pushed her way to the foot of the ladder placed against his window : Anne, grown white-haired in his service, who insisted on mounting it so that she might be the first at his side. Next to his father and mother it was to Anne that Ruskin's thoughts turned in the loneliness of age and mental depression.

Length of service was the rule with Mrs. Ruskin's servants. They rarely left her except to be married, and were never turned off on account of age. The household arrangements were quite feudal in their adaptation to aged domestics past active service. The story is told that a visitor once ventured to ask the duties of one of these ancient maids. Mrs. Ruskin drew herself up and said—

" She, my dear, puts out the dessert."

At a very early age Ruskin was able to read whole words at sight, and books being evidently not under the same ban as toys, this precocious child was sending to the circulating library at the age of five ! Daily Bible readings with his mother must have commenced long before that. This was the first occupation after breakfast, and they took the whole Bible, verse by verse, going steadily without any omissions from the first verse of Genesis to the last of the Apocalypse ; taking two or three chapters a day. All the old Scottish paraphrases had to be learned by heart : in one instance three weeks were spent over one verse before the accent was put on the proper word to her entire satisfaction. Other lessons were gradually added : never more than would keep the boy at work beyond noon, after which he was left to his own devices ; with no companions to divert him from his books, or solitary musings in the garden.

Before his mornings had any duties beyond the Bible reading and paraphrases, the family had removed to Herne Hill, then quite a rural neighbourhood. Ruskin was about four years old at the time, and gained in exchange for his favourite watering cart the bliss of wandering in a real country garden ; well provided with fruit-trees—which he was not permitted to touch. The powers of observation cultivated during lonely hours in Hunter Street had a wider field here, and he found ample amusement in watching insects, birds, stones,

and flowers, wondering over their construction and habits, and already forming theories of his own on the subject.

In his seventh year his first attempts at composition offered a new and engrossing occupation for his restless brain : the difficulty of writing being overcome by copying printed characters. No attempt had been made to force his mental powers up to now—unless by the attempt to wrestle with Old Testament names at such an early age—and the dullness of his solitary playhours may have been entirely salutary for a child with abnormal brain development, but these infantile compositions were at once hailed by his parents as marking him out for early fame, and every encouragement was given him to persevere ; a money payment on a fixed scale being offered by way of reward.

By this time he had learned independence of thought, if not of action, and rarely troubled the grown-up people about him. He had no child playmates except, occasionally, his cousins at Croydon, and still more rarely, when he and his mother, with Anne in attendance, would remain in Perth with Mr. Ruskin's sister, while he himself continued his journey ; calling for them on his way back. One of the Perth cousins, Jessie, seems to have been the only child of about his own age with whom Ruskin ever had much in common. She also was abnormal, and died of water on the brain.

The natural result of such a system of solitude,

self-repression, and premature stimulation followed. John Ruskin became precocious, self-centred, shy and awkward in company. His health also suffered : he became a delicate boy ; the over-wrought brain reacting on his physical frame, so that although he lived to within a few days of his eighty-first birthday, the various crises of his life were marked by more or less serious illness, and his latter years clouded by long and increasingly frequent periods of mental trouble.

The days of helpless infancy belonged to his mother, but as the boy grew older, without apparent interference with her educational theories, it was his father who guided Ruskin's tastes and awakened his latent genius. A keen lover of art, Mr. Ruskin was a good judge of pictures and possessed some artistic skill. He had also sound literary taste, so that from his earliest years, John, sitting in his special corner of the drawing-room, could, if he chose, listen while his father read aloud with expression and understanding. Shakespeare's comedies and historical plays, Scott, Spenser, Byron, Pope, Goldsmith, Addison, Johnson, and (a special favourite) " Don Quixote," were heard in this way. Added to the morning Bible study, these evening readings give us the secret of Ruskin's incomparable prose.

While in most respects leading the dull, common-place life of a suburban, Evangelical, middle-class household, the Ruskins differed in one noteworthy

custom from most of their class and time. Mr. Ruskin was not content with managing the office affairs of Ruskin, Telford, and Domecq ; he also acted as their country traveller. Two of the summer months in each year were devoted to a leisurely tour of the English counties, with an occasional extension to Scotland. This was made the occasion for a family holiday. They travelled post, Mr. Telford lending his own carriage until increasing wealth allowed Mr. Ruskin to hire one for himself. Travelling by stages of forty or fifty miles a day, they made a practice of visiting any great houses or other objects of interest in the district they were traversing, Mr. Ruskin and his little son in perfect sympathy over the art treasures to be seen : the merchant, shrewd and sensible in his artistic tastes as in business matters, careful always that the child should see none but the best, in order that his taste should not be vitiated by bad or debased art.

As they travelled, Ruskin was so placed that he had a good view of the country, his seat being the little box containing his clothes, with a cushion on one end, in front of, and between, his father and mother. Anne went with them, and occupied the " dickey " ; Mr. Ruskin sometimes sharing it with her in fine weather in order that he might enjoy the view. These journeys must have done much to draw father and son into the close relationship and sympathy which remained unbroken to the

end, unaffected even by differences of opinion on the subject of Raphael's art or the intrinsic value of minerals.

These tours, and the reverential visits made under his parents' care to stately castles and old baronial halls, had another far-reaching influence on Ruskin's after-life. The dreamy, imaginative child, fed on Scott's romances from babyhood, and with the " Tales of a Grandfather " for his sole historic guide, had ideals of feudal times and chivalry which he could not reconcile with existing conditions. In place of glittering trains of knights with their men-at-arms, or ladies' bowers, he found absentee landlords spending their rents in London ; while their castles fell into ruin or were left to the care of servants. It was an age when the wine-merchant flourished, but knight-errantry was out of date when George IV. was king. The gulf between idealism and realism was too great to be bridged yet by the boy's mind, but a tiny seed had been sown there, to lie apparently lifeless for many years until, in pain and sorrow, it germinated ; growing into his schemes for social regeneration, the work of St. George's Company, and much of the teaching of " Fors Clavigera." At the time Ruskin was only a precocious little boy with an entirely childlike delight in the novelty of this nomadic life and the necessarily relaxed discipline it entailed. Much of the narrowness induced by his home life was neutralised by these journeys,

and if his acquirements in ordinary school subjects fell short of the usual standard for boys of his age, few could have such a practical knowledge of topography, and store of general information.

At four years old he had travelled to Scotland by road ; a year later he made a tour of the English Lakes ; at six he had been across the Channel to Paris, Brussels, and Waterloo—the battle only seven years past—in every case travelling with ample leisure to see every place of note, according to a carefully thought out route, with his father, a clever well-informed man, as companion and mentor, and with every encouragement given him to write daily impressions of everything he saw. These early writings can have little value from a literary point of view, but they serve to show how keenly observant he was of all natural phenomena, and what a marvellous aptitude he had for expressing his thoughts in words.

At seven years old he began to write verses showing remarkable promise. Hopes of the Laureateship were now added by his parents to the bishopric they anticipated for him. At twelve he began an ambitious journal in verse of a journey to the Lakes, and Mary Richardson, sister of the Perth cousin, Jessie, plodded after him in prose when the youthful poet, unused to settled study, tired of his subject.

Mary Richardson had become one of the household two years earlier, on her mother's death. From this time until her marriage she was an elder

sister and admiring satellite to Ruskin, sharing his lessons and amusements; an affectionate, amiable, commonplace girl, missed in absence for her domestic qualities, but not of much account in Ruskin's mental development, although she was four years his senior. Indeed, until he entered Christ Church as gentleman-commoner, his character had, to a singular degree, remained uninfluenced by any one but his parents.

As we have seen, Mrs. Ruskin disliked society. Her pride and shyness grew more marked and impenetrable with years. Neighbours who would have been friendly were kept at arms' length, and with the exception of an occasional business dinner the Ruskin doors seldom opened to visitors. Ruskin, so fond of the society of children and young people in later years, saw little of them when he was a boy. Over-anxious care on the part of his mother kept him apart from the companionship and sports suited to his age; with the result that when he happened to find himself in young society he was awkward and self-absorbed. Even in his education Mrs. Ruskin jealously excluded outside influence as long as she could. At last, when it became necessary that he should commence Greek, she sent him to Dr. Andrews for private lessons.

Dr. Andrews was already well known to the family as the eloquent and pious minister of Beresford Chapel, Walworth, where the Ruskins had a pew. Some years later, Edward Burne-Jones, a

schoolboy with no foresight of future fame, also attended Beresford Chapel with his aunt. He said of it :—

" There were two red fat cushions on a piece of upholstery called a Communion table, and a big fat cushion for the preacher, and a less fat one for the curate, and a hard, dry, mean one for the clerk." [1]

The *mise en scène* must have been the same when the Ruskins attended it, but, by the time Burne-Jones came there to note the varying degrees of plumpness in the cushions, Mr. Ruskin had removed to Denmark Hill and occupied a pew of becoming dignity in Camden Chapel. The Brownings attended Camden Chapel, and apparently about the same time, but there is no record of any acquaintance-ship until many years later.

The Greek lessons were hardly a success, but they resulted in a very pleasant friendship between the Andrews family and Ruskin, afterwards extended to Coventry Patmore by reason of his marriage with Emily Augusta, a younger daughter of Dr. Andrews. She was his first wife, a sweet and beautiful woman who died young, of consumption. Patmore, the poet of matrimonial love—" the only living poet," Ruskin wrote in " Sesame and Lilies," " who strengthens and purifies "—drew his in-spiration for " The Angel in the House " from her. She showed unusual generosity on her death-bed : not only urging Patmore to marry again, but actually

[1] " Memorials of Edward Burne-Jones."

leaving her wedding ring as a bequest to his future second wife. Patmore obeyed her wishes, and entered the married state not only a second but a third time—surely a tribute to her excellence as a wife. During the first Mrs. Patmore's time Ruskin was a frequent visitor at their house. He became godfather to their youngest son, and procured a nomination to the Blue-Coat School for their second boy. The second wife was a rich Romanist, and Patmore retired with her to a country house.

That and Ruskin's increasing distaste for society made their intercourse more rare, but friendly relations were kept up with the family, and Ruskin gave Bertha Patmore—a daughter of Patmore and the " Angel "—lessons in perspective. Patmore, with all the zeal of a proselyte, would have guided Ruskin, wandering in the wilderness of religious doubt, into the fold of the Catholic Church, but had to reluctantly admit that Catholicism had no attractions for Ruskin beyond that of " pleasant intellectual repose." He was visiting at Brantwood as late as 1879.

After Dr. Andrews, Ruskin went for two years to a school kept by the Rev. Thomas Dale—his only experience of schoolboy life. The boys there do not seem to have treated him badly, but they held themselves aloof. He was like a girl, useless at games, and consequently beneath notice. Finally, from poor asthmatic Mr. Rowbotham he learnt a

little French Grammar, the three first books of Euclid, and Algebra as far as Quadratics. Neither of these tutors could claim to have moulded the boy's character in the slightest degree, and Richard Fall, a boy selected for him by Mr. Ruskin as a desirable holiday companion, treated him with good-humoured tolerance, which was reciprocated by Ruskin. Richard as a public-school boy must have looked upon home-bred Ruskin with contemptuous pity, and Ruskin had for too long been accustomed to be regarded by his home circle as a pattern of perfection and fountain of knowledge to feel much sympathy with other boys.

Mr. Ruskin was his son's best companion in those youthful days. At twelve Ruskin had been promoted to dining with his parents, at their four o'clock dinner, with Byron readings during dessert and a little wine. Byron became a special favourite with him : perhaps his early love troubles would have been taken less seriously if he had escaped the poet's romanticism.

Ruskin's thirteenth birthday brought as a gift from his father's partner, Mr. Telford, Rogers' " Italy," with the Turner vignettes. An unfelt need was supplied in his life by the first sight of these engravings : he immediately set to work to copy them in fine pen-shading. His enthusiasm about the book led to a mistaken introduction by Mr. Pringle to Samuel Rogers. Mistaken, because his admiration was for the illustrations rather than for the

poems, and Ruskin, eager only to express his
delight in the drawings, did not add the compli-
ments convention dictated—and Rogers evidently
expected—on the poems themselves.

The Turner vignettes were not his first attempts
at sketching, for he had spent much time over
Cruikshank's illustrations to Grimm's " Fairy Tales,"
but they gave him a new ideal to strive after, and
were more to his taste than the formal drawings
given him to copy by Mr. Runciman, his first
drawing master. Mr. Ruskin had enjoyed Rogers'
" Italy " almost as much as his son, and bought
Prout's "Sketches in Flanders and Germany" shortly
after in order to please Ruskin.

This gave the family so much delight that they
determined to visit these countries and see the
places for themselves. So it was that in the spring
of 1833 they set off on a tour through France,
Belgium, Germany—following the course of the
Rhine from Cologne to Strasburg—then, by way of
the Black Forest, to Schaffhausen, whence Ruskin
had his first, and unforgettable, view of the Alps, and
so through Switzerland to Italy with intention to
press on to Rome. It was too late in the year for
this, so they crossed the Simplon and returned by
way of Geneva, Lyons, and Dijon. Quite the Grand
Tour for a boy of fourteen. They had a travelling
carriage from Long Acre for the tour, fitted with
every convenience for so long a journey, with a
roomy " dickey " for Anne and Salvador, the

courier, an outside seat in front for Mary Richardson and Mr. Ruskin, and pockets, drawers, and receptacles innumerable for their luggage. Mrs. Ruskin travelled inside with her son. It seems rather a strange arrangement, but his delicacy—probably in a great measure due to " coddling "—offered the excuse. There was room also inside for Mary and her uncle if the weather was unfavourable. Four good horses, and a gaily dressed postillion, completed the party, which no doubt excited some attention as it passed through the villages en route, and some envy perhaps from travellers with less satisfactory bank balances who had to be content with the diligence, or, like Turner, barber's son and heaven-born genius, go on foot with a bundle wrapped in a handkerchief for luggage.

Mr. Ruskin had worked hard for his money, and now he was not averse to reaping the benefit of his toil—not so much for himself as for his beloved son, for whom nothing could be too good. It was quite sufficient return to see the lad busy jotting down notes and sketches, and witness his joy at the first glimpse of the Alps.

The period between the gift of Rogers' "Italy" in 1832 and the visit to Herne Hill of the Domecq sisters in 1836 was the happiest in Ruskin's life. The shy, sensitive lad was completely happy with his drawings and his minerals ; intercourse with his contemporaries had not made him aware of home-bred gaucheries ; he was heartwhole, and

with all the world before him. If the Evangelical opinions of his mother necessitated irksome attendance at Beresford or Camden Chapels, he had a silent sympathiser in his father, who was none too fond of it himself. But even this and the formalism Mrs. Ruskin delighted in had not yet begun to worry him, for he had no other standard to judge by and had been trained in it all his life.

CHAPTER II

FIRST LOVE

IN accounting for the unhappiness and melancholy
that shadowed Ruskin's life, too much stress
seems to have been laid on his unrequited love for
Adèle Clotilde Domecq. The question is—had she
accepted the boy's attachment, and married him,
would the tenour of his life have run more smoothly ?
A very little consideration will show that, whether
Ruskin himself was aware of it or not, his un-
happiness was due to the hypersensitive tempera-
ment of genius, increased by deprivation of sports
and companionship suited to his age. Had he
been sent to school and allowed to mix freely with
boys of his own age, or even been allowed to run
wild, as he himself suggests, with a Welsh pony on
the Welsh hills, his originality might have suffered,
but both mind and body would have gained in
robustness.

Calf-love is no uncommon ailment. Most lads
have it more or less severely, but with a normal,
healthy boy it is neither dangerous nor lasting.
Poor John Ruskin, at seventeen, was neither able

to resist the disease nor strong enough to throw
it off. Shy, sensitive, awkward, pedantic, he was
little used to the society of young girls—much less
to any as self-possessed and highly bred as the
Domecqs with their Parisian dress and experience.
Adèle laughed at him. Little wonder ; for at
fifteen the sterling worth and genius of her admirer
were unlikely to blind her to his disadvantages of
manner. With his customary candour he tells us
that the subjects he selected for conversation when
they were alone were " the Spanish Armada, the
Battle of Waterloo, and the doctrine of Transub-
stantiation "—all from the ultra British and Evan-
gelical standpoint. And Adèle a Spanish Catholic
educated in France ! His love sonnets he was too
shy to show her, but he wrote her a story of Neapoli-
tan bandits (published in " Friendship's Offering ")
which made her laugh, and sent after her to Paris
a letter of seven quarto pages in bad French—and,
again, Adèle laughed. A Spanish blonde, maturing
early, she must have been very beautiful at fifteen ;
but, by Ruskin's own account, not amiable. Yet
she made a good wife to Baron Duquesne, so per-
haps it was not cruelty but only girlish thought-
lessness that made her seem so heartless. One
thing is evident : she was utterly unsuitable, both
as regards character and religion, for Ruskin, and
if he had been left to himself most probably the
episode would have ended naturally in a very short
time.

Meanwhile the seniors seem to have watched the tragi-comedy with indifference. The two fathers, while recognising that the boy was too young to know his own mind, were agreed in hoping that his thoughts would turn later to one of the Domecq girls : a very suitable arrangement for business reasons. Mrs. Ruskin was less willing to welcome a Romanist daughter-in-law, yet she seems to have taken no steps to separate the young people—in fact, as will be seen later, she even brought them together again when time had nearly effected a cure. Her action in this respect cannot be explained, unless she fondly imagined that a long course of Bible-reading and Scottish paraphrases, combined with many sermons by worthy Dr. Andrews, had rendered her son proof against the wiles of a daughter of Heth.

The writing of a Venetian tragedy, and sundry love poems addressed to Adèle, followed her departure ; the love-lorn youth's leisure being spent over Byron and Shelley.

A notice from Christ Church that he could go into residence the following January (1837), and would be required to matriculate in October 1836, gave a new and healthy impetus to his thoughts.

It must have been a painful shock to the doting parents, who had been accustomed to look on Ruskin as a prodigy of learning, when they were told that he was far behind his years in such subjects

as were necessary for matriculation. Failure was
so probable that Mr. Ruskin found it an argument
in favour of his being entered as gentleman-com-
moner. Perhaps he was not unwilling to have a
valid excuse for setting aside his old-school Tory
doubts as to the propriety of a merchant's son
mixing with nobles, for without any desire to climb
himself, he was of opinion that his son was entitled
to the best. Money was plentiful, so the doubt
about matriculation settled the question, and Ruskin
went to Oxford entitled to wear the velvet cap and
silk gown of a gentleman-commoner. Even home-
bred lads have to leave the parental nest sooner or
later. This would have been the time to let Ruskin
fight his own battles. Mrs. Ruskin was not of this
opinion. The older he grew the more jealously did
she guard against his separation from her. She went
to Oxford with him ; lodging in High Street all term
time, and stipulating that he should visit her every
day from tea-time at seven o'clock until " Tom "
rang out the summons that sent him back to his
rooms for the night. Mary Richardson and Anne
were with her, and Mr. Ruskin spent the week-ends
there. On Sundays Ruskin went with them to
St. Peter's.

A gentleman-commoner who was not a public-
school man, read hard, never missed chapel, and
did not care for sports, was sufficiently uncommon
to excite remark. Added to this his parents, by
coming to Oxford—certainly a most extraordinary

action—had laid him open to a charge of being in leading strings, an imputation to which young men of his age are naturally sensitive. Class distinctions were more marked then than now : the social difference between Ruskin and the men of his college was emphasized by the presence of his homely family, and this must have been felt, if not expressed openly. He gave good wine to those who were willing to accept his hospitality ; his father paid, ungrudgingly, any bills he might incur—as far as money was concerned he was possibly better off than the majority of freshmen—but no one recognised more acutely than Ruskin the gulf of class traditions yawning between a wine-merchant's son and these scions of aristocracy. Contemptuous indifference seems to have been the general tone adopted towards him ; taking a more active form on occasion—as when he violated the unwritten law of gentlemen-commoners by writing a readable essay exceeding twelve lines of four words apiece. But there was also some rowdyism, to which Ruskin owed his first acquaintance with Henry Wentworth Acland ; the commencement of a life-long friendship.

Acland had been two years at Christ Church when Ruskin entered. He was a man of warm sympathies and chivalrous nature ; a sound Church-man, and thoughtful beyond his years. As a baronet's younger son, and descended from an old west-country family of such pride of race

that, locally, humanity was divided into "men, women, and Aclands," he had the assured position Ruskin lacked. Having interfered to protect the young freshman from persecution, Acland took him in hand and taught him all the traditions of healthy honourable youth as learnt in our great public schools—Acland was educated at Harrow.

Both high-minded, pure-living, and studious, they also had other kindred sympathies. Both were keen lovers of art : Acland was no mean artist. Acland's special bent was towards medicine, but he was fully able to enter into Ruskin's enthusiasm for minerals. Lastly, both were of delicate constitution, unable to take part in the usual sports : a circumstance which threw them together more than would otherwise have been possible. Ruskin could have had no better Mentor. In his second term he was put up for election to Christ Church Club, Acland being one of his proposers. Other introductions followed. Charles Newton became his friend—would have had Ruskin go with him to Greece a few years later, to study Greek archæology, but the old people would not hear of it. Dr. Buckland opened his hospitable doors to him. There he met Dr. Daubeny and Charles Darwin, the latter remaining always on friendly terms although Ruskin's aversion to Darwinism was unconquerable.

But if Ruskin owed to Acland his first admission into Oxford society, his fascinating personality did

the rest. In spite of a scarred lip, his smile was peculiarly sweet, and his voice sympathetic. He was a good listener; courteous, and without any trace of dogmatism or arrogance in conversation. Above all he had the valuable but unexplainable gift of charm. Both now and throughout his life he had a singular power of attracting to himself all that was good and noble in man or woman. Strange that a man so rich in friends should have been so unhappy.

Mr. and Mrs. Ruskin were proud of their son's grand acquaintances, but they never attempted to enter into society for which they felt unfitted. Ruskin confesses that once, in Mr. Ryman's, the print-seller's, shop, he was ashamed of his father and mother. Perhaps some supercilious silk-gownsman had come in while they were with him there. Yet we feel confident from his whole behaviour towards them, that the feeling he describes as shame was due to an uneasiness lest their homeliness should be made the subject of college witticisms, rather than to any filial shortcoming. He declares that his mother's presence in Oxford was never misunderstood, nor made the subject of sarcastic comment. Possibly Acland's influence had something to do with this, or the touching filial reverence Ruskin showed his parents may have shamed the thoughtless into silence.

Ruskin had commenced authorship at a very early age. Mr. Pringle, editor of " Friendship's

Offering," published by Smith & Elder, printed several of his poems and the story written for Adèle. In the March number for 1834 of *Loudon's Magazine of Natural History* appeared his article " On the Strata of Mountains and an Inquiry as to the Colour of the Rhine " : an ambitious subject for a lad of fifteen. In 1837 he started fairly on his career as an art critic with an article in the November number of *Loudon's Architectural Magazine*—" Introduction to the Poetry of Architecture ; or, The Architecture of the Nations of Europe considered in its Association with Natural Scenery and National Character." This, which excited some comment, was signed " Kataphusin," as he feared if his name appeared his youth would prejudice the public against it.

New friends, new aims and ambitions, with a life of hard work and healthy interests, had driven love into the background. Adèle's image had so far faded that when Charlotte Withers, a clinging, fragile, sympathetic girl of about sixteen, came on a visit to Herne Hill in the spring of 1838, he found her a very pleasant companion. Unlike Adèle, she was immensely proud of an essay he wrote for her " On the Relative Dignities of Music and Painting," and they were drifting placidly in the direction of matrimony when her visit came to an end.

Another month, he was of opinion, might have settled the matter, but Mr. and Mrs. Ruskin had

formed more ambitious plans for their only son than marriage with a coal-merchant's daughter. She would have made a meek, adoring wife, and would never have disputed precedence with her mother-in-law. Her father arranged a marriage for her soon after, and she died after a short and unhappy married life. Ruskin's fancy had been touched, but the young people were separated before any harm had been done. He might have gone back to Oxford, plodded on with his classical studies, taken his degree, and—in dutiful obedience to his parents—presented himself for ordination as a preliminary step towards the coveted bishopric, if Mrs. Ruskin had not tempted Fate by bringing him into Adèle's too fascinating presence again.

Mr. Domecq sent his daughters to England again in the autumn of 1838 in order that they might complete their education. They were at a convent at Chelmsford, and Mrs. Ruskin drove over to see them. For some strange reason she took Ruskin with her. Perhaps, as a staunch Protestant, she did it to show her disregard for conventual rules. She also invited the girls to spend their holidays at Herne Hill. The result might have been expected. A fresh spark was applied to his inflammable heart, and there was a renewal of the fruitless sighings and morbid gloom of 1836. For Adèle was no more touched by his passion now than then, although both fathers would have welcomed the match.

With her sisters, she came to Herne Hill for the
Christmas holidays, and the two young people were
thrown together, each day adding to Ruskin's
passion. As Adèle continued indifferent, her father
accepted a proposal of marriage for her from Baron
Duquesne ; hoping that Ruskin might later on
transfer his affections to one of her younger
sisters.

Ruskin was now reading seriously for his degree,
and a dread lest news of the proposed Duquesne
marriage should unsettle him led Mr. and Mrs.
Ruskin to keep it secret. They did what they
could to interest him in other girls, but the wound
was too recent to be healed so readily. Mr. Domecq's
death in the spring of 1839 delayed the marriage
negotiations, and Adèle remained at the Chelmsford
convent until the following September, when she
returned to Paris. Ruskin saw her, for the last
time, before her departure, and wrote a long poem
—" Farewell "—the same evening. Sorrow and
overwork injured his health. Osborne Gordon, who
came to him about this time as private tutor, made
him moderate his reading, and, after Christmas, he
was able to return to Oxford with hopes of getting
a First. He came of age in February 1840, and his
father assured him an independent income of £200
a year by transferring to his name stock producing
that amount. One of his first acts of independence
was the purchase of Turner's " Harlech " for £70,
to the great distress of his thrifty father.

Adèle was married in March 1840. Ruskin went
back to Oxford ; reading from six in the morning
until twelve at night, with insufficient exercise
and in a state of mental depression. His constitu-
tion could not stand the strain. One evening he
spat blood. All work was stopped ; he was ordered
rest and fresh air, and told to leave England before
the autumn. All hope of honours had to be aban-
doned—more to the disappointment of his parents
than himself. The usual course of University
teaching had been of little use to him. His was
an uncommon mental organization, and he had to
find out his own powers by slow and painful
stages. The most valuable result of his under-
graduate life was Acland's friendship, and his
influence could not be tested in the Schools.
The Newdigate Prize, awarded him in June 1839
for his poem "Salsette and Elephanta," was, so
far, his only University distinction, and this
marked the end, not the beginning, of his career
as a poet.

Ruskin's youthful promise of poetic genius had
not been fulfilled. His adult verses, while correct
in rhythm, were not remarkable as poetry. Fortu-
nately for us he ceased to make verse the medium for
expressing his thoughts, and turned his attention
to prose. In this he excelled. John Ruskin stands
in the foremost rank of English prose-writers. He
was wont to complain, perhaps not without reason,
that his readers thought too much of the sound of

his prose and too little of its meaning. The retort was obvious : if his teaching was neglected in the delight of those mellifluous sentences, dogmatism, cynicism, and inconsistencies were also forgotten under the same spell.

CHAPTER III

"MODERN PAINTERS"—SWITZERLAND
AND ITALY

WITH the double object of seeking a milder climate and diverting Ruskin's thoughts by change of scene, the family went abroad. As usual, they had a travelling carriage from Long Acre—such as had fascinated Ruskin when a boy and held his affections ever after. But the zest that had attended their first Continental tour was wanting. Ruskin was in a nervous, depressed condition : too ill and weak to take pleasure in the journey. He was feeling the reaction after his effort to take honours, and still nursing the idea that his heart was hopelessly lost.

The party consisted of Ruskin, his father and mother, Mary Richardson, and Anne. Their route was by way of Rouen, the Loire, Tours ; crossing France by Auvergne, they travelled down the Rhone to Avignon ; then, by way of the Riviera, to Florence and Rome. Ruskin ever after deplored his apathy on this first visit to Italy, and the scales of Evangelical prejudice that blinded him to re-

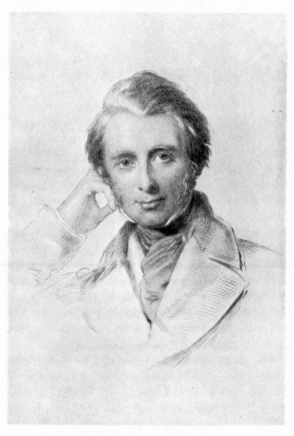

From an engraving by Armytage after a drawing by George Richmond.

JOHN RUSKIN

P. 34]

ligious art. He seems to have behaved like a spoiled child on this occasion : declined to look at any art treasures unless by Michael Angelo, Rubens, Vandyke, and Velasquez ; shocked his friends by refusing to admire Raphael and Titian ; and finally summed up all the discomforts of Italy, from dirt to malaria, as direct consequences of Papacy. In this last particular all the party were agreed. It was a favourite theory of Mrs. Ruskin's that dirt and Papacy were inseparable. She was also delighted to find a new indictment against Papacy in the state of the roads. Sitting rigidly upright in the travelling carriage, as was her custom, she pointed out triumphantly that the surface steadily deteriorated as they approached Rome.

After-events proved that Ruskin's mind was unconsciously storing impressions and throwing off the cramping effects of early training during the months when he especially accuses himself of wasted time. A more groundless self-accusation was certainly never made. Ruskin's life was one ceaseless round of activity. When he was not sketching or writing he was collecting minerals, engravings, manuscripts ; studying geology, mineralogy, cloudforms, birds, insects, flowers : classifying each by methods of his own, and in the case of minerals using shorthand of his own invention in the descriptive catalogue. And as far as the prejudices of these youthful years are concerned, when we consider the formalism and flattery of his home

circle, narrowness and dogmatism on his part cease to be remarkable. Only a naturally sweet and loveable nature could have saved him from insufferable and incurable priggishness.

Acland had given Ruskin letters of introduction to Mr. Joseph Severn—the genial British Consul at Rome ; friend and devoted nurse of the poet Keats, who died in Severn's arms—and to George Richmond, the artist, who in 1842 painted Ruskin's portrait with an Alpine background. Mr. Severn, the son of an engraver, was himself, also, an artist by profession. He had been the winner of the Royal Academy prize in 1819 for his picture illustrating Spenser's "Cave of Despair." He was a very well-known figure in Roman society, and through his friendship with Keats had been associated with all the literary life of his generation. With the Ruskin family he quickly became intimate, winning the old people's goodwill by remarking on the poetical countenance of their son. Fate had marked him out for closer relationship with the Ruskin family by the marriage of his son Arthur to Joanna Ruskin Agnew—Ruskin's cousin and adopted daughter— but this event was many years removed at the time of the Ruskins' first visit to Rome.

The end of their stay at Rome was saddened by a return of the ominous hæmorrhage, but it soon passed. After this he seems to have thrown off the consumptive tendency, but he never became strong, and ill-health, added to a naturally melan-

choly disposition, made him averse to any society but that of intimate friends.

Venice, where he was busy with notes to be used at a later date in " Modern Painters," Padua, Milan, and Turin were all visited in turn, and then they turned towards Switzerland again, with renewed health and strength to cheer them.

By the end of June they were back in England with full sketch-books and such store of health that, at his earnest request, Ruskin was allowed to take Richard Fall—the Shrewsbury schoolboy who had been his holiday friend—as companion, and go to the Welsh mountains, *without* his parents, provided he consulted Dr. Jephson of Leamington first. Dr. Jephson ordered him to stay in Leamington for six weeks ; Ruskin refused, and continued his journey. At Pont-y-monach he received the paternal order to return at once to Leamington, and submissively obeyed—his first attempt at insubordination ending without a struggle. He settled down in Leamington lodgings to study geology, which he did in his own way. Science as it is generally understood never interested Ruskin. Agassiz now, as Darwin and Huxley later, never met with more than impatient tolerance from him. He valued his agates and native silver for their beauty. Evolution was to him as a red rag to a bull, although in 1869 he was bound to admit that there were geological proofs of ages of existence before man.

About this time was written " The King of the Golden River," chiefly of interest because of the child for whom it was written. Ruskin, always devoted to children, turned naturally to his pen when he wished to give pleasure to his mother's little visitor, Euphemia Chalmers Gray, and this fairy tale was the result. Impossible then for any one to guess that less than seven years later she would be his wife.

Meanwhile Acland was studying medicine at St. George's Hospital ; even in his student days striving to raise the tone of his chosen profession, and better the condition of medical students living in London lodgings. Pure-minded, and thoughtful beyond his years, the same sympathy and chivalry that had led him to protect Ruskin at Oxford made him now feel a personal responsibility for these young men—exposed at a most impressionable age to grave temptations. Sincerely religious, he was shocked at the indifference to death and blunting of their finer feelings, induced by too great familiarity with death in the necessary study of anatomy. The result of his thoughts was embodied in " A Letter from a Medical Student on some Moral Difficulties in his Studies, and on the Duty of the State to aid him in lessening them," published in November 1841 ; addressed to the Rev. J. H. North, and criticising a letter sent by him to Sir Benjamin Brodie, which advised the application of the Collegiate System to the Medical Schools. Acland's amendment

to the scheme was that temporarily subsidised houses should be established, situated near the hospitals, in which the students could live economically.

Acland's studies and plans for the protection of the students did not make him forgetful of old friends. In November 1841 his diary notes—" day spent with curious Ruskin and his more curious household." [1] Probably the day's visit was often repeated, for the friendship begun at college was growing steadily : to remain unbroken until severed by death. Acland, at St. George's Hospital, was studying for his diploma. ·Ruskin, with Osborne Gordon as tutor, was preparing for his degree. This he took the following spring (1842). For a young man who on entering college could not matriculate, and whose studies had since been interrupted for two years by serious illness, his pass was more than creditable, as he was given an honorary Fourth in both classics and mathematics.

As soon as Ruskin had taken his degree the family went to Chamonix, in order that he might be near his beloved Alps ; travelling by way of Rouen and Fontainebleau : Ruskin sketching industriously, and busy with notes for " Modern Painters." In the autumn they returned to England, and soon after moved to Denmark Hill—a larger house, standing in its own grounds, but without the

[1] "Sir Henry Wentworth Acland," by J. B. Atlay. (Smith, Elder & Co.)

childish memories that clung round the old home and endeared it to Ruskin.

In 1844 they were back at Chamonix ; Osborne Gordon joining them there for part of the time. Joseph Couttet, an experienced guide and " Captain " of Mont Blanc, who had recently been superannuated, was engaged to give his exclusive attention to Ruskin's safety, with strict injunctions from the parents that he was not to be allowed to get into danger.

" Le pauvre enfant,—il ne sait pas vivre ! " was Couttet's pitying remark.

Under Couttet's charge Ruskin was allowed to make independent excursions among the Alps, and even to prolong his stay at Chamonix after his parents left for Vevey—on condition that he wrote daily to satisfy them of his safety.

" Modern Painters " had served as an excuse for this visit to the Alps, but, once there, so many other interests claimed Ruskin's attention that the book progressed too slowly to satisfy his father. Back from Switzerland, and away from the witcheries of rocks and Alpine flora, the second volume might have been brought to an end had not new views on the subject of Art and the recognition of Titian's power made Ruskin insist upon seeing Italy again before he resumed work.

Turner joined his protest to those of Mr. and Mrs. Ruskin. Switzerland was in a state of political ferment—impossible for Ruskin to resist the tempta-

tion to visit Switzerland once he crossed the Channel —the old people were never happy if their idolised son went out of their sight. But Ruskin had his full share of obstinacy, and his parents could not deny him a pleasure his heart was so set upon. Their opposition was withdrawn: Couttet and Ruskin's man George being detailed to look after him.

It was characteristic of Ruskin that he should insist upon going, and equally so that, having obtained his own way, he should suffer pangs of conscience for the unhappiness and anxiety his parents suffered on his account. A Sunday climb to the peak above Gap also weighed heavily on his conscience as a lapse into Sabbath-breaking. His mother's creed still had firm hold on him. He went to Romanist churches when abroad, for the sake of the music or scenic effects, but not even the temptations of Alpine scenery could tempt him to sketch on Sunday. It was 1858 before he so far threw off the old Evangelical strictness as to use his pencil on that day.

In spite of uneasy prickings of conscience, Ruskin enjoyed to the full his quiet opportunities for architectural study at Lucca, and the hours of patient work in the cloistered Campo Santo at Pisa, where he obtained permission from Abbé Rosini to erect scaffolding from which to copy the frescoes. His customary charm of manner won him the good-will of the monks, from whom he obtained special

facilities for studying the Ghirlandajos and Angelicos he had neglected on his previous visit to Florence. He even succeeded in visiting the Convent of the Magdalen. At Santa Maria Novella the monks allowed him to go in and out as he pleased, so that he came into closer contact with the ceremonial of the Romish priesthood than would have pleased his mother. He boasted that he was the only painter ever allowed the privilege of erecting a scaffolding over the high altar at Assisi from which to copy Giotto's fresco of "The Marriage of Poverty and St. Francis."

By six o'clock in the morning, and at times much earlier, he was hard at work. His time was divided between studies of form and colour, taking copious notes for "Modern Painters," going into the symbolic meaning of religious and legendary pictures, and reading Italian history. Working at this high pressure, and passing from the hot Italian sunshine into cold churches, it seems a marvel how a man of such frail physique could have stood the strain. Couttet objected—found climbing the roof of Santa Maria della Spina, to watch the sunset, tame after Alpine climbing, no doubt, and pined for the invigorating air of his native land. But his charge could not be persuaded to give up this life. Perhaps it was now that Couttet told Ruskin he was good for nothing but to keep cows at nine sous a day!

In the autumn J. D. Harding joined him at

Baveno, and the two made a fortnight's sketching tour, ending at Verona. Later, they went on to Venice together, where a casual visit to the Scuola di San Rocco resulted in plans for writing "The Stones of Venice." Mr. Boxall, the artist, and Mrs. Jameson of legendary fame, were also at Venice, and the four made up a pleasant if not always harmonious artistic coterie.

But the strain upon Ruskin's nervous energy had been continued too long. His health began to fail. Couttet, anxious, persuaded him at last to move homewards. He got no farther than Padua, however, before the collapse came. Couttet nursed and doctored him. In a few days he was able to resume his journey, by easy stages, but a long-continued strain cannot be recovered from so quickly, and he returned home in a condition to need Anne's ministrations and his mother's care.

In 1845, Acland returned to Oxford as Lee's Reader in Anatomy, and set up in practice for himself there. The following year he married, and during the honeymoon went to Chamonix, where he met the Ruskins—just back from a pilgrimage over the ground covered by volume two of " Modern Painters," then recently published. The tour had not been quite as pleasant as they had anticipated. Ruskin, flushed with the success of a young author, and eager to point out all his favourite pictures, nothing doubting that his father would share the

delight, was disappointed to find that the old man had opinions of his own. It was the point of divergence. Nothing but Art at present found them divided, but the rift was there, and growing. It was to widen with years until all the old dogmas had been thrown aside and Ruskin started on his solitary path as a Theist and social reformer.

But here at Chamonix all differences were forgotten. Acland was one of the few people with whom Ruskin seemed always happy. Mrs. Acland, now a new acquaintance, was soon to be one of his most helpful friends—in after-years he was never happier than when staying in the Acland house, where " Mama " (Mrs. Acland) made him so comfortable. Their presence now was much to his liking. Mrs. Ruskin and Mrs. Acland remained at Chamonix, while Dr. Acland went off with Ruskin to sketch and geologise at Montanvert and the Jardin.

Ruskin passed through a time of great depression in the spring of 1847 : possibly the reaction after his literary work. He was also shadowed by a passing fancy for pretty Charlotte Lockhart, granddaughter of Sir Walter Scott. The early spring was spent at the Salutation inn at Ambleside, and from thence he went to Leamington for the waters. Mr. Macdonald, whose mother had been an old friend of Mr. Ruskin, was there also, and at his invitation, Ruskin went to visit him in the autumn, 1847, at his shooting lodge below Schehallien.

Sport had no charms for Ruskin, so he left his host to do the shooting while he looked out for more congenial occupation. He found it—a field overrun with thistles—and started, on the principles taught later to his Oxford disciples, to clear them away.

CHAPTER IV

TURNER

THE autumn of 1836 saw Ruskin's first appearance as an art critic with the answer to an article in *Blackwood's Magazine*, in which Turner's " Juliet and her Nurse " had been severely criticised. The substance of this letter was subsequently published as the first chapter of " Modern Painters." The letter itself never appeared. Turner, to whom it was sent for approval, contented himself with a polite acknowledgment, and sent the letter to the purchaser of the picture.

It was in this way that Turner first became aware of the young man's admiration for his work. They were not formally introduced until 1840. There is a story that this introduction took place in Mr. Ryman's shop at Oxford, whither Ruskin was accustomed to resort in order that he might copy some of the Turner engravings—Turner himself coming in while he was thus engaged, and being introduced by Ryman. But Ruskin himself tells us that they first met at a Norwood dinner, and were introduced by Mr. Griffith : the date being

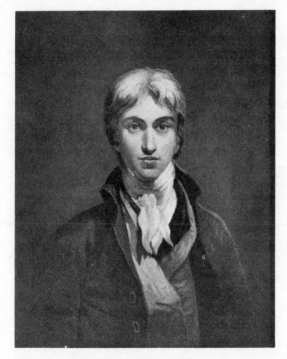

From an engraving by Holl after a painting in the
National Gallery, by J. M. W. Turner, R.A.

J. M. W. TURNER, R.A.

p. 46]

22nd June 1840. Ruskin was not likely to forget such a memorable occasion as a first meeting with the great painter. No close intimacy resulted from it. His enthusiasm was for Turner's work and genius more than for the man himself, and the artist, on his part, tolerated rather than encouraged the young man's admiration.

Apart from the disparity of age, Turner, whose manners and speech betrayed his humble origin, and young Ruskin, fresh from Oxford, could have had little in common except their love of Art. The painter was on more familiar terms with old Mr. Ruskin : probably he felt more at home with the worthy merchant. Turner frequently dined at Denmark Hill, and occasionally received a present of their home-grown pork.

Ruskin bewailed that ten years of his life were wasted because Turner, after this introduction, did not follow it up by showing him how to paint. It was one of Turner's foibles not to admit visitors to his studio, though—had Ruskin asked him—perhaps he might have been induced to make an exception in his favour : a rich dilettante, and ready buyer as well as sworn champion. This rule of Turner's did not keep him from working on his pictures at the Academy on varnishing days, when he painted vigorously on the half-finished paintings ; his myopic eyes close to the work, and his old tall beaver hat, the nap always brushed the wrong way, pushed to the back of his big head.

His father, no longer obliged to work at his trade as a barber, went to live with Turner, and prepared colours, set the palette, and even acted as cook in his devotion to his wonderful son. Sometimes visitors lingered in his picture gallery until the old gentleman, behind the scenes, was confronted with the risk of overdone chops. On one occasion anxiety for Turner's creature comforts overcame his discretion. Putting his head in at the door of the gallery he whispered mysteriously—

" That 'ere's done."

The artist disregarded the appeal, and the visitors tried to look unconscious. There was an interval, and then Turner père looked in once more.

" That 'ere 'll be spiled," he announced, reproachfully.

Ruskin learnt drawing and painting successively from Mr. Runciman, Copley Fielding, and J. D. Harding. But his admiration for the work of Turner and Prout, and his habit for so many years of copying every example of their work he could get, led to their influencing his style more than either of his teachers. His talent was greater with the pencil than with the brush. He excelled as a copyist and in fine line-work. He also sketched landscapes with great delicacy and feeling, but lacked the ability to compose a picture. Nature gave him the artist's eye and hand, but with intent that he should make his special work the interpretation, not the creation, of Art.

An extract from the chapter " Of Finish " from the third volume of " Modern Painters " will illustrate Ruskin's patient study of detail. Turner's finish he has just described as " so delicate as to be nearly uncopiable." He then gives instances of it— " Every quarter of an inch of Turner's drawings will bear magnifying . . . much of the finer work in them can hardly be traced, except by the keenest sight, until it is magnified. In his painting of Ivy Bridge, the veins are drawn on the wings of a butterfly, not above three lines in diameter ; and in one of his smaller drawings of Scarborough, in my own possession, the mussel-shells on the beach are rounded, and some shown as shut, some as open, though none are as large as one of the letters of this type ; and yet this is the man who was thought to belong to the ' dashing ' school, literally because most people had not patience or delicacy of sight enough to trace his endless detail.

" ' Suppose it was so,' perhaps the reader replies ; ' still I do not like detail so delicate that it can hardly be seen.' Then you like nothing in Nature (for you will find she always carries her detail too far to be traced). . . . It is not the question now whether we *like* finish or not ; our only inquiry here is, what finish *means* ; and I trust the reader is beginning to be satisfied that it does indeed mean nothing but consummate and accumulated truth, and that our old monotonous test must still serve us here as elsewhere. And it will become us to

consider seriously why (if indeed it be so) we dislike this kind of finish—dislike an accumulation of truth. For assuredly all authority is against us, and—*no truly great name can be named in the arts— but it is that of one who finished to his utmost.* Take Leonardo, Michael Angelo, and Raphael for a triad, to begin with. *They* all completed their detail with such subtlety of touch and gradation, that, in a careful drawing by any of the three, you cannot see where the pencil ceased to touch the paper; the stroke of it is so tender, that, when you look close to the drawing you can see nothing; you only see the effect of it a little way back! Thus tender in execution, and so complete in detail, that Leonardo must needs draw *every several vein in the little agates* and pebbles of the gravel under the feet of the 'St. Anne' in the Louvre.

" Take a quartett after a triad—Titian, Tintoret, Bellini, and Veronese. Examine the borage blossoms, painted petal by petal, though lying loose on the table, in Titian's 'Supper at Emmaus,' in the Louvre, or the snail-shells on the ground in his 'Entombment'; examine the separately de-signed patterns on every drapery of Veronese, in his 'Marriage in Cana'; go to Venice and see how Tintoret paints the strips of black bark on the birch trunk that sustains the platform in his 'Adoration of the Magi'; how Bellini fills the rents of his ruined walls with the most exquisite clusters of the erba della Madonna. You will find them all in a

tale. Take a quintett after the quartett—Francia, Angelico, Dürer, Memling, Perugino,—and still the witness is one, still the same striving in all to such utmost perfection as their knowledge and hand could reach."

No wonder that such microscopic scrutiny resulted in Turner's petulant complaint that Ruskin knew more about his pictures than he did himself. It also explains Ruskin's liking for Pre-Raphaelitism, and his feud with Whistler.

The introduction to Turner (22nd June 1840) had only served to whet Ruskin's admiration and enthusiasm. Turner was now at the height of his power. His conceptions were finer and his colouring richer than ever : the former showed as yet none of the vagueness and indistinctness that marked the last five or six years of his life, nor had he yet become reckless in the use of his pigments—caring nothing about the risk of fading or alteration in colour if only he could get the effect he desired. He had amassed a fortune by the sale of his engravings, yet he lived in dirt and squalor at the house in Queen Anne Street ; hoarding his pictures jealously amidst dirt, dust, damp, and disorder. He had a strange dislike to parting with his paintings, and was not at all disposed to let things go for less than a fair price, so that most of his Academy pictures returned to him unsold. It is said that he employed a butcher's boy to attend picture sales and bid for his work when any of it came into the market ;

either buying, to add to his gallery in Queen Anne
Street, or getting the satisfaction of running up the
price.

Yet, having obtained possession of a picture,
he took no precautions against injury. The rain
came through the skylight in his picture gallery ;
the furniture was shabby, ricketty, and thick with
dust ; and amidst such incongruous surroundings
were his pictures in their vivid, glowing colouring—
gorgeous sunsets or shimmering moonlight—shining
through the gloom. Hannah, his old housekeeper,
intended by his will to be custodian of his pictures,
went about the house with her head wrapped in
dirty flannel, and her tailless cats crept in and out
through a broken window, ineffectually blocked by
his picture " Bligh Sand."

Was it eccentricity, or a taint of madness in-
herited from his mother, that made him store away
priceless sketches and pictures to mildew and decay ?
Boxes upon boxes crammed full of sketches were
there, and not a single precaution taken to preserve
them—as we shall see later, in Ruskin's report on
the bequest to the National Gallery. " Keep
them together," was Turner's one desire, and he
seems to have carried out the idea in his own queer
way.

The first volume of " Modern Painters " appeared
in May 1843, Ruskin, still shy of signing his name,
publishing as " An Oxford Graduate."

Turner seems to have been rather embarrassed at

the enthusiasm displayed by his young disciple. He grumbled to his friends about Ruskin's eloquent interpretations. The kind, eccentric, humble-minded artist, so ready to see genius in others, felt uneasy under so much laudation. On one occasion, finding that one of his pictures hopelessly dulled the colouring of its neighbour on the Academy walls, Turner is said to have daubed his own over with lampblack. "It will wipe off," he said, in reply to remonstrance. His genius had been recognised by artists and collectors : as for the critics, and the general public swayed by their comments, they might irritate him by their vapid remarks, but he could treat them with disdain. Sometimes though they stung him to fury—as when a critic objected to his picture "The Snowstorm," exhibited at the Royal Academy, 1842, saying that it was "soapsuds and whitewash."

"Soapsuds and whitewash!" the old painter exclaimed indignantly.

Ruskin endeavoured to console him.

"Soapsuds and whitewash!" repeated Turner. "What would they have? I wonder what they think the sea is like? I wish they'd been in it!"

Little wonder that he should express indignation with armchair critics when, to get the necessary experience for such a picture, he had spent four hours, half-frozen, lashed to the mast of the steamer *Ariel*, memorising the effects of the drifting snow-wreaths and tossing waves. As a rule, Turner was

too sure of his own power to feel either jealousy or envy. Let the critics rave. He went on painting as his genius dictated, and contented himself with the challenge to posterity expressed in his will—

" Hang up my two favourite pictures, which I once resolved should be buried with me, by the side of Claude's, and let those who come after judge between me, whom you neglect, and him, whom you worship."

The pictures he selected to bear silent witness to his genius as compared with that of Claude were " The Sun rising in a Mist " and " Dido building Carthage." They are very fine specimens of his work, and might have been sold had he not obstinately refused all offers for them. Fortunately for the nation he did not carry out his first declared intention of having them wrapped round him as a winding-sheet. They now hang, as he desired, by Claude's, in the National Gallery.

Turner died in a riverside lodging on 19th December 1851. He left no legitimate kin except some cousins he neither knew nor cared for. It was not for them he had hoarded money and pictures. His great desire was to befriend the less fortunate members of his profession, and, incidentally, perpetuate his name, by founding houses in which unsuccessful artists could live, something after the style of almshouses—to be called " Turner's Gift "—and the bulk of his property (sworn under £140,000) was left in trust for this purpose. Ruskin

was named as one of the executors, but when it became known that the will was to be contested on behalf of the cousins, he refused to act. Legacies were left to his housekeeper and others, generous sums set aside for the encouragement of Art, and his pictures and sketches were left to the nation—with the request that they should all be kept together, and that until a proper gallery was provided for their accommodation, Hannah Wheeler should remain in charge of them at Queen Anne Street.

Turner's was an instance of the danger attending on amateur will-making. 'A Chancery suit swallowed up a large portion of the money, the property left to endow the Turner's Gift homes was held to come under the Statutes of Mortmain, and Turner's dearest wish was never carried out. But the Court allowed £20,000, free of legacy duty, for the encouragement of Art, and the bequest of pictures to the nation was ratified; the country being the richer by 362 oil-paintings, 135 finished water-colours, and about 20,000 sketches. These were in such a state of neglect and chaotic disorder that little good could have resulted, had not Ruskin come to the rescue and earned the gratitude of all Art lovers by devoting six months of his valuable time to the task of sorting, arranging, and preserving the nation's newly acquired property. His labours lasted from the autumn of 1857 to May 1858, and some idea of his colossal task may be gathered from his own report :—

" In seventeen boxes in the lower room of the National Gallery I found upwards of 19,000 pieces of paper, drawn upon by Turner in one way or another—many on both sides. Some with four, five, or six subjects on each side (the pencil point digging spiritedly through from the foregrounds of the front into the tender pieces of sky on the back). Some in chalk, which the touch of the finger would sweep away. The best book of studies for his great shipwrecks contained about a quarter of a pound of chalk débris, black and white, broken off the crayons with which Turner had drawn furiously on both sides of the leaves ; every leaf with peculiar foresight and consideration of difficulties to be met by future mounters containing half of one subject on the front of it and half of another on the back. Others in ink rotted into holes. Others (some splendid-coloured drawings among them) long eaten away by damp and mildew, and falling into dust at the edges, in various states of fragile decay. Others worm-eaten ; some mouse-eaten ; many torn half way through ; numbers doubled (quadrupled, I should say) into four, being Turner's favourite mode of packing for travelling ; nearly all rudely flattened out from the bundles in which Turner had finally rolled them up and squeezed them into the drawers in Queen Anne Street. Dust of thirty years' accumulation, black, dense, and sooty, lay in the rents of the crushed and crumpled edges of these flattened bundles, looking

like a jagged black frame, and producing altogether unexpected effects in brilliant portions of skies, whence an accidental or experimental finger-mark of the first bundle unfolder had swept it away.

" About half, or rather more, of the entire number consisted of pencil sketches in flat, oblong pocket-books, dropping to pieces at the back, tearing laterally whenever opened, and every drawing rubbing itself into the one opposite. These first I paged with my own hand, then unbound, and laid every leaf separately on a clean sheet of perfectly smooth writing-paper, so that it might receive no further injury. Then enclosing the contents and boards of each book (usually ninety-two leaves, more or less, drawn on both sides, with two sketches on the boards at the beginning and end) in a separate sealed packet I returned it to its tin box. The loose sketches needed more trouble. The dust had first to be got off them (from the chalk ones it could only be blown off), then they had to be variously flattened ; the torn ones to be laid down, the loveliest guarded so as to prevent all future friction, and four hundred of the most characteristic framed and glazed, and cabinets constructed for them, which would admit of their free use by the public."

Probably no one but Ruskin—deeply versed in Turner lore—could have done the work and systematized the fragmentary notes and sketches in such a manner that they would be intelligible. Turner trusted in a great measure to his memory for

atmospheric effects, and his notes and sketches—
many of them made on odd scraps of paper—were
meaningless to the uninitiated. Ruskin's labour of
love included more than the gift of his time and
strength. The expense of classification, and of the
reversible frames and cases to contain the sketches,
amounted to a considerable sum, and this Ruskin
paid out of his own pocket.

CHAPTER V

MARRIED LIFE

RUSKIN'S frequent excuses for leaving home troubled his parents, who began to feel him drifting from them. The distaste he showed for society, and his tendency towards morbidness and depression, also worried them. They turned to matrimony as a panacea. A wife might induce him to settle down quietly near them instead of spending so much of his time on the Continent. Having made this resolution, Mrs. Ruskin, who had ordered his life for him hitherto, took upon herself the choice of a wife. Of all the blunders into which well-meaning people fall, none can be greater than that of interference in matters matrimonial. All known theories must fail here, and yet, as long as the world lasts, women will go on making matches between people who are—so these priestesses of Hymen say—" just made for one another," and perjuring themselves to keep apart others who, they profess to see, are " not a bit suited," without thinking it at all necessary to consult the people most interested—who generally contrive to upset

all theories and popular fallacies dear to the afore-
said meddlers.

Mrs. Ruskin was no exception to the rule.
Ruskin had already declined her choice of Miss
Wardell ; Miss Lockhart would not have anything
to do with him. His mother looked round, and
invited a young and pretty cousin from Perth—
Euphemia Chalmers Gray—to pay them a visit.
She was a very attractive girl in her teens, lively,
fond of society, and interested in Art. Ruskin,
always appreciating the company of young and
pretty girls, although usually too shy to interest
them, found it very pleasant to act as escort
round the picture galleries to a lively attractive
girl who could take an intelligent interest in
pictures. He showed undisguised pleasure in her
company.

Mrs. Ruskin took this as a good omen. Miss
Gray's high spirits were just what was needed to
cheer Ruskin and drive away his morbid despon-
dency, and since she liked gaiety and society she
would induce him to take part in the society func-
tions he found so distasteful. It is a favourite
theory that contrasts of character make for happi-
ness in married life. Here they were well marked :
nothing could be plainer to the parents than that
their son and Miss Gray were meant for one another.
So the mischief began.

It is a dangerous amusement for a young man
to superintend the artistic education of a beautiful

girl. Ruskin's attentions were construed by Mrs. Ruskin into proofs of attachment. His protests that they showed nothing more than a friendly interest were disregarded. He slackened his attentions; was asked not to do so as Miss Gray did not know of Mrs. Ruskin's wishes. The visitor remained at Denmark Hill, and Mrs. Ruskin, after allowing a short time to elapse, returned to the subject again. His parents' wishes were pleaded as an argument in favour of the marriage. She urged its desirability, persuaded him that the pleasure he took in Miss Gray's society was a proof of love. He had his parents' consent—nay, their urgent wishes—for an early marriage. Ruskin, as we know, carried filial obedience to extremes. To please his mother he proposed. Miss Gray was very young and inexperienced, the match was a good one, she accepted. Mrs. Ruskin had attained her wish: the young couple were married at Perth on 10th April, 1848.

The honeymoon began ominously. Posting southward, Ruskin caught a chill while sketching in Salisbury Cathedral. He became seriously ill, his mother was in charge as nurse, and all plans were disorganised. As soon as he was strong enough to travel the whole family went to Normandy, in order that Ruskin might study cathedrals for " The Seven Lamps of Architecture " : his health giving old Mrs. Ruskin a welcome excuse for watching over her son, the bride being pushed into the background—

secondary possibly even to Anne on account of
inexperience in nursing. It must have been an
unendurable position for any woman of spirit. We
can only suppose that Ruskin was too weak in
health and engrossed by his work to recognise
this.

On their return the young couple went to a house
taken for them in Park Street. The true and
complete story of that household has never been
told. We can only piece it together, bit by bit,
from stray letters, contemporary gossip, and so
forth—with all the necessary deductions to be made
from hearsay evidence, and the gaps to be filled in
by reasoning. Ruskin preserved complete silence
about the six years of his married life—Ruskin,
who chats so freely about his youthful amourettes,
and took the whole world into his confidence about
Rose La Touche.

Collingwood skims over the subject ; the Millais
memoirs are silent—the previous marriage of Lady
Millais is mentioned in a footnote without names,
and her identity with Mrs. Ruskin, mentioned in
the earlier pages of the same book, is not disclosed.
There is a conspiracy of silence on the subject. As
might be imagined, rumour has been busy. It
would have been wiser to discount it by giving the
plain, unvarnished truth. This seems to be that
Ruskin, wedded to Art, and with pronounced views
on the subject of his foreordained mission as the
interpreter of artistic beauty, had only a second

place in his life to offer the girl he had married to please his mother.

" Præterita " gives no record of the time between the autumn of 1847 and the spring of 1849, leaving unrecorded the whole of the first year of his married life. When he takes up the thread of his autobiography again, " The Seven Lamps of Architecture " had just been published, and Ruskin is in Switzerland with his father and mother, studying mountain forms in connection with Turner's works. He has a separate carriage now—a small brougham—so that he may be independent of the old people and choose his own pace. One might suppose that his young wife would have shared the brougham, but she does not appear to have been with the party. Richard Fall joined him at Chambery, and accompanied him to Vevey and Chamonix. Of the wife there is no mention.

But in the autumn of the same year (1849) they were in Venice together. Young Mrs. Ruskin went into society a good deal ; much admired. Ruskin took her to a ball there, and was bored. He was in the thick of preparations for " The Stones of Venice "—his reason for being there—and had neither time nor inclination for society. They returned to Park Street in the spring (1850), and Ruskin became at once busy preparing " The Stones of Venice " for publication. A young gay wife, fond of dress, excitement, and social life, was no helpmeet for him. He went with her to Court, taking pride

in the compliments paid her, but society bored him. She often went out alone. Not a wise thing to do perhaps, but she was very young, and the home must have been dull—her husband absorbed in architecture and his spare time claimed by the old. people. Materially, young Mrs. Ruskin had all she could desire ; was always well dressed, had splendid jewels, and all the advantages of wealth. But her husband could do without her ; Mrs. Ruskin, senior, would not abdicate : the wife's position in the household must have been that of a handsome figure-head.

The Rev. A. G. L'Estrange, author of " The Friendships of Mary Russell Mitford," tells me that a friend of his met Mrs. Ruskin at a London party. ' She was conversing with some gentlemen, one of whom asked,—

" ' Where is Mr. Ruskin ? '

" ' Oh, Mr. Ruskin ? ' she replied. ' He is with his mother—he ought to have married his mother ! ' "

Early in 1851 *The Times* printed an attack on Millais' painting " Christ in the Carpenter's Shop." Ruskin, always ready to champion genius in distress, replied to this criticism by a letter in the same paper. Coventry Patmore says that Millais asked him to use his influence with Ruskin on behalf of the Pre-Raphaelites, and that this reply to *The Times* was the result. Whether this was the case or not, Millais and Holman Hunt wrote to thank Ruskin

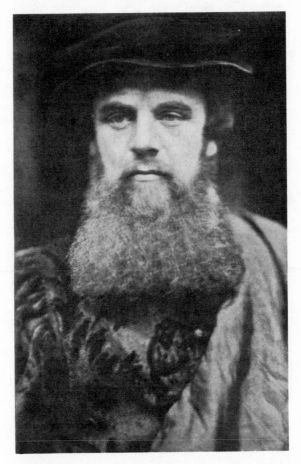

WILLIAM HOLMAN HUNT

for his remarks. The day after receiving this letter Ruskin and his wife called at their studio. Millais made a very favourable impression on both, and went back with them to lunch and dinner.

The acquaintance thus begun was continued, and grew into friendship. Millais and Ruskin frequently differed on questions of Art, especially as to the genius of Turner, but this did not prevent a suggestion from Ruskin that Millais should accompany him to Switzerland (1851). The project seems to have fallen through, but in 1853 an invitation was given Millais and his brother William to spend a long holiday at Glenfinlas with the Ruskins. It was accepted.

Now, Ruskin is usually said to have been utterly indifferent to his wife, and in proof of this it was remarked that no signs of affection or intimacy passed between them—hardly conclusive evidence when we consider that they were both Scotch, and so racially given to concealment of emotion. But a letter written to Miss Mitford shortly before this visit to Glenfinlas appears to show that, if the marriage had originally been one of convenience, Ruskin was now attached to his wife and looked forward to a happy future.

"KESWICK, *Good Friday*, 1853.

" The pain of self-reproach was mixed with the delight which your letter gave me yesterday. Two

months back I was each day on the point of writing
to you to ask for your sympathy—the kindest
and keenest sympathy that I think ever filled the
breadth and depth of an unselfish heart. But my
purpose was variously stayed, chiefly, as I re-
member, by the events on the Continent, fraught
to me with very deep disappointment, and casting
me into a depression and fever of spirit which,
joined with some other circumstances nearer home,
have, until now that I am resting with my kind wife
among these quiet hills, denied me the heart to
write cheerfully to those very dear friends to whom
I would fain never write sadly " . . . (He comments
on her pony-chaise accident). . . . " But you are
better, and the spring is come, and I hope, for I am
sure you will allow me, to bring my young wife to
be rejoiced (under the shadow of her new and
grievous lot) by your kind comforting. But pray
keep her out of your garden, or she will certainly
lose her wits with pure delight, or perhaps insist
on staying with you and letting me find my way
through the world by myself, a task which I should
not *now* like to undertake. I should be very, very
happy just now but for these wild storm-clouds
bursting on my dear Italy and my fair France, my
occupation gone, and all my earthly treasures
(except the one I have just acquired and the ever-
lasting Alps), periled amidst the ' tumult of the
people,' the ' imagining of vain things.' . . .

.

" My wife begs to return her sincere thanks for your kind message, and to express to you the delight with which she looks forward to being presented to you—remembering what I told her among some of my first pleadings with her that, whatever faults she might discover in her husband, he could at least promise her friends, whom she would have every cause to love and to honour. She needs them, but I think also deserves them." [1]

When Miss Mitford's correspondence was being prepared for publication, Mr. L'Estrange wrote to Mr. Ruskin asking if he should send him his letters for perusal and excisions. Ruskin replied in the negative, saying " he was not afraid of anything he had written being published." The foregoing was one of the letters in question, and so, it may be by accident, we have here a document which lifts the veil and shows him in a more human light than would have been the case if our judgments had to be based on the rest of the evidence.

Then came the holiday at Glenfinlas. Up to this time there is nothing to show that Mrs. Ruskin was not resigned to circumstances. Until she met Millais there does not seem to have been any question of freeing herself from her husband. But towards the end of June (1853) Millais and his brother

[1] " The Friendships of Mary Russell Mitford," by A. G. L'Estrange.

went North, and the Ruskins met them at Morpeth.
From thence they travelled together by private
coach to the Trossachs, visiting Melrose and Stirling
by the way. The weather was atrocious. It rained
incessantly for five weeks, and a shooting-lodge
party, weatherbound, must inevitably either quarrel
or get more friendly than would be possible under
other circumstances. The two Millais brothers and
Mrs. Ruskin were young and full of vitality. They
defied the weather, sketched and planned picnics,
wrapped in Scotch plaids : in the evenings they
played battledore and shuttlecock, and Millais
freely caricatured the whole party. Fun, chaff, and
repartee passed incessantly. Ruskin, some years
older, and never accustomed to the light badinage
of young people ; engrossed also in his work—he
was making the study of gneiss now at Oxford—did
not always join in their excursions. Still, all
seemed harmonious, and Ruskin gave Millais some
lessons in architecture, as a result of which Millais
designed a Gothic window.

Acland was there for a few days, and he and
Ruskin naturally paired off together. It was while
Acland was there, and at his request, that Millais
sketched Ruskin at Glenfinlas.

Millais actively resented Ruskin's indifference to
his wife's amusements, and taxed him openly with
neglect. He seems to have constituted himself the
lady's champion. Not, perhaps, quite in good
taste from guest to host, but there is no doubt that

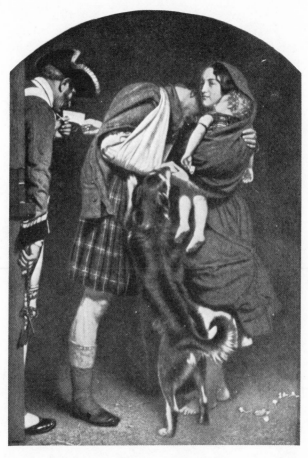

From a mezzotint engraving by Samuel Cousins after the picture by Sir John Everett
Millais, Bart., P.R.A.

"THE ORDER OF RELEASE"

Millais was greatly attracted by Mrs. Ruskin from the first. It was about this time that " The Order of Release " was painted, with Mrs. Ruskin as the wife—only her hair was auburn, not dark, as in the picture. She can also be traced in other pictures of his painted about this period.

The Glenfinlas party broke up ; the Ruskins went back to their ill-assorted life—Ruskin making his first appearance as a lecturer before the Edinburgh Philosophical Institution—but the tie had now become unendurable. A few more months passed, and then, one morning, Mrs. Ruskin left her husband's house without any warning, and went back to her father at Perth. Mrs. Carlyle, writing to Dr. John Carlyle, under date 9th May 1854, says :—

. . . " There is a great deal of talking about the Ruskins here at present. Mrs. Ruskin has been taken to Scotland by *her* parents ; and Ruskin is gone to Switzerland with *his* ; and the separation is understood to be permanent. There is even a rumour that *Mrs.* Ruskin is to sue for a divorce. I know nothing about it, except that I have always pitied Mrs. Ruskin, while people generally blame her,—for love of dress and company and flirtation. She was too young and pretty to be so left to her own devices as she was by her Husband, who seemed to wish nothing more of her but the credit of having a pretty, well-dressed Wife."

On May 10th, that is to say in the first shock

of his wife's desertion, Ruskin was drawing the jib which appears as a frontispiece to the second volume of " Præterita," on board the steamer from Dover to Calais with his parents : their Continental tour having been hastened, no doubt, by this recent domestic upheaval; since they spent old Mr. Ruskin's birthday crossing the Channel instead of eating the traditional gooseberry pie, proper to that day's menu, in the Denmark Hill dining-room.

Mrs. Ruskin had spent six years under her husband's roof, but she no sooner left him than she commenced a suit for nullity of marriage in the Scotch Courts. Ruskin did not defend it. He did not even seem to cherish any malice against Millais, for whose sake his wife desired her freedom.

On the day Millais married the lady, Mr. L'Estrange tells me that an old friend of his was with Ruskin, looking at his pictures. Ruskin drew his attention to one of himself and said—

" *There !* what do you think of *that ?* "

" Very good," replied Mr. Harrison. " Excellent ! "

" So it ought to be," returned Ruskin with solemn emphasis—" it was painted by Millais."

Ruskin's after-dealings, as a critic, with Millais' work show the same impartiality. Millais married the lady, in her maiden name, 3rd July 1855, and in 1856 we find Ruskin giving high praise to Millais'

pictures " The Return from the Crimea " and
" Autumn Leaves." Personal feelings were evi-
dently not allowed to bias his criticisms.

What were his real feelings in the matter ? The
Mitford letter expresses affection and evident hope
of future happiness, yet this can hardly be re-
conciled with his study of the curves in a wind-
filled sail during the first days of bereavement,
or with his stoicism at the time of the nullity
decree.

From such a passionate writer one would expect
reproaches ; bitter words against " Fors " ; scathing
denunciations of feminine fickleness. Magnanimity
might explain his praise of Millais. Does wounded
pride account for his silence ? But his pride was
wounded deeply by both Adèle Domecq and Rose
La Touche, yet he made no secret of these episodes
in his life. His conscience could not have been
entirely easy—Art had been first with him, and his
mother second ; the wife had only had a third place
in his affections.

No blame appears to be attached to either side.
Lady Millais made an admirable wife. She was
much better suited to Millais than Ruskin, and
Millais owed much of his success to her help in
business matters, and the care with which she
guarded his working hours from intrusion. She was
his secretary ; verified the details of his historical
pictures, cheered and encouraged him as only a
good wife can.

Millais fully appreciated her worth. Her previous marriage barred her from Court. His dying request was that Queen Victoria would receive his wife. He had his desire : she was sent for—by command.

CHAPTER VI

RUSKIN AND THE PRE-RAPHAELITES

" IN our greatest literary epoch," wrote Matthew Arnold, " that of the Elizabethan age, English society at large was accessible to ideas, was permeated by them, was vivified by them, to a degree which has never been reached in England since. . . . A few years afterwards the great English middle-class, the kernel of the nation, the class whose intelligent sympathy had upheld a Shakespeare, entered the prison of Puritanism and had the key turned on its spirit there for two hundred years." It was not until the middle of the nineteenth century, when the influence of the Oxford revival was felt in a national recoil from Puritanism, that artists shook off these shackles and began to paint Nature in glowing colours instead of in the dull browns and murky tints that accorded with the pleasure-dreading tenets of that gloomy creed : hesitatingly at first—even Turner was slow to paint in colour—and then more surely, as, following in his lead, artists began to see Nature in colour. Puritanism had not only made it a mark of un-

regeneration to please the eye : it had discouraged and deadened artistic conception, so that painting had become a matter of formalism. The artist no longer worked from a spontaneous delight in creation, but according to set rules, handed down to him by tradition.

Youth is the great iconoclast. The awakening of the Church began at Oxford: the breaking of conventional art fetters was the work of two lads in their teens. Older men might have quailed before the ridicule cast upon their new methods of work : worldly wisdom hesitate before spending months of labour on a canvas which when completed would not be appreciated by the average picture-buyer. Future fame is an insufficient incentive to a man who has given hostages to Fortune ; even if, after painting his pictures on conventional lines for the best years of his life, his eye and hand are able to conform to new rules. Better for him to go on producing what the public can appreciate : let them have their trees brown, and painted according to tradition, if popular taste prefer them so. Art is long, truly, but life very short, and the wherewithal to support it is in the purse of the artcollector.

Fortunately for us, individual youth perpetually renews the youth of the world. John Everett Millais and W. Holman Hunt were exercising this prerogative of youth when they—mere lads, clean-living, pure-minded, pledged to neither drink, swear, nor

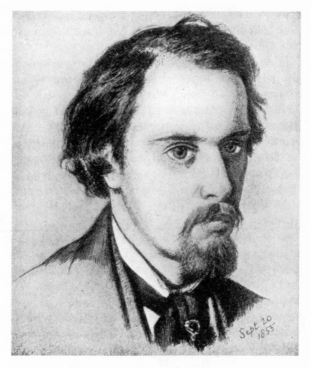

From a drawing by himself, by permission of Mr. Charles Fairfax Murray.

DANTE GABRIEL ROSSETTI

p. 74]

smoke (though Millais took to smoking in later life)—
impelled by the force of genius, rose up against the
trammels of conventional art, took their canvases
out into the open air, painted directly from Nature,
and founded the Pre-Raphaelite Brotherhood.
There is a delightful flavour of youth even in the
name they adopted, and in the cryptic monogram
the members of the Brotherhood attached to their
works : a naïve self-confidence in its wholesale con-
demnation of all art after Raphael's, and a touch of
mystery, quite after the style of Tom Sawyer, in
proclaiming it a " Brotherhood."

" I thank God that the Pre-Raphaelites are
young," wrote Ruskin in 1853, replying to a
pamphlet in which the Pre-Raphaelites were
described as " exceedingly young men of stubborn
instincts." " I thank God that the Pre-Raphaelites
are young, and that strength is still with them, and
life, with all the war of it, still in front of them.
Yet Everett Millais, in this year, is of the exact
age at which Raphael painted the ' Disputa,' his
greatest work ; Rossetti and Hunt are both of them
older still ; nor is there one member so young as
Giotto when he was chosen from among the painters
to decorate the Vatican of Italy. But Italy, in her
great period, knew her great men, and did not
despise their youth. It is reserved for England to
insult the strength of her noblest children, to wither
their warm enthusiasm early into the bitterness of
patient battle, and to leave to those whom she

should have cherished and aided no hope but in resolution, no refuge but in disdain."

Would the Pre-Raphaelite principles have found acceptance if Ruskin had not come to their assistance ? Unquestionably yes, for the new truths they had discovered were old eternal truths, the faithful copying of what they saw in Nature, from Nature and as each saw it. But if Ruskin had stayed his hand it might have happened, as has so often chanced in the world's treatment of genius, that they had grown old and embittered by poverty and neglect until the fire of genius was dulled and trampled out for lack of encouragement. Ruskin was peculiarly able to appreciate their work on account of the habit of looking closely into details acquired during his quiet, lonely childhood. He tells us in "Præterita" how he pulled flowers to pieces in the Herne Hill garden and wondered over their parts until he knew them by heart ; that he was contented to do the same things, read the same books, again and again. He carried the same habit of careful study into art. He loved to pore over Turner's drawings, inch by inch, with the magnifying glass. When he first came across the works of the Pre-Raphaelite school he was quick to observe the painstaking finish of all the accessories in their pictures. There were no signs of hurry, nor of slovenly painting—which Ruskin abhorred. He praised them accordingly :—

" That two youths, of the respective ages of

eighteen and twenty, should have conceived for themselves a totally independent and sincere method of study, and enthusiastically persevered in it against every kind of dissuasion and opposition, is strange enough ; that in the third or fourth year of their efforts they should have produced works in many parts not inferior to the best of Albert Dürer, this is perhaps not less strange. But the loudness and universality of the howl which the common critics of the press have raised against them, the utter absence of all generous help or encouragement from those who can both measure their toil and appreciate their success, and the shrill, shallow laughter of those who can do neither the one nor the other—these are strangest of all—unimaginable unless they had been experienced." [1]

The two originators of the Pre-Raphaelite Brotherhood, John Everett Millais and William Holman Hunt, had been friends and fellow-students at the Royal Academy. They discussed painting and painters ; coming to the conclusion that Art, which had been progressive up to the time of Raphael, had since become fettered by conventions.

Each successive generation had copied its forerunner's faults, working by set rules instead of going straight to Nature for their models. Even Raphael himself had fallen from the ideal state, so, with the egoism of youth, they would have none of him, but agreed to call themselves Pre-Raphaelites.

[1] " Pre-Raphaelitism," by John Ruskin.

Ruskin's definition of Pre-Raphaelitism was wider,
but then he was older and had seen more of the
world :—

" I wish it to be understood how every great man
paints what he sees or did see, his greatness being
indeed little else than his intense sense of fact.
And thus Pre-Raphaelitism and Raphaelitism, and
Turnerism are all one and the same, so far as educa-
tion can influence them. They are different in their
choice, different in their faculties, but all the same
in this, that Raphael himself, so far as he was great,
and all who preceded or followed him who ever were
great, became so by painting the truths around them
as they appeared to each man's own mind, not as
he had been taught to see them, except by the God
who made both him and them."

Millais and Holman Hunt's Pre-Raphaelite part-
nership dated from 1848. The Brotherhood was
formed a little later, when the two originators were
joined by a few others. Dante Gabriel Rossetti,
son of an Italian refugee who divided his life be-
tween revolutionary politics and the study of Dante,
was the first to join them. He had been a fellow-
pupil of Holman Hunt at the Academy, but his
versatile genius wavered between painting and
poetry. He left the Academy to follow literature,
found that a poet's reputation is of slow growth,
tired of waiting for Fame, and came back to the
study of art under Madox Brown. But the im-
patient Italian chafed against the restraints of Madox

Brown's methodical training : he left his studio in disgust, and came to Holman Hunt, who rather reluctantly agreed to let Rossetti paint in his studio, and under his guidance. Rossetti was therefore admitted to a knowledge of their system, made a member of the Brotherhood, and enlisted several others—Woolner, the sculptor ; F. G. Stephens, who subsequently gave up art and took to criticism ; James Collinson, who vacillated between painting and the religious vocation ; and Walter Deverell, who was enrolled as a probationer. This last named was a young artist who showed promise of rising to the first rank of artistic merit. Life was too hard for him. Fatherless and motherless, he was the support of the family. His brother artists, when they had discovered his struggle for existence, did what they could ; Ruskin was interested in the case and behaved with his customary generosity. The help came too late to save his life. He died early in 1854.

With intent to spread their ideas and educate their fellows, the Pre-Raphaelites started a magazine which they called *The Germ*. William Michael Rossetti, a literary member of the Brotherhood, and brother to Dante Gabriel, was appointed editor. Christina Rossetti, their sister, contributed ; so did D. G. Rossetti himself—a wonderful family that—and among other contributors were Coventry Patmore and Ford Madox Brown. This last-named artist had anticipated their methods but preferred

to keep aloof from cliques, so he never became one
of the Brotherhood. In the third number they
changed the name of the magazine to *Art and
Poetry*, and with the fourth it ceased to exist.
Ruskin had been doubtful of success from the first.
He believed that honest criticism was not wanted,
and honest journalism must be doomed to failure.
The fame of *The Germ* was posthumous : owing to
its scarceness a complete set has been sold by auction
for £100.

The Pre-Raphaelite monogram had a longer life,
but even this was discontinued after a time as it
had a needlessly irritating effect on the critics—
" . . . men whose entire capacities of brain,
soul, and sympathy," wrote Ruskin in " Modern
Painters," " applied industriously to the end of
their lives, would not enable them, at last, to
paint so much as one of the leaves of the nettles
at the bottom of Hunt's picture of ' The Light of
the World.' "

Pre-Raphaelitism itself gradually affected the
work of their younger contemporaries, so that Pre-
Raphaelite methods became less noticeable every
year. In Ruskin's " Notes on Pictures exhibited
at the Royal Academy," 1856, he remarked that
Pre-Raphaelite works were no longer distinguishable
as a special class ; that there were comparatively
few pictures of the old school, and between these
and the actual Pre-Raphaelite pictures " an un-
broken gradation of works of painters in various

stages of progress struggling forward out of conventionalism to Pre-Raphaelitism," . . . and expresses satisfaction that "A true and competent school of art is at last established in the Royal Academy of England."

Of the two originating members, Millais, by his marriage, ceased to have any close relationship with Ruskin, who from thenceforth was an impartial critic but could hardly, in the nature of things, pretend to warm friendship. Holman Hunt's intercourse with Ruskin suffered for the same reason. Having to choose between an old friend and a new, Hunt, out of loyalty to Millais, avoided Ruskin's society for some time. But Holman Hunt was not often in England. Quieter and less self-assertive than his partner, he soon found himself in danger of being extinguished by Millais' overwhelming personality. To keep his reputation free from the charge of imitating the latter's methods, Hunt decided to go abroad and show the public what he was capable of by working alone. He went to Syria ; to carry out Pre-Raphaelite teaching by studying the scenery for his religious pictures on the spot.

Ruskin and Holman Hunt met again in 1869, at Venice, and renewed the friendly intercourse of former years. They went to the Scuola di San Rocco together, taking with them a first edition of " Modern Painters," so that Ruskin might compare his impressions of twenty years earlier with those

6

of his riper experience. He found them little altered.

In 1855 Ruskin had said of Millais' picture " The Rescue," " It is the only *great* picture exhibited this year ; but this is *very* great "; and of the painter himself, " Millais is a great colourist and of course works on the principles of the colourists." But in 1857 Ruskin thought he detected signs of deterioration in the artist's work, and since, in his zeal for art, he would accept nothing but their best from its votaries, he was as outspoken in his condemnation as he had been before in praise.

He wrote in his " Academy Notes " for that year : " The Pre-Raphaelite cause has been doubly betrayed by the mistimed deliberation of one of its leaders, and the inefficient haste of another ; and we have to regret at once that the pictures of Holman Hunt were too late for the Exhibition and that those of Everett Millais were in time for it." In detail he objected to Millais' picture " News from Home " because the officer's uniform was improbably new for the Crimea, and found fault with " Sir Isumbras " because of its irregularity of conception : pointing out the carelessness with which the reflections in the knight's armour were carried out, and the absence of ripples in the water round the horse. Millais did not take the criticism in good part. He seemed to think that Ruskin's unfavourable opinion was due to personal animosity. But as, in 1892, the picture was extensively re-

touched by the artist, it appears probable that he was not entirely satisfied with it himself.

Dante Gabriel Rossetti, the most enthusiastic member of the Brotherhood, soon became least representative of that, or any school. Romantic, mystic, dreamy—half-artist, half-poet—he had too marked an individuality to follow any leader. As in the case of many another young and unrecognised genius, Ruskin came to Rossetti's assistance when he was struggling with poverty. He assured him a fixed income by the regular purchase of studies to a stated amount, introduced him to other collectors, and did all in his power to smooth the path to success ; not only for Rossetti himself but also for Elizabeth Eleanor Siddal, his beautiful fiancée. It was not easy to help Rossetti. He was abnormally sensitive to real or fancied injuries, too savagely proud to brook the slightest semblance of patronage, and unable to bear criticism. That he accepted so much help from Ruskin is a proof of the delicacy with which it was given.

Rossetti's devotion to Lizzie Siddal made him accept gratefully during her short life anything that could give her health or happiness. His love was quite Italian in its intensity. She was a milliner's assistant when he met her—a singularly beautiful girl of most un-English type: Ruskin likened her to a Florentine thirteenth-century lady. Their engagement was long and saddened by her frequent and dangerous illnesses, which Dr. Acland attri-

buted to " mental power long pent up and lately overtaxed." It was the penalty the poor girl paid for her poet-artist lover.

The Aclands were very kind to Miss Siddal during her stay at Oxford, whither Ruskin sent her to be looked after by Dr. Acland, who disagreed with the idea that her lungs were fatally affected, and recommended a winter abroad. Ruskin helped to give her this. At last the lovers were married, and had a brief time of wedded happiness.

In spite of real affection for his wife, Rossetti must have made an unsatisfactory husband. He was always in financial difficulties, from which Ruskin and his own relations had to release him at frequent intervals. A dead child was born in 1861; a terrible disappointment to the poor young wife, who was half distraught when she found her hopes of motherhood blighted. She recovered and all seemed well, but one morning, early, the Burne-Jones's were awakened by Rossetti, frantic with grief : his Lizzie was dead —from an overdose of laudanum taken for sleep-lessness.

Probably Rossetti's Italian blood was responsible for the next act in the drama. On the day of his wife's funeral he came to take a last look at her before the coffin was fastened down. He carried the manuscript book containing his poems in his hand, and, in spite of remonstrances from those

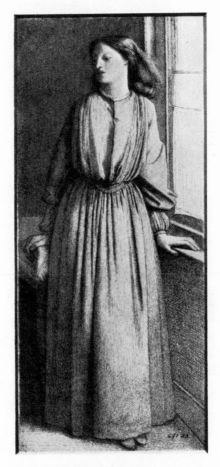

From a photograph by W. A. Mansell & Co.
after the drawing by D. G. Rossetti.

ELIZABETH SIDDAL

[p. 84] (Mrs. Dante G. Rossetti).

present, placed it in the coffin. For the time at least the act was sincere. She had inspired the poems ; they were hers, and without her presence valueless to him.

Fragments of the poems were recovered from the little circle of friends to whom they had been read, or from those who possessed a copy of one or another of the poems, but they were necessarily incomplete. The husband had been stronger than the poet in him when he consigned the children of his brain to oblivion. But time passed and the wound healed. The poet now was uppermost. Seven years after Mrs. Rossetti's death her coffin was opened under an order from the Home Secretary, and the book recovered. Rossetti was not present at the opening of the grave, which was carried out under the supervision of Mr. Howell (at one time secretary to Ruskin), but after the necessary steps had been taken to purify the volume, Rossetti helped Mr. Fairfax to copy the poems, which were soon after published. The propriety of this action is open to discussion. Should a sacrifice made on the impulse of the moment, under the influence of overwhelming loss, be binding for all time ?

It would be hardly just to Rossetti if we attributed his change of mind to inconstancy in the face of all the evidence we have against it. During his wife's life-time he made frequent studies from her ; taking a triumphant delight in the artist's

crowning triumph of immortalising the woman he
loves :—

> " . . . Above the enthroning throat
> The mouth's mould testifies of voice and kiss,
> The shadowed eyes remember and foresee.
> Her face is made her shrine. Let all men note
> That in all years (O Love, thy gift is this !)
> They that would look on her must come to me."

So Rossetti wrote in the tenth sonnet of his " House
of Life," and shortly before her death he painted her
as " Regina Cordium."

After death her memory was undoubtedly
cherished by him, and the same desire to perpetuate
her beauty governed him. A year after she died
he painted her from memory as " Beata Beatrix,"
bought by Lord Mount-Temple. Some time before
his first meeting with Miss Siddal, Rossetti had
written some verses, " The Portrait," and after her
death he made some slight alterations in the poem,
which is now so appropriate that we can describe
the " Beata Beatrix " in his own words :—

> " This is her picture as she was :
> It seems a thing to wonder on,
> As though mine image in the glass
> Should tarry when myself am gone.
> I gaze until she seems to stir,—
>
> ♦ ♦ • • • •
>
> And yet the earth is over her.
>
> • • • ♦ • •

'Tis she : though of herself, alas !
Less than the shadow on the grass,
Or than her image in the stream.

 • • • • • •

O heart that never beats nor heaves,
In that one darkness lying still,
What now to thee my love's great will
Or the fine web the sunshine weaves ? "

Probably, owing to a poet's fancy that he drew
inspiration from her in the same way that Dante
did from Beatrice, Rossetti found consolation in
returning to this subject. In 1871 he painted a
replica of the " Beata Beatrix " in water-colour,
the following year he did a second replica in oil,
and in 1880 a third, also in oil—this being nearly
the last finished painting from his brush.

After his wife's death D. G. Rossetti, his brother
W. M. Rossetti, Swinburne, and George Meredith
shared a house—No. 16, Cheyne Walk. A brilliant
and most curiously assorted household. Perhaps it
is hardly to be wondered at that they soon dissolved
partnership. D. G. Rossetti must have been a
queer house-mate. Apart from his uncertain temper,
which had led him to break away from all inter-
course with his fellow Pre-Raphaelites—Holman
Hunt and Millais—as early as 1857, he had a
peculiar fancy for strange pets. He kept wombats,
woodchucks, armadilloes, and once even went to the
extent of getting a zebu, which he tethered to a tree
in the garden ; a treatment resented by the creature,

which vented its displeasure by chasing its master round the garden. Mr. Watts-Dunton has given a study of Rossetti and his menagerie in his novel " Aylwin "—the poet-painter appearing therein as " D'Arcy."

First Meredith, and then Swinburne, moved away from Cheyne Walk. A breach with Ruskin occurred in 1865 owing to the resentment with which Rossetti received a criticism of his picture " Venus Verticordia."

Since his wife's death Rossetti had become more than usually quick to take offence, and was gradually alienating all his friends. Passionate despair at her loss led to insomnia ; that, in its turn, to the habit of taking chloral hydrate. Unfounded suspicions and fancied injuries—the usual consequences of indulgence in this drug—followed, and caused him to avoid all his old friends, in spite of all their efforts to prove unbroken loyalty. Ruskin, after an interval, took the first steps towards a reconciliation. He went to see Rossetti, who failed to return the call. Between 1867 and 1870 Ruskin made several attempts to renew the old friendship, but one unfavourable criticism outweighed all the benefits of former years in Rossetti's diseased imagination.

In the *Contemporary Review* for October 1871 appeared an article by Robert Buchanan, writing under the pseudonym of Thomas Maitland, " The Fleshly School of Poetry," in which Rossetti's poetry was severely and most unjustly handled. This

aggravated the mischief. Rossetti took the accusation to heart ; his health, both mental and physical, suffered, and in the following June he had a dangerous illness affecting his brain. The downward path was kept to ; his brother William and William Morris were loyal to him to the last, but the Dante Gabriel Rossetti who lingered on until 9th April 1882 was only an outward husk of the ardent young genius who worked so hard in the cause of Pre-Raphaelitism thirty years earlier.

CHAPTER VII

CARLYLE

CARLYLE the epigrammatic, writing to Dr. John Carlyle in 1855, described Ruskin as " a bottle of beautiful soda-water . . . very pleasant company now and then." [1] Not a bad simile when applied to a man whose moods alternated between the clouds and the slough of despond.

Ruskin made Carlyle's acquaintance in 1850 : his " Master," he called him. What Turner and Prout had been to Ruskin in art, Carlyle was in ethics : the source from which was drawn inspiration for his mission of social reform. Ruskin had been so hedged in by maternal solicitude in his youth that social problems did not trouble him until middle life. It was Carlyle, whose works fired the youth of early Victorian days, who awakened in him a burning zeal for the service of mankind. In " Fors " Ruskin said that there was only Thomas Carlyle in all England to guide him.

But if Ruskin learned his first lessons in social economy from Carlyle, he adapted them in his own

[1] " New Letters of Thomas Carlyle," edited by A. Carlyle.

fashion. He used Carlyle as a spring-board from which to leap. Once in the air he needed no further impetus ; the wings of his genius expanded, and the subsequent direction of his flight was self-controlled. Carlyle, the " Master," watched his disciple's progress ; sometimes with approval, often bewildered and amazed at his wonderful gyrations. He especially admired Ruskin's peculiar facility for finding connections between apparently dissimilar subjects, as when, in " Ethics of the Dust," he " twists symbolically in the strangest way all its geology into morality, theology, Egyptian mythology, with fiery cuts at political economy." [1] The author of " Sartor Resartus " understood and could appreciate such versatility.

Early associations and the ties of blood—Ruskin's father was Scotch ; so was Anne, his old nurse— made Carlyle's Annandale accent a homely and pleasant sound in Ruskin's ears. He sought Carlyle out, calling frequently at Cheyne Row when in London. Ruskin never came empty-handed : there was always an offering of flowers for Mrs. Carlyle, with whom he was a special favourite. When Ruskin's " Sesame and Lilies " was severely criticised by a professed admirer of Mrs. Carlyle's, her husband claimed her sympathy for her favourite, Ruskin, and urged her to have nothing to do with his traducer. " Don't you return his love," Carlyle

[1] " Thomas Carlyle " (Life in London), vol. ii., by J. A. Froude.

wrote to her. " Nasty creature ! with no eye for the beautiful, and awefully interesting to himself." [1]

An education and intellectual powers above the average had not unfitted Mrs. Carlyle for household life. Judging from their letters, her periodical house-cleanings must have been domestic upheavals necessitating the migration of her husband. She had, however, the satisfaction of hearing un-qualified approval of her labours on his return. But she was not only an active wielder of brush and duster, and director of the more or less incom-petent maid who shared her labours ; she was an excellent manager, made the most of her husband's earnings, and had an enviable reputation for being always well dressed. Jane Welsh Carlyle possessed an all too rare combination of intellectual and administrative talent. Ruskin liked a simple home life, and his mother had been a notable housekeeper : he could appreciate the ordered simplicity of Cheyne Row.

Carlyle's house was a rendezvous for all the notable people of his time, but he never tolerated bores or uncongenial society. To such he was as prickly as the thistles of his native land. Ruskin, deferential, sympathetic, a good listener and sincere admirer, proved a welcome guest. It made for peace between them that Ruskin, who could lash himself to fury on paper, was mildness itself in

[1] " Thomas Carlyle " (Life in London), vol. ii., by J. A. Froude.

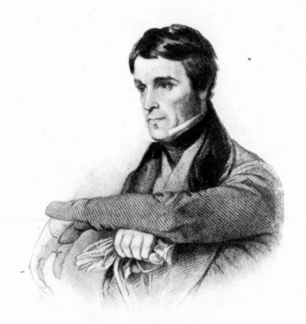

From an engraving by J. C. Armytage after a drawing by Samuel Laurence.

THOMAS CARLYLE

p. 92]

speech. Had it been otherwise these evening meetings must soon have come to an end. No room could have held the two writers if Ruskin had been as volcanic as his " Master."

Carlyle was a good talker when he could get an attentive listener. Some of the divine afflatus of his books then appeared in his flow of eloquent speech. He talked on, heedless of any interruptions until he had said his say ; his dark blue eyes kindling and his Scotch accent becoming more marked as he warmed to his subject. All one to him then if they discussed the eternal verities, or if local topics had suggested a discourse in eloquent monologue on " demon " fowls, spluttering pens, pianos, night-watchmen, barrel-organs, or whatever the latest grievance might be.

" Born in the clouds and struck by the lightning," was Ruskin's comment on Carlyle. One of the penalties of Fame has been to drag the seamy side of the Cheyne Row domestic life into such prominence that Carlyle's real distinction of character is in danger of being overlooked. Better to dwell upon his open-handed generosity, honesty of purpose, and filial affection : on the many mice brought by the " kitlin " to the " auld cat "—money, and little comforts of more value than money because showing so much loving thoughtfulness, sent to Scotsbrig at times when the Cheyne Row purse was none too full. Undue value has been given to passing friction between the Chelsea philosopher and

his clever, witty, somewhat shrewish wife. Both were victims of frequent nerve storms, during which they found relief in speaking their minds. Poor, irritable, dyspeptic, honest Carlyle, with his nerves always strung to concert-pitch ! His bark was worse than his bite : so also that of his sharp-tongued " Goody." It was a little weakness of Carlyle's to talk and write in superlatives, and invoke malisons on the slightest provocation. Ruskin did the same when he put pen to paper ; he could understand and make allowance for the outbursts of his old friend.

It would be folly to imagine that all this was incompatible with real and deep affection, and there is not a shadow of doubt that both husband and wife would have been indignant at the bare idea of such an interpretation. Carlyle reproached himself after his wife's death for his exactions and blindness to her failing health. The most devoted husband, in the first bitterness of bereavement, might do the same.

The shock of her death was so terrible in its suddenness, rendered more distressing too by his absence, that Carlyle may well have been overcome. It will be remembered that he was in Scotland ; had gone there to be installed as Rector of Edinburgh University ; visiting Annandale afterwards to rest after the Rectorial festivities and nurse a strained ankle. Mrs. Carlyle remained at Cheyne Row. She was in rather better health than

usual, and looking forward to her husband's return in a day or two. On the afternoon of 21st April 1866, she went out for her usual drive, accompanied by her little dog. She put it out of the carriage for exercise near Victoria Gate : the wheel of a passing carriage crushed its foot. Mrs. Carlyle alighted hurriedly to rescue her pet, which was yelping with pain and fright ; took it in her arms and re-entered the brougham, which was driven on. The dog was not much hurt, but Mrs. Carlyle's heart, debilitated by frequent illness, could not stand the shock. They found her placidly sitting in the corner of the carriage—dead. Ruskin, calling a little later in the day with some flowers for her, found a house of mourning. Carlyle, summoned by telegram, hurried home. " My poor little woman ! " was all he could utter in the first agony of grief.

He kept her memory green. All the signs of her presence in the house were retained, by Carlyle's orders : her books remained as she had left them ; her workbox in its usual place. She had played all his favourite airs to him only a short time before their last parting : he decreed that no other fingers should touch the keys ; her piano was never opened after her death. And as long as he lived, Carlyle, whenever he passed that way, bared his head and made a brief pause at the spot in Hyde Park where his wife was last seen alive. Remorse, said the scandalmongers. More like the old Covenanter's

acknowledgment of God's will, and a lonely old man's sigh

> ". . . for the touch of a vanished hand,
> And the sound of a voice that is still ! "

In a little while, when the first crushing sorrow had passed and Carlyle was able to bear the society of his friends again, he turned to Ruskin, who had always shown such gentle courtesy to his lost " Goody." From Mentone, whither Carlyle had been persuaded to go for a change of scene and diversion of thought, he wrote that he anticipated returning to London because of seeing Ruskin and " tasting a little human conversation " on Wednesday evenings.

In 1866 public opinion was so excited by the recent disturbances in Jamaica that even Carlyle and Ruskin, neither of them active politicians, were drawn into the vortex, and proclaimed themselves supporters of Governor Eyre. It is difficult even now, when time has removed the affair from the turmoil of active politics to the calm of history, to decide whether the Morant Bay riots were unpremeditated or part of a settled plot to overthrow the whites. How much more difficult then, with the whole country in a ferment. Probably the finding of the Royal Commission—that Mr. Eyre acted rightly in promptly nipping the rebellion in the bud, but that martial law was enforced too long, and that the punishments administered were ex-

cessive—is as just and impartial a conclusion as any that could be drawn.

The black record of the Jamaican troubles in October 1865 does not add lustre to our history. Like other punitive measures of their kind, they were the inevitable result of government by a minority of superior race. Kindness has been so often interpreted as weakness by subject races that a firm rule is one of the necessities forced upon us by empire. It does not, however, excuse such unpardonable cruelty as was meted out to the Jamaican negroes for their share in the riot outside Morant Bay court-house. The horrors of the Indian Mutiny were fresh in people's minds, and panic—natural perhaps in men overburdened by the responsibility of safeguarding white women and children—proved the excuse for a reign of terror.

The Jamaican planters hated and feared the blacks almost as much as they despised them, and as Coleridge says in his " Table Talk ": " In politics, what begins in fear usually ends in folly " : sadly true in this case, because their panic-bred severity provided an heritage of hatred for their children.

The public were not satisfied with the recall of Governor Eyre : they clamoured for a trial. Government refusing to prosecute, the " Jamaica Committee " was formed by those who sympathised with the negroes ; Mill, Herbert Spencer, and Huxley being prominent supporters. They made

several attempts to bring Mr. Eyre to trial : in each
case the grand jury threw out the bill of indictment.

Opposed to the " Jamaica Committee " was
the " Eyre Defence Committee," and ranged under
this banner were Carlyle, Ruskin, Kingsley, and
Tennyson. Ruskin subscribed a hundred pounds to
the Eyre Defence Fund ; thus depriving himself,
so he told the readers of " Time and Tide," of his
anticipated Swiss holiday. He threw himself into
the controversy with his usual ardour. A speech
he made in defence of Eyre met with delighted
approval from Carlyle :—

" While all the world stands tremulous, shilly-
shallying from the gutter, impetuous Ruskin plunges
his rapier up to the very hilt in the abominable belly
of the vast blockheadism, and leaves it staring very
considerably." [1]

It is easier to imagine Carlyle on the side of
armed force than Ruskin. And Kingsley too—the
author of " Alton Locke "—" que diable allait-il faire
dans cette galère ? "

Ruskin and Carlyle possessed all the requisites
for a strong friendship—kindred aims and high
ideals. Their characters were not dissimilar, yet
there was sufficient diversity to keep two such
strong wills from clashing. Both were generous,
but Carlyle's generosity was wise and tempered by
Scotch thrift, while Ruskin's was lavish and some-
times ill-advised, yet, like Carlyle's, prompted by

[1] " Thomas Carlyle," vol. ii., p. 330, by J. A. Froude.

a tender heart. Neither would stoop to adapt his writings to the public taste : Ruskin carried this independence to such an extreme that he even took the publication of his works into his own hands. Each was tortured by excessive sensitiveness and a melancholy temperament. Carlyle, who would not profess adherence to any school of politics, could very well agree with Ruskin, who called himself a Tory and professed Radical views. Religious doubts tortured Ruskin more than Carlyle, for the latter had taken refuge in a sturdy Theism. While Carlyle's melancholy had its seat in the liver —that much-abused organ—Ruskin's was undoubtedly due to threatened brain trouble : he had none of the robustness of Carlyle.

Like Teufelsdröckh, Ruskin lost his " Blumine," and " thick curtains of Night rushed over his soul." [1] Again like Teufelsdröckh, he was " quite shut out from Hope : looking not into the golden orient, but vaguely all round into a dim copper firmament pregnant with earthquake and tornado.

" Alas, shut out from Hope, in a deeper sense than we yet dream of ! For as he wanders wearisomely through this world, he has now lost all tidings of another and higher. Full of religion, or at least of religiosity, as our friend has since exhibited himself, he hides not that, in those days, he was wholly irreligious : ' Doubt had darkened into

[1] " Sartor Resartus."

unbelief,' says he ; ' shade after shade goes grimly over your soul, till you have the fixed, starless, Tartarean black.' " [1] All this describes very well the darkness that descended on Ruskin during the middle years of his life.

Lady Burne-Jones, in her " Memorials of Edward Burne-Jones," tells how Ruskin took her husband and herself to call on the Carlyles one evening towards the end of 1862, and describes her sensations when Carlyle, with the hand that wrote " The French Revolution," lifted the kettle from the fire for his wife when she made tea.

The affection between the two prophets of the nineteenth century was deep enough to smooth over minor differences of opinion. They had a slight misunderstanding in 1867, but it was soon put right. In the autumn of 1869 Carlyle was enthusiastic about " The Queen of the Air." He had not met with such a book for many years, and thought Ruskin was " the one soul now in the world who seems to feel as I do on the highest matters." A little later in the same year he wrote to Ruskin, " the sight of your face will be a comfort."

Most of the teaching of " Fors " met with Carlyle's approval, but when Ruskin attempted to put his theory into practice by forming St. George's Company, Carlyle did not sympathise. He flatly refused to contribute to the funds, and denounced the scheme as absurd. At first he declined to

[1] " Sartor Resartus."

believe that Ruskin was in earnest, and when his seriousness was proved without a doubt, mourned that so great a man should have his moments of folly. Here it was that the two men who made it their mission in life to point out the plague spots corrupting our social and commercial life differed most essentially. Carlyle was satisfied to point out the disease and leave others to find a cure ; Ruskin must needs supply a panacea, and because it was not accepted, he allowed chagrin to prey upon his mind to such an extent that he lost, for a time, his reason.

Any differences that arose between Ruskin and Carlyle were but minor, and related more to the means by which reforms could be carried out than to any fundamental truths ; consequently the general harmony remained undisturbed. To please Carlyle, who was a great smoker, Ruskin, who never smoked and wrote of " the filth of tobacco," would overcome his dislike of it enough to bring his old friend a present of some. To " think and smoke tobacco " with a new clay pipe every day— put out on the doorstep at night for any poor brother-smoker or souvenir-hunter to carry off— were Carlyle's chief luxuries.

Carlyle, in his turn, dwelt more on Ruskin's excellences of head and heart than on his foibles. " To my dear and ethereal Ruskin, whom God preserve. Chelsea, 4 May 1875 " was written in a copy of Carlyle's " Early Kings of Norway,"

over his autograph signature. The helplessness of Carlyle's right hand would account for the remainder of the inscription being written in another hand.

When he was out for exercise, Carlyle would often turn his horse's head towards Denmark Hill and drop in there for a talk or to spend a short time looking over Ruskin's collection of minerals while the owner descanted on their merits, geological and ethical—for his minerals were to Ruskin more than mere scientific specimens. Ruskin lamented afterwards that he had not given Carlyle the freedom of garden and stables during his frequent absences from Denmark Hill, since Carlyle derived so much pleasure from his visits there; especially in the sultry summer days when Cheyne Row was almost unendurable.

Many of Carlyle's letters to Dr. Carlyle contained allusions to Ruskin. On 14th December 1865 he wrote that Ruskin was leaving Denmark Hill, " going to Oxford and Coniston Water : I am very anxious about him." [1] He again showed considerable anxiety when, in July 1871, Ruskin was dangerously ill at Matlock with internal inflammation ; recovering in spite of an obstinate refusal to accept the doctors' diagnosis, or carry out the treatment they prescribed. He insisted on reversing it ; his first order being for beef with plenty of pepper !

[1] " New Letters of Thomas Carlyle," edited by A. Carlyle.

Old Mrs. Ruskin died on 5th December 1871, and on the 13th of the same month Lady Ashburton—not the one who had so often roused poor " Goody's " jealousy, but the second wife—having lent Carlyle her brougham, he drove down to Denmark Hill to see Ruskin ; finding, to his great disappointment, that Ruskin had gone to London with Mrs. Severn.

Carlyle called him his " valiant Ruskin," and as age crept on he seemed to depend more upon him. Carlyle may have hoped that his disciple would continue the work he could no longer hope to do himself : the difference in their ages making it probable that Ruskin had many years of strenuous work before him. In a letter to Dr. Carlyle, dated 24th February 1872, the old man wrote : " I am reading Ruskin's books in these evenings. . . . I find a real spiritual comfort in the noble fire, wrath, and inexorability with which he smites upon all base things and widespread public delusions ; and insists relentlessly on having the ideal aimed at everywhere ; for the rest I do not find him wise—headlong rather, and I might even say weak. But there is nothing like him in England in these other respects." [1]

Much of Ruskin's life was spent at Oxford about this time, but when in London he was not forgetful of his friends. Carlyle wrote to Dr. Carlyle on 17th November 1874 : " . . . I have seen Ruskin,

[1] " New Letters of Thomas Carlyle," edited by A. Carlyle.

these three Saturdays in punctual sequence at two p.m., who promises to come weekly at the same day and hour, by way of holiday at London, I get but little real insight out of him, though he is full of friendliness and is aiming as if at the very stars, but his sensitive, flighty nature disqualifies him for earnest conversation and frank communication of his secret thoughts." [1] Uncommunicativeness seems a strange charge to bring against Ruskin.

Age was creeping on apace with Carlyle, and he grew very feeble. The end was not far off. In his diary the poet William Allingham relates how he witnessed a meeting between Ruskin and Carlyle in the early part of 1879. Ruskin knelt on the floor by the old man's chair, after an affectionate greeting, and on leaving kissed the philosopher's hand.

Ruskin's " second friend after Dr. John Brown," Professor Charles Eliot Norton, of Harvard University, is inseparably associated with Carlyle, so it is fitting that he should receive notice in the same chapter. In 1855 he came to England and presented a letter of introduction to Ruskin at Denmark Hill. Chance brought the two men together again in 1856 on the steamer plying between Vevey and Geneva, when Ruskin was touring Switzerland with Mr. and Mrs. Ruskin. Norton was then travelling in Europe with his mother and

[1] " New Letters of Thomas Carlyle," edited by A. Carlyle.

sisters—" a quiet and gracefully cheerful family "—
and in the tiny cabin of the lake steamer the two
young men struck up a sudden but lasting friend-
ship. On Norton's side it soon became protective
and guiding, although he was the younger. Ruskin's
opinions on many subjects were intuitive—brilliant
flashes of genius : Norton's, the result of a wide
and varied experience. Their political views were
irreconcilably opposed, but in most other matters
Ruskin was willing to defer to Norton's opinions,
and so it came about that the latter criticised his
friend's work, dealing out praise and censure in true
professorial style, while Ruskin, appreciative of
Norton's superior scholarship, described him as his
" first real tutor."

Norton was a friend of Emerson, and so also of
Carlyle. On the completion of " Frederick the Great,"
Carlyle presented all the works of reference he had
used for it to Harvard University, and it was Norton
who undertook their arrangement. Carlyle called
him " a pious-minded, cultivated, intelligent, much-
suffering man," and announced that he liked him
" more and more."

The Norton family were in Europe again in 1868 ;
a truly patriarchal family—three generations, all
living under the same roof in perfect harmony.
Norton visited Ruskin at Abbeville in that year,
and in 1869 they were at Thun together. Ruskin
lamented that his friend was American and a
Northerner—" a runaway star dropped into Purga-

tory "—instead of an English Tory, or, better still,
a Savoyard Count of the feudal ages. Norton was
in Europe five years this time, and when he took
his family back to America in May of 1873 it was
without his wife, who died at Dresden in 1872.
Fifteen years after he wrote to Ruskin compli-
menting him upon the freshness of youthful memories
shown in " Præterita," and complaining of the hazi-
ness that enveloped his own early years—a dullness
due to his bereavement, so he believed.

It is as editor of the Carlyle-Emerson corre-
spondence that Professor Norton is best known in
England, but he should also be remembered as a
gracious connecting link—this " gentleman of the
world," with the " sweet quiet smile " of a nun—
between three of the greatest ethical writers of their
century, Emerson, Carlyle, and Ruskin. Ruskin
made him his literary executor, and so did Lowell ;
trusts which he carried out in a way that has earned
him the gratitude of two continents. His work in
this field rather overshadowed his own literary
reputation, though he earned some distinction
as the translator and critic of Dante's " Divine
Comedy " and " New Life."

Norton, who had become Professor of the History
of Fine Art at Harvard in 1874, came to England
again in 1884 as the representative of Harvard
University at the Tercentenary of Emmanuel College.
He was a great advocate for international inter-
course, and urged Americans to complete their

education at Oxford in order that they might acquire and bring home the culture and distinctive character of that ancient seat of learning.

Although he lived quietly, Norton made many friends. In 1905 it was reported that he was about to sell his library; sacrificing his long-expressed wish to bequeath it to Harvard. A meeting of his friends resulted in the subscription of £4,000, which was presented to him in order that he might keep his books and carry out his desire to leave them to his old University.

Norton lived in quiet retirement at Shady Hill, the last survivor of the brilliant band of literary men with which he was so intimately connected, until his death on 21st October 1908.

CHAPTER VIII

EDWARD BURNE-JONES—WILLIAM MORRIS

" I 'M not ¡Ted any longer, I'm not E. C. B. Jones
now—I've dropped my personality—I'm
a correspondent with RUSKIN, and my future title
is ' the man who wrote to Ruskin and got an answer
by return.' " [1] And the warm-hearted, impulsive
young artist, in the first flush of delight at being in
correspondence with his hero, added to his letter
a sketch of himself prostrate before a figure,
with a nimbus, representing Ruskin. A long and
faithful friendship followed—on the younger man's
side amounting to passionate hero-worship. How
strange that Ruskin should bewail his loneliness
when such full measure of affection, pressed down
and running over, was lavished upon him. Nothing
but disease can account for such petulant out-
bursts against fate.

Burne-Jones supplies us with one of the strange
instances in which genius lies dormant for many
years until awakened by some outside influence.

[1] " Memorials of Edward Burne-Jones."

Like Ruskin he was intended for the Church:
unlike the great critic he cared nothing for Art in
childhood and early youth. A tour in France with
William Morris, his staunch friend, opened his eyes
to artistic beauty and awakened the craving for an
artist's life. On the quay at Havre one night, the
momentous decision was made to adopt Art as a
profession. Burne-Jones followed the bent of his
imaginative Celtic temperament: Morris, poet and
artist, starting with architecture, became a worthy
successor to the artists of old who thought it no
shame to apply their genius to designing and making
articles of domestic use.

When first he met Burne-Jones, Ruskin was still
smarting from the wound left by his unhappy
matrimonial experience. The young artist's evi-
dent admiration was not unwelcome, we may
suppose, at such a time. Morris, Burne-Jones, and
Rossetti—with whom Burne-Jones lived for a while
before his marriage—all enthusiastic seekers after
artistic beauty, were delighted readers of Ruskin's
books. In the case of Burne-Jones and Morris, the
loftiness and purity of their ideals brought them
especially into sympathy with the elder man.
Ruskin, melancholy, and incapable both by nature
and education of the high spirits and pure fun that
characterised the two friends, could appreciate—
and perhaps even envy—their light-heartedness.
He sought their society, much to Burne-Jones's
gratification.

" Just come back from being with our hero (Ruskin) for four hours," Burne-Jones wrote to Miss Sampson in November of 1856—" so happy we've been : he is so kind to us, calls us his dear boys and makes us feel like such old, old friends. To-night he comes down to our rooms to carry off my drawing and show it to lots of people ; to-morrow night he comes again, and every Thursday night the same—isn't that like a dream ? Think of knowing Ruskin like an equal and being called his dear boys. Oh ! he is so good and kind—better than his books, which are the best books in the world." [1]

Those must have been golden days. Two out of the three young men who were Ruskin's " dear boys " were poor, one (Burne-Jones) was frail of health, but youth and hope and the keen joy of living were theirs—and all had genius. Not much wonder that Ruskin loved to visit them—to watch their work and listen to their ideals and aspirations. Perhaps sometimes Morris, with his strong vitality and storm-gusts of passionate temper, might have startled the gentle and peace-loving Ruskin, but there was sunny-tempered Burne-Jones with his joyous laugh to clear the air, and both the young men had a keen sense of humour—best of all salves for a temporary misunderstanding.

Morris and Burne-Jones went down to Oxford at Ruskin's suggestion ; to help paint the frescoes

[1] " Memorials of Edward Burne-Jones,"

on the walls of the Union Debating Room, in conjunction with Watts, Rossetti, Holman Hunt, Spencer Stanhope, Val Prinsep, and Hungerford Pollen. Unfortunately this work, which should have been one of the glories of Oxford, was utterly wasted owing to a want of proper precaution in preparing the groundwork.

These years were full of work for Ruskin. His Edinburgh lectures in 1853 were quickly followed by demands for others—much against the will of old Mr. Ruskin, who could not be reconciled to this new departure on the part of his son. An engagement to lecture at the Camberwell Institute in the same year (1853) specially provoked the father's censure. The idea of Ruskin appearing on a public platform in a district so near their own home was impossible : he told Ruskin he must write to the committee and tell them that his parents objected to the engagement—and Ruskin was then thirty-four ! But in 1857 Ruskin had either overcome his objections or was no longer in subjection, as he gave a series of lectures in Manchester which were subsequently published as " A Joy for Ever," and from this time onwards a considerable portion of his work first appeared as lectures and was afterwards reproduced in book form.

Burne-Jones married and started housekeeping in Russell Place. The bride shared her husband's enthusiasm for Ruskin, so this marriage meant one friend more. In her delightful " Memorials of

Edward Burne-Jones " she says : " Our friendship
with Mr. Ruskin was one of the happiest things of
these early days, for we loved him profoundly and
he drew us very near to himself. When he was in
England we often saw him, and when abroad he
wrote to us, at first as ' My dear Edward and
Georgie ' and afterwards as ' My dearest Children,'
which name was never quite dropped. It was his
custom to write freely when he wrote at all ; his
notes and letters must lie thick as leaves in Autumn
in many a desk and drawer, and we received our
share of this golden shower." [1]

Unfortunately Ruskin had a habit of destroying
his correspondence. The " golden shower " he poured
out on others was returned by countless letters from
every man and woman of note in his time, but very
few of these have been preserved. The loss to
literature and art is irreparable. Fortunately
most of the people he wrote to treasured his
letters, so that one side of the correspondence is
available.

Ruskin, always generous to his friends, carried
off Burne-Jones and his wife to Italy in 1862, paying
all their expenses. They deplored his despondency.
This seemed to settle upon him like a cloud, and
it seems probable that it was a precursor of and
connected with the brain trouble that clouded his
later years. While he was away he wrote or tele-
graphed every day to his parents, but it would

[1] " Memorials of Edward Burne-Jones."

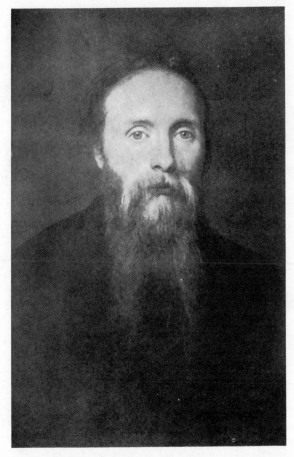

From a photograph by permission of Frank Hollyer after the picture by
George Frederick Watts, R.A.

SIR EDWARD BURNE-JONES, BART., R.A.

appear as if this apparently close communion with
them was more force of habit than unity of thought,
as Mrs. Burne-Jones remarked on his spiritual
loneliness. For years he had been drifting away
from the old people—religiously and politically.

At this time he was in a state of religious doubt ;
the pain, sin, and sorrow of the world pressed heavily
upon him—all the more so as familiarity had never
blunted his perceptions of life's seamy side, owing
to the care with which he had been guarded from
contact with it in early years. The cloud lifted
occasionally, as at Milan, where some of his old
enthusiasm revived when he showed Burne-Jones
his special treasures, and Mrs. Burne-Jones was
alarmed by the sight of him " skipping about " on
the roof of the cathedral. Ruskin seems to have
had a fondness for roof-climbing.

With the fifth volume of " Modern Painters,"
published in 1860, Ruskin voluntarily ended his
career as art critic. He now intended to devote his
time and energies to social regeneration. Burne-
Jones was too enthusiastically attached to Ruskin
for this to raise any barrier between them, although
he was strongly of opinion in the case of Morris—
when he, later, became a Socialist—that an artist
had no business to neglect his work for politics.
Differences of opinion came later, when Burne-Jones,
older and more experienced, therefore more self-
confident, insisted on following his own ideas in
Art, giving more attention to the human form in

his pictures, and less to the landscape and accessories, than Ruskin approved.

As if he wished to make up for his lonely childhood, Ruskin took a keen delight in the company of children and young girls. Winnington School was one of his favourite haunts. He was a frequent and always welcome visitor there. The head mistress, Miss Bell, an autocrat in her little kingdom, ruled with a judicious mixture of firmness and kindness, was a woman of strong personality and far in advance of her time on the subject of feminine education. Ruskin had decided theories on the subject of education, and she allowed him to put some of them into practice at Winnington. Ethical training was to Ruskin of far more value than mere book-learning. The first and absolutely essential need of child-life he held to be Beauty—the higher beauty of happy, loving faces, gentle voices, sweet and harmonious surroundings at home ; externally, green fields to play in ; flowers and beasts, with all other humanising gifts of Nature for the child's education and delight. Obedience—implicit and unquestioning—came next in his scheme, and on this as a foundation was to be reared the superstructure ; in which all knowledge derived from books was made subordinate to the cultivation of Truth—taught by example of its elders as well as by precept—Reverence for all constituted authority, Humility, and Honour.

Rhythmic dance movements expressed both the

joy of life and beauty, so they naturally formed part of his educational scheme. He taught the Winnington girls singing-dances, watching them with intense delight, and would sometimes join in the dances himself. In later years he took the same pleasure in going to see Miss Kate Vaughan dance, and at both Whitelands College for Pupil-Teachers and the High School, Cork, he instituted May Queen Festivals : the revival of Maypole dancing in other places being due to his encouragement.

Ruskin's melancholy and cynicism were forgotten when the girls clustered round him for one of his " talks." " Ethics of the Dust " reproduces the substance of some of these. Loving Winnington so much it was like him that he should wish his friends to share the pleasure : in August 1863 Burne-Jones and his wife accompanied him there, and they also were made free of Winnington.

About this time Ruskin was in bad health, despondent, and wishful to withdraw from the world to some secluded Swiss home. He had once before bought land above the châlets of Blaitière with the same intent, but sold it again because he foresaw that the place would be overrun by tourists. The top of the Brezon, 4,000 feet high, now seemed to be a suitable spot, and he entered into negotiations with the Commune of Bonneville for its purchase. Burne-Jones was at Winnington when he heard of the scheme, and the impulsive, warm-hearted artist was in a state of consternation at the idea of losing

their friend. With characteristic impetuosity he
wrote off to Ruskin :—

" Oh, don't despair about health, or ever think it
is too late ; you must and shall grow strong, and do
lots of work, and when you are very old you shall
sleep somewhere where we can kiss every stone or
blade of grass that covers you. I sometimes think
of that sad time when my light will go out when you
are withdrawn, but when that comes I must spend
my love about the place, and paint the place and
make it pretty, and that shall be years to come
when I am old myself, and worthy of doing it. So
never any more mention that mountain-top, please,
dear." [1]

The grasping Commune of Bonneville, finding a
rich Englishman desirous of buying their land, put
a prohibitive price on it. This, with Osborne
Gordon's prosaic calculations of the inconveniences
likely to beset the housekeeper in Alpine solitudes,
put an end to the Brezon plan. Burne-Jones fore-
saw, however, that the craving for solitude was too
strong to be repressed, and endeavoured to find
some less remote spot on English soil, where it could
be indulged without entailing complete separation
from his friends. He suggested the lovely, and then
unfrequented, country between Ross and Hereford,
and offered to take upon himself all the burden of
finding a suitable spot. By way of bribery, he told
Ruskin that it should be made beautiful by loving

[1] " Memorials of Edward Burne-Jones."

hands. They would make him a tapestried room,
illustrating Chaucer's " Legend of Good Women " ;
the designs by Burne-Jones himself, and the tapestry
worked by Winnington girls under the guidance of
Mrs. Burne-Jones. Unluckily, when the cartoons
had been made, it was found impossible to carry out
the needlework as arranged, and the labour of love
never advanced beyond Burne-Jones's own part in
it. So the cartoons and the following description of
the scheme are all that exist of what was to have
been a visible reminder to Ruskin of "a love passing
the love of women."

" . . . I think you may have as much quiet as
possible there, in Ross or some place near, and only
see those you want, and only them when you want ;
we only bargain to be asked to tea one night in the
tapestried room. Let me describe that tapestry.

" The ground thereof will be green cloth or
serge, and a fence of roses will run all along behind
the figures, about half-way up them, these roses to
be cabbage and dog, red and white. All the ground
will be powdered with daisies—only when Dido,
Hypsipyle, and Medea and Ariadne come there will
be sea instead of grass, and shells instead of daisies.
First will come Chaucer, looking very frightened
according to the poem, and inditing the poem with
a thrush upon his shoulder—then comes Love, a
little angry, bringing Alcestis : Chaucer in black,
Love in red and white, and Alcestis in green. Then
a tree, and a vision of ladies begins, all to have

scrolls, with their name and life and death written, above their heads. The ladies are to be in uniforms of blue and wnite, and red and white, alternately, and at the end of all—to come by your fireplace— will be Edward the Third and Philippa sitting and looking on. So on one side of your fireplace will be Chaucer beginning the subject, and on the other side of it the king and queen.

" Shall you like it, dear, and will it ever make a little amends for sorrow ? I know it won't, only you will pretend it will. I suppose nothing can ever make amends for your troubles—I think and think about it—it is so detestable for me to be happy and you not—I can't bear that sometimes." [1]

There is a touch of feminine sympathy and devotion in these letters from Burne-Jones. They are just what we should expect of a man who drew his most frequent inspiration from the Arthurian legends. It is not every one who can express grati- tude gracefully, or who carries his boyish enthusiasm and hero-worship into the calmer years of manhood. Burne-Jones perhaps only put into words what many of his brother-artists felt without having the power of expression, for Ruskin used his wealth royally, and when he recognised genius in a struggling artist was always ready with substantial encourage- ment in the way of commissions and introductions. Nor did little difficulties escape his notice. When Mrs. Burne-Jones contracted scarlet-fever and was,

[1] " Memorials of Edward Burne-Jones."

for a time, dangerously ill, Ruskin ordered the street in front of her room to be covered with tan at his expense, in order that she might not be disturbed by the noise of passing traffic.

Time passed and brought changes. Burne-Jones was no longer unknown, and had found his distinctive style. He had long been in partnership with Morris, Rossetti, Madox Brown, Faulkner, and Webb as Morris, Marshall, Faulkner & Co., decorators and artistic furnishers. Morris, big, boisterous, and possessed of a happy mixture of practical knowledge and imagination, as well as the elusive quality described as genius, was at the same time beautifying our homes with his tapestries, carpets, glass-work, and furniture, and delighting us with his poems and stories. Always careless about the conventions, he was as averse to fashionable society as Ruskin, though for a different reason. Ruskin avoided society because it bored him ; Morris, primarily, because he hated dress clothes. In the days when the little band of artists were at Oxford, decorating the Union, he had feigned illness to avoid dressing for a dinner at Acland's, and had been discomfited by the unexpected arrival of Acland to offer his professional services. Time had increased instead of lessening his distaste for formality, or even for the usual costume of the day. Morris's favourite wear was a workman's blue blouse, and he appeared in it at most unseasonable times. The story goes that, thus attired, he called

to see a lady for whom he was making designs, and was mistaken by the bewildered maid for the butcher.

Between 1860 and 1870 Ruskin threw himself into the work of purifying and reorganising social life with all the old enthusiasm that had marked his Art writings. These latter he had decided not to reprint, his object being to concentrate all his influence on the subject he now believed to be his lifework. But although he ceased to write on matters of Art—until his appointment as Slade Professor made it necessary to resume it in his Oxford lectures—he was still very decided in his likes and dislikes. Burne-Jones, less amenable to criticism than formerly, declined to follow Ruskin's advice and curb imagination by copying Nature in every detail.

This dispute as to the relative merits of idealism and realism affected their friendship for a time. Burne-Jones also ventured to have opinions of his own about the merits of various artists, and this, again, helped to widen the rift between them. In 1870 we find Burne-Jones writing to Professor Charles Eliot Norton, a mutual friend, " And Ruskin I see never—and when I see him he angers me, which is bad." [1] Again, in 1871 he writes to Norton, who has evidently been inquiring about their friend, " You know more of him than I do, for literally I never see him or hear from him, and

[1] " Memorials of Edward Burne-Jones."

when we meet we clip as of old and look as of old,
but he quarrels with my pictures and I with his
writings, and there is no peace between us—and you
know all is up when friends don't admire each other's
work." [1] (Lady Burne-Jones explains " clip " to
be the half-embrace used by her husband and
Ruskin as their usual greeting.)

Later there was a temporary forgetfulness of
differences, for Burne-Jones writes again to Norton
telling him that Ruskin has been to see him, and—
I forgave him all his blasphemies against my
Gods—he looked so good through and through." [2]
But he goes on to beg Norton to " keep the peace "
between them, as future quarrels are imminent.

Michael Angelo was the innocent cause of much
disagreement. Ruskin read his lecture on Michael
Angelo to Burne-Jones just after writing it, and
Burne-Jones was grieved and shocked. " As I went
home," he said, " I wanted to drown myself in the
Surrey Canal or get drunk in a tavern—it didn't
seem worth while to strive any more if he could
think it and write it." [3]

As time went on the friends grew more tolerant
of such differences of opinion, or possibly Burne-
Jones, with years, became less impulsive and made
allowances for the elder man's limitations, since
there appears to be less friction. The Ross scheme
had been abandoned ; a plan to buy a fourteenth-

[1] " Memorials of Edward Burne-Jones."
[2] *Ibid.* [3] *Ibid.*

century baronial castle, on the banks of the Arve below La Roche, had shared the same fate; so had another for a farm on the ridge between the Forclaz and the Trient glen, 2,000 feet above Martigny. Finally, in 1871, Brantwood, by Coniston, which had been successively the home of Linton the engraver and a hotbed of the Italian revolutionary movement, was bought, and converted at considerable cost into the home in which Ruskin elected to spend his declining years.

To Brantwood, in 1873, Mrs. Burne-Jones and her little daughter Margaret came on a visit, and Ruskin was his old self again—thoughtful and considerate. He insisted on their breaking the journey at Lancaster; sent Crawley, his own man, to meet them there, see to their comfort at the hotel, and bring them to Brantwood next day. Ruskin, as was his wont with children, unbent to six-year-old Margaret. The man who was writing biting sarcasm in " Fors," and planning an upheaval of the whole social system, spent a wet afternoon jumping over piles of books heaped on the drawing-room floor at the bidding and for the amusement of a little girl. In the same way, eleven years later, he —the toyless child—strayed into a toyshop on his way from the National Gallery to Miss Kate Greenaway's, and came away with a kaleidoscope, some magnetic fish, and a skipping-rope as a present for her model, the cabman's daughter. After a sitting for his never-completed portrait by Miss Greenaway,

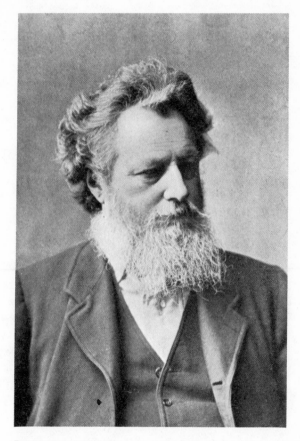

From a photograph by Elliott & Fry.

WILLIAM MORRIS

he wound up the afternoon by tea and muffins with the artist, and marbles, magnetic fish, and skipping with her model. Ruskin might be bored by men— even by women on occasion—but he never failed to find entertainment in the company of children.

William Morris had more in common with Ruskin than Burne-Jones, but their friendship does not seem to have been of the same closely intimate character. Yet Morris not only admired Ruskin's writings, he also carried out in practice much of his ethical teaching. The burly poet-artist, his hands ineradicably stained with dye, was a living example of Ruskin's desire that a healthy balance should be kept between mind and body by giving to every brainworker a daily share in manual work. Morris made his lifework the quest of beauty ; he ennobled the handicraftsman ; opposed excessive subdivision of labour as destructive to Art by its deadening influence on the soul of the worker ; with Burne-Jones, he took an active part in founding the Society for the Protection of Ancient Buildings. So far they saw eye to eye. Morris also held that the chapter, in " The Stones of Venice," " On the Nature of Gothic " laid the basis of true Socialism. But, as time went on, Morris's Socialism went beyond Ruskin's idealised mediæval communism. He joined the Democratic Federation—alien from Ruskin's teaching because it advocated absolute equality, which the author of " Fors " rightly denounced as impracticable, since there is no dead

level of uniformity in Nature. But before Morris took the decisive step of embracing Social Democracy, Ruskin was drifting peacefully towards the Dawn in the quiet retirement of Brantwood, his fighting days over, so there was only Burne-Jones to be distressed by Morris's political opinions and subsequent share in the Trafalgar Square Riots. Burne-Jones took his defection very much to heart. In 1889 he notes: " Every Sunday morning, as of old, Morris to breakfast—and yet not as of old— for we are silent about much now and used to be silent about nothing."[1]

Happily the Ruskin friendship was pursuing a smoother course now. Early in 1883 Burne-Jones wrote to Mr. Norton: " And Ruskin flourishes— gave a lecture on Cistercian architecture the other day that was like most ancient times and of his very best, and looks well—really looks stronger than for many a year past. The hair that he has grown over his mouth hides that often angry feature, and his eyes look gentle and invite the unwary, who could never guess the dragon that lurks in the bush below."[2]

On 12th May 1883 Ruskin took Burne-Jones as the subject of his Slade lecture, just as in June of 1877 he had favourably criticised him in " Fors." During 1883 he also gave him commissions for several designs—one for a cross of hawthorn design to be given to the May Queen at Whitelands

[1] " Memorials of Edward Burne-Jones." [2] *Ibid.*

College ; another for a window in the chapel of the same college, in which St. Ursula was to be accompanied by some " cheerful and Rectorial or Governessial Saints," and with explicit directions for having the glass as opalescent as possible. A third commission was for a picture of Proserpine going down into Hades with Pluto, of which nothing more was done than the pencil sketch.

So they grew old, steadfast in friendship to the last.

" That's my dear brother Ned," said Ruskin one evening, standing before a portrait of his old friend. Sir Edward Burne-Jones died that night, 16th or 17th October 1898, of angina pectoris ; called away before his hand had failed in its cunning.

Morris had died two years earlier (3rd October 1896).

CHAPTER IX

MARY RUSSELL MITFORD—THE BROWNINGS

THREE women are pre-eminent in our literature for their simple, faithful studies of the life around them—Miss Austen, Mrs. Gaskell, and Miss Mitford. They made no pretence of fine writing; they were contented to chronicle the quiet, uneventful lives of their own neighbours, and out of this humility that restricted their pens to familiar scenes came their strength. The coquetries and heartburnings of Miss Mitford's village belles, the tragedies and comedies that ruffled the tranquillity of " Our Village," are as fresh to-day as when they were first written, while more pretentious books of the period have become hopelessly out of date.

Ruskin's liberality, as we have seen, gave Rossetti the means to support himself by his art while still unknown to fame, and nursed Lizzie Siddal back to health. It comforted Miss Mitford's declining years, and provided her with all the delicacies money could buy to tempt her failing appetite. His

generosity was unbounded, and although it was often abused, he never let the discovery of mis-applied bounty check the flow of his gifts in other directions. Many a struggling artist or literary worker had the weight of some financial burden lifted by timely help from their richer brother : his money purchased ease and health for the sickly. The greatest pleasure his wealth brought Ruskin was the power of giving. He says that charity appealed most strongly to him in the lavish extra-vagance of the " Arabian Nights " : a triumphant progress on horseback through the town, with unlimited bags of sequins and ducats on his saddle-bow to scatter by generous handsful amongst the acclaiming crowd. This confession exaggerates his little weakness in true Ruskinian style, but there was a grain of truth in it. There was a lavishness about his expenditure that almost passed the bounds of sanity at times, yet he was far from ostentatious in his charity as a general rule, and no one could give more delicately ; none knew better than John Ruskin how to confer a favour with the air of accepting one.

Miss Mitford's health was already much impaired when Ruskin made her acquaintance. He, who so fully appreciated the dogged fidelity of Miss Laffan's " Baubie Clarke " to her drunken father, could not fail to sympathise with the tragic and pathetic loyalty of the poor little authoress to that handsome old reprobate Dr. Mitford. " The dear Papa,"

as his sweet, simple-minded daughter insisted on calling the selfish gambler and sensualist, was dead before her friendship with Ruskin commenced. She was living in a barely furnished and ruinous labourer's cottage, crippled by rheumatism, and exhausted by her long struggle against poverty. Her only luxury was her flower garden. This garden of Miss Mitford's has been alluded to in a previous chapter, when Ruskin warned her to keep his wife out of it, lest she should " lose her wits with pure delight, or perhaps insist on staying with you and letting me find my way through the world by myself. . . ."

This little garden, attached to a mean cottage " rich only in printed paper," as Miss Mitford describes it, deserves to rank in fame with that of Penshurst and its memories of Sir Philip Sidney, Waller, and his " Sacharissa," or of Horace Walpole's at Strawberry Hill. Under her bay tree or in her " garden room " Miss Mitford held audience with the most famous men and women of her time. When she was leaving that cottage for another—driven into removal by its dangerous state of dilapidation —she dwelt lingeringly on the associations that bound her to the old garden : " Friends, many and kind,—strangers, whose mere names were an honour, had come to that bright garden, and that garden room. The list would fill more pages than I have to give. There Mr. Justice Talfourd had brought the delightful gaiety of his brilliant youth, and

poor Haydon had talked more vivid pictures than he ever painted. The illustrious of the last century—Mrs. Opie, Miss Porter, Mr. Cary—had mingled there with poets, still in their earliest dawn. It was a heart-tug to leave that garden." [1]

Even the flowers that made her garden a glowing mass of colour and riot of sweetness were associated with the brilliant intellectual company who sought her society. Gifts of plants and seeds came to her from far and wide. Daniel Webster visited her, and "we talked naturally of the roses and pinks that surrounded us, and of the different indigenous flowers of our island and of the United States. I had myself had the satisfaction of sending to my friend, Mr. Theodore Sedgwick, a hamper, containing roots of many English plants familiar to our poetry—the common ivy (how could they want ivy, who had no time for ruins ?) ; the primrose and the cowslip, immortalized by Shakespeare and by Milton ; and the sweet-scented violets, both white and purple, of our hedgerows and our lanes ; that known as the violet in America (Mr. Bryant somewhere speaks of it as ' the yellow violet ') being, I suspect, the little wild pansy (*viola tricolor*) renowned as the love-in-idleness of Shakespeare's famous compliment to Queen Elizabeth. Of these we spoke ; and I expressed an interest in two flowers, known to me only by the vivid description

[1] " Recollections of a Literary Life," by Mary Russell Mitford.

of Miss Martineau—the scarlet lily of New York and of the Canadian woods, and the fringed gentian of Niagara. I observed that our illustrious guest made some remark to one of the ladies of his party; but I little expected that, as soon after his return as seeds of those plants could be procured, I should receive a packet of each, signed and directed by his own hand. How much pleasure these little kindnesses give! And how many such have come to me from over the same wide ocean!" [1]

The vicissitudes of Miss Mitford's life are stranger than fiction. Her father was a medical man of good family, who settled in Alresford, and there wooed and married an heiress ten years his senior. She, foolishly fond, refused to have a marriage settlement, and with the exception of £200 a year as pin-money, allowed her husband to have control of her fortune—£28,000, besides landed property. Dr. Mitford was not an unkind husband, but he was a gambler and wild speculator. Mary Russell Mitford started life in a luxurious home as the pet and plaything of her " dear Papa," who was proud of her precocity, and would perch her on the breakfast table when she was only three years old to read leading articles from the daily papers for the amusement of his friends. Her reward after each performance of this kind was to have the ballad

[1] " Recollections of a Literary Life," by Mary Russell Mitford.

of " The Children in the Wood " from Percy's " Reliques " read aloud to her.

From Alresford the family moved into Berkshire, and thence again to Lyme Regis, living in luxury, but, alas ! at the expense of Mrs. Mitford's fortune. Dr. Mitford was reputed one of the finest whist-players in England, but he did not stop at whist. He was a born gambler, and possessed the gambler's sanguine temperament. The house they took at Lyme Regis was the finest in the town : one that had formerly been rented by the first Lord Chatham for the use of his sons. The Mitfords lived here on a scale suited to the house, but not to their failing fortunes. The child, sensitive and observant, had a strange foreboding that something was wrong. A presentiment of coming sorrow oppressed her in spite of the apparent tranquillity of her life in their fine house with the beautiful garden. One day her indulgent father went to London, and soon after the gay company Dr. Mitford liked to fill his house with departed ; there were comings and goings of lawyers and auctioneers, " and I knew —I can't tell how, but I did know—that everything was to be parted with, and everybody paid." [1]

All Mrs. Mitford's fortune had melted away. Her pin-money was safe, and there was a small legacy that had come to the child from a cousin. London, the refuge for those of broken fortunes,

[1] " Recollections of a Literary Life," by M. R. Mitford.

was now the goal of this ruined family. They started from Lyme with the intention of travelling post, but at Dorchester it was impossible to get any other conveyance than a tilted cart, in which they jolted slowly over the roads to their resting-place at the next stage : a roadside alehouse, where a " miserable bedroom " fell to their lot after a supper of " stale bread and dirty cheese." This was Mary Mitford's first experience of poverty, and was a fit preparation for the squalid lodgings to which they retired " in one of the suburbs beyond Westminster Bridge."

During their residence in London Mary Russell Mitford celebrated her tenth birthday (1796). The good-natured, careless, father selected her birthday present with a view to gratifying his own ruling passion, irrespective of its suitability to the child's age and tastes—he bought her a lottery ticket. The story of this ticket can best be told in Miss Mitford's own words :—

"In the meantime his " (Dr. Mitford's) " spirits returned as buoyant as ever, and so, now fear had changed into certainty, did mine. In the intervals of his professional pursuits he walked about London with his little girl in his hand ; and one day (it was my birthday, and I was ten years old) he took me into a not very tempting-looking place, which was, as I speedily found, a lottery office. An Irish lottery was upon the point of being drawn, and he desired me to choose one out of several bits of printed

paper (I did not then know their significance) that lay upon the counter.

" ' Choose which number you like best,' said the dear Papa, ' and that shall be your birthday present.'

" I immediately selected one, and put it into his hand : No. 2,224.

" ' Ah,' said my father, examining it, ' you must choose again. I want to buy a whole ticket ; and this is only a quarter. Choose again, my pet.'

" ' No, dear Papa, I like this one best.'

" ' Here is the next number,' interposed the lottery office keeper, ' No. 2,223.'

" ' Ay,' said my father, ' that will do just as well. Will it not, Mary ? We'll take that.'

" ' No ! ' returned I, obstinately ; ' that won't do. This is my birthday, you know, Papa, and I am ten years old. Cast up *my* number, and you'll find that makes ten. The other is only nine.'

" My father, superstitious like all speculators, struck with my pertinacity, and with the reason I gave, which he liked none the less because the ground of preference was tolerably unreasonable, resisted the attempt of the office keeper to tempt me by different tickets, and we had nearly left the shop without a purchase, when the clerk, who had been examining different desks and drawers, said to his principal :—

" ' I think, sir, the matter may be managed if the gentleman does not mind paying a few shillings

more. That ticket, 2,224, only came yesterday, and we have still all the shares ; one half, one quarter, one eighth, two sixteenths. It will be just the same if the young lady is set upon it.'

" The young lady was set upon it, and the shares were purchased.

" The whole affair was a secret between us, and my father, whenever he got me to himself, talked over our future twenty thousand pounds—just like Alnaschar over his basket of eggs.

" Meanwhile, time passed on, and one Sunday morning we were all preparing to go to church, when a face that I had forgotten, but my father had not, made its appearance. It was the clerk of the lottery office. An express had just arrived from Dublin, announcing that No. 2,224 had been drawn a prize of twenty thousand pounds, and he had hastened to communicate the good news.

" Ah, me ! In less than twenty years what was left of the produce of the ticket so strangely chosen ? What ? except a Wedgwood dinner-service that my father had had made to commemorate the event, with the Irish harp within the border on one side, and his family crest on the other. That fragile and perishable ware long outlasted the more perishable money." [1]

Miss Mitford derived some lasting benefit from her prize beyond the commemorative dinner service. Her father, whose faults were due to a weakness of

[1] " Recollections of a Literary Life," by M. R. Mitford.

moral fibre rather than vice, spent the money as freely on her education as on his own pleasures. Between the ages of ten and fifteen she was boarder at a good school, with all the " extras " then considered essential in the education of a gentlewoman. But she read Voltaire's dramas and the comedies of Molière while she was supposed to be practising on the harp, and so acquired a taste for the drama which fired her ambition to become a playwright. Her first published work was a volume of poems reviewed in the *Quarterly* by Sir Walter Scott. From poetry she passed to plays, the branch of literature in which she most coveted distinction.

Had Dr. Mitford been a prudent father, and his daughter still heiress to her mother's wealth, she might now be known only as a minor poet and the writer of some seldom-acted plays. Stern necessity forced her to study rural life. The lottery money vanished, three legacies left to her shared the same fate, and the pin-money that might have kept them from want was always heavily taxed to pay the spendthrift's debts. At one time she even contemplated opening a shop, after the example of Hawthorne's " Hepzibah Pyncheon."

" Ah, I have a strong fellow-feeling for that poor Hepzibah," wrote this other decayed gentlewoman.

A man of Dr. Mitford's stamp does not improve with age. Miss Mitford's work was their chief

support, and it was essential that she should have
leisure to write, yet the selfish old man encroached
shamelessly upon her time. Uncomplaining, she
would, after giving up to his caprices the best
hours of the day, play cribbage with him all the
evening until he chose to go to bed—often midnight
—after which she must sit up writing for some
hours, to the injury of her health and the quality
of her work, in order to earn money to keep a roof
over their heads. Little wonder that her many
friends—keenly appreciative of her powers as a
writer, conversationalist, and correspondent—chafed
at the selfishness and prodigality that fed upon her
talents.

They never convinced her of her self-sacrifice.
She mourned him most sincerely when he died. To
her he had always been " the dear Papa "—hand-
some, debonair, and kind : her great sorrow seems
to have been that he was not appreciated by her
friends.

A public subscription was raised in 1843 to pay
debts she had incurred during Dr. Mitford's long
illness, and a Civil Pension of £100 a year secured
her a modest income during the remainder of her
life.

After living thirty years in her cottage at Three
Mile Cross, Miss Mitford was perforce obliged to
find another home.

" In truth it was leaving me. All above the
foundation seemed mouldering, like an old cheese,

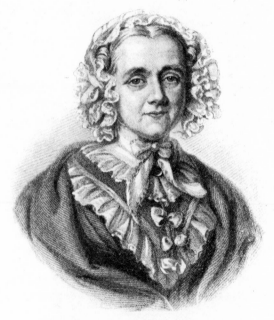

From an engraving by Freeman after a painting by John Lucas.

MARY RUSSELL MITFORD

p. 136]

with damp and rottenness. The rain came dripping through the roof and steaming through the walls. The hailstones pattered upon my bed through the casements, and the small panes rattled and fell to pieces every high wind. My pony was driven from his stable by a great hole where the bricks had fallen out of the side, and from the coach-house, where he was placed for refuge, by a huge gap in the thatch above. There was some danger that his straw bed must be spread in the little hall ; but the hall itself was no safer, for one evening, crossing from the door to the staircase, I found myself dragging off the skirting-board by no stronger impulsion than the flounce of a muslin gown. The poor cottage was crumbling around us, and if we had stayed much longer we should have been buried in the ruins." [1]

But the ties that bound her to the old cottage were strong. It was connected by a thousand memories with the worthless old father who had sapped her strength ; lived on her earnings ; been sheltered by her love. His death did not bring a sense of relief. Their positions had been reversed so long that she was like a mother deprived of a sickly but favourite child—her occupation was gone. " There I had toiled and striven," she writes of the old cottage, " and tasted as deeply of bitter anxiety, of fear, and of hope, as often falls to the lot of woman. There, in the fulness of age,

[1] " Recollections of a Literary Life," by M. R. Mitford.

I had lost those whose love had made my home sweet and precious. Alas! there is no hearth so humble but it has known such tales of joy and of sorrow ! " [1]

So, reluctantly, she walked one summer evening from one cottage to the other ; her staff—the one that she had used so many years—in her hand, no doubt, and Fanchon, her pet spaniel, by her side. The sands of life, unknown to herself, were running low, but at least her remaining days were passed in a weather-tight cottage, " the snuggest and cosiest of all snug cabins ; a trim cottage garden, divided by a hawthorn hedge from a little field guarded by grand old trees ; a cheerful glimpse of the high road in front, just to hint that there is such a thing as the peopled world ; and on either side the deep silent woody lanes that form the distinctive character of English scenery." [2]

It was during these closing years of life that Ruskin's friendship came to her. An accident to her pony-chaise resulted in injuries which incapacitated her, and this gave Ruskin an opportunity to show his respect and affection for a woman who had carried out to the letter his theories on the subject of obedience to parents. He sent her photographs of the places he visited ; forwarded every book he came across that was likely to interest her. Old Mr. Ruskin, as generous as his son

[1] " Recollections of a Literary Life," by M. R. Mitford.
[2] *Ibid,*

in such a case, kept her supplied with the champagne that had been prescribed in a vain attempt to revive her failing strength. No wonder that she wrote to a friend: " Dearly, most dearly do I love John Ruskin ; he and his excellent father and mother have been, perhaps, the very kindest of my friends."

On her last birthday, when her strength was ebbing fast, Ruskin wrote her an affectionate letter wishing that he and others who loved her could lengthen her life by giving each a day from their own. But her life was over, and on 10th January 1855 this gentle, humorous, loving woman, with the heart of a little child, passed peacefully into rest.

Among Miss Mitford's literary friends Elizabeth Barrett, the poetess, took a prominent place. The attachment between them was very close and tender, dating from a much earlier period than the acquaintance of either with Ruskin.

The Brownings first met Ruskin in 1852, while on one of their infrequent visits to England. Mrs. Browning wrote to Miss Mitford that they both liked Ruskin very much, and counted him amongst the valuable acquaintances made during their stay in England. The liking was reciprocal, for Ruskin also made a confidant of Miss Mitford, telling her that he had been prepared to like " her dear Elizabeth Browning," but had not expected to like her husband so much. Robert Browning, he said, was

" a very fine fellow," and Elizabeth Browning the only sensible woman he had met on the subject of Italian politics. He approved also of Browning's rational views on Italy, and they parted with a feeling of mutual esteem and respect.

Ruskin quoted Browning in " Modern Painters " in illustration of the relationship of Mediæval and Renaissance life to art. He described him as " unerring in every sentence he writes of the Middle Ages, always vital and right and profound ; so that in the matter of art there is hardly a principle connected with the mediæval temper that he has not struck upon in those seemingly careless and rugged lines of his."

In 1855 Ruskin wrote to Robert Browning asking him to explain his style. Browning's answer was to ask if it was the poet's duty to tell people what they knew already or to teach them new truths. " A poet's affair is with God—to whom he is accountable, and of whom is his reward."

When Miss Mitford died it was Ruskin who undertook the painful task of writing to her friend Mrs. Browning, relating all the particulars of the last illness. Their mutual affection for the poor little authoress, and a knowledge of Ruskin's kindness to her, gave him a claim upon Mrs. Browning's good will which she was not slow to acknowledge. Mrs. Browning took the active part in their correspondence, Robert Browning being

generally content to add a postscript to her letters.

The history of literature can show no parallel to the romantic story of Elizabeth Barrett Browning. Miss Mitford describes her appearance in 1836, when they first met, as " of a slight delicate figure, with a shower of dark curls falling on either side of a most expressive face, large tender eyes, richly fringed by dark eyelashes, a smile like a sunbeam, and such a look of youthfulness, that I had some difficulty in persuading a friend, in whose carriage we went together to Chiswick, that the translatress of the ' Prometheus ' of Æschylus, the authoress of the ' Essay on Mind,' was old enough to be introduced into company, in technical language was *out*." [1]

The poetess was then aged thirty, and less than two years after a broken blood-vessel on the lungs sent her into the retirement of a sick-room. The Barretts had moved to London from Herefordshire shortly before this accident, and town air being considered prejudicial, she was sent to Torquay—her favourite brother accompanying her. There it was that the tragedy of her life took place. This favourite brother, accompanied by two of his friends, went out sailing one day, and through some mishap— never properly understood—the boat went down in Babbicombe Bay ; the three young men were drowned. In her weak state of health the blow came with crushing force. Morbid from sickness,

[1] " Recollections of a Literary Life," by M. R. Mitford.

she blamed herself as the cause of the accident, since it was for her sake he had come to Torquay. For a time her life was despaired of, but she recovered sufficiently to be taken back to London, where she entered upon the life of an invalid recluse. Even after the lapse of many years she could not bear any reference to the subject, and Miss Mitford's account of the accident in her " Recollections " nearly caused a breach in their friendship.

That was the age of the " coddling " treatment for weak lungs. For more than half the year Elizabeth Barrett was shut up in one room, from which every breath of fresh air was excluded ; the temperature was kept unnaturally warm, and heavy curtains obscured the sunlight. By the time our cold spring winds gave way to summer warmth the patient was so enfeebled for want of fresh air that winter was upon her again before she regained strength, and she was imprisoned as before. In addition to the lung weakness, spinal trouble showed itself as the result of some strain received in girlhood, and she had to be lifted from her bed to the couch. It speaks well for her constitutional vitality that she was still alive in 1845 to meet Robert Browning, her future husband, after seven years in

". . . a curtained room
Where no sunbeam brake the gloom
Round the sick and dreary.

Roses, gathered for a vase,
In that chamber died apace,
Beam and breeze resigning." [1]

Not content with hermetically sealing her, she was only visible to a few chosen friends, Miss Mitford being one of these, and Mr. Kenyon, a relative and dear friend, another. Miss Mitford, kind generous soul, would sometimes make a special journey up to London to spend an hour or so in the sick-room, and returned to Reading the same day. But the greater part of her time Miss Barrett was left to her own thoughts, with nothing to divert her mind from brooding over her brother's death and her own ill-health. Needless to say that under such conditions her nervous system became a wreck.

In January of 1845, Robert Browning, who had been reading Miss Barrett's recently published poems, was encouraged by their mutual friend Mr. Kenyon to write to her. In letters written to friends about this time she expressed her delight at being in correspondence with the author of "Paracelsus." Letters grew into meetings, and these into an absorbing friendship. It was in May 1845 that Browning was first allowed to call and see her, and the affinity between them was so strong that he soon outstepped the bounds of friendship and declared a passionate attachment for her, in spite of the fact that he believed her hopelessly

[1] "To Flush, my dog," by E. B. Browning.

crippled and incapable of moving from her couch.
Elizabeth Barrett, grown familiar with the thought
that her sufferings must end in an early death,
shrank from this glimpse of possible love and fought
against her own growing desire to yield :—

> "We have met late—it is too late to meet,
> O friend, not more than friend !
> Death's forecome shroud is tangled round my feet,
> And if I step or stir, I touch the end.
> In this last jeopardy
> Can I approach thee, I, who cannot move ?
> How shall I answer thy request for love ?
> Look in my face and see.
>
>
>
> "Can life and death agree,
> That thou shouldst stoop thy song to my complaint ?
> I cannot love thee. If the word is faint,
> Look in my face and see.
>
>
>
> "But now . . . God sees me, God, Who took my heart
> And drowned it in life's surge.
> In all your wide warm earth I have no part—
> A light song overcomes me like a dirge.
> Could Love's great harmony
> The saints keep step to when their bonds are loose,
> Not weigh me down ? Am I a wife to choose ?
> Look in my face and see—
>
>
>
> "Meantime I bless thee. By these thoughts of mine
> I bless thee from all such !
> I bless thy lamp to oil, thy cup to wine,
> Thy hearth to joy, thy hand to an equal touch

> Of loyal troth. For me,
> I love thee not, I love thee not !—away !
> Here's no more courage in my soul to say
> ' Look in my face and see.' " [1]

Browning drew back for a while in obedience to her wish, and begged for her friendship at least. Meantime his visits were paid with regularity two or three times a week, and letters passed between them still more frequently—since published as witness to this idyll of two poets. But this unforeseen happiness was having its effect on Elizabeth Barrett's health. She gained strength in a most unusual manner during the summer of 1845, was able to take drives, and even to walk a short distance ; and as the autumn approached she prepared to face the winter with so much more strength than usual that the doctors urged her to winter in Italy, where she could have sunshine and fresh air instead of being cooped up in one close room. Miss Barrett, struggling against the promptings of her own heart in her resistance of Robert Browning's renewed protestations of love, and pouring out her soul secretly in the most impassioned love poems written by a woman since the days when " burning Sappho loved and sung," caught at even this slight chance of health and happiness, and asked permission of her father to spend the winter in Italy.

Mr. Barrett was a domestic tyrant of the deepest

[1] " A Denial," by E. B. Browning.

dye. He loved his children in a queer proprietary way, but insisted on ordering their lives according to his own pleasure ; stamping out any signs of independence with ruthless severity. He now positively declined to sanction the scheme, couching his refusal in such terms that Miss Barrett feared to go lest he should bring his displeasure to bear upon her brothers, one of whom would have had to accompany her as she was not able to travel alone. So she prepared for her usual winter's imprisonment, the utmost encouragement she would give Browning being a promise to reconsider the subject of marriage in the spring if she passed through the winter without a relapse.

> " . . . What hast *thou* to do
> With looking from the lattice-lights at me,
> A poor, tired, wandering singer, singing through
> The dark, and leaning up a cypress tree ?
> The chrism is on thine head,—on mine, the dew,—
> And Death must dig the level where these agree."

So she wrote, still reluctant to accept the sacrifice of his life to an invalid wife, and torn by conflicting emotions :—

> " Can it be right to give what I can give ?
> To let thee sit beneath the fall of tears
> As salt as mine, and hear the sighing years
> Re-sighing on my lips renunciative
> Through those infrequent smiles which fail to live
> For all thy adjurations ? "

But the spring came, and newly budding hopes, for

the still unacknowledged love had helped her
through the winter.

> "... A mystic shape did move
> Behind me, and drew me backward by the hair;
> And a voice said in mastery, while I strove,—
> 'Guess now who holds thee?'—'Death,' I said. But
> there,
> The silver answer rang,—'Not Death, but Love.'"

And at last she accepts his vows that in her weak-
ness she is dearer than any other woman on earth :—

> "Even so, Belovëd, I at last record,
> Here ends my strife. If *thou* invite me forth,
> I rise above abasement at the word.
> Make thy love larger to enlarge my worth."

The tacit engagement was ratified in secret, for
Mr. Barrett was known to be obstinately averse to
the marriage of his children. Even to her brothers
and sisters she dared not talk of her plans, since
only ignorance of her marriage could protect them
from his displeasure. She had to choose between
father and lover, and must leave her father's house
with the certainty that his anger would be deep
and lasting.

> "If I leave all for thee, wilt thou exchange
> And be all to me? Shall I never miss
> Home-talk and blessing and the common kiss
> That comes to each in turn, nor count it strange,
> When I look up, to drop on a new range
> Of walls and floors, another home than this?"

She might well pause; a woman of forty; a con-

firmed invalid ; going out into the world with a
man six years her junior—a poet, with perhaps a
poet's fickleness. If it should prove only a passing
fancy with him there was no going back, for she
knew her father too well to hope that he would
relent. This was her—

> " . . . still renewable fear . . . O love, O troth . . .
> Lest these enclaspëd hands should never hold,
> This mutual kiss drop down between us both
> As an unowned thing, once the lips being cold."

But she took the risk, and the future proved that
her trust in Browning was justified. He made a
devoted husband ; nursed her with the tenderness
of a woman, and left her only one regret in life—for
the unyielding old father in England, who showed
no signs of softening even when happiness and the
mild Italian air had restored his daughter to com-
parative strength.

 All through the summer of 1846 Robert Browning
continued his frequent visits to the house ; letters
were constantly passing between them, and he kept
her supplied with flowers—all quite openly, yet
without provoking any sign from Mr. Barrett that
he noticed any attentions the poet paid his daughter.
Miss Barrett's sisters were partly in her confidence,
but even to them she dared not tell the arrange-
ments she was making for her wedding, while her
brothers were kept out of the secret so that they
might truthfully say they knew nothing of the

matter. Miss Mitford begged to be allowed to attend the wedding, but even this tried friend was not allowed to help her. Miss Barrett would have no one blamed afterwards.

On 12th September (1846) Miss Barrett and her maid, Wilson, went out together. They drove to Marylebone Church, were met there by Browning, and the two poets left it as man and wife. Mrs. Browning drove home again with her maid from the church door, and remained under her father's roof for a week to recover from the exertion and agitation of her marriage. Browning did not make his usual visits during this time, as he could not do so without going under false colours. On 19th September she left again, this time finally, crossed the Channel, rested in Paris for a while, and then travelled south ; gaining strength every day under the loving care of her husband, and of Mrs. Jameson ; who travelled with them at Browning's request in order that his wife might have the comfort of a woman's presence.

Perhaps from a greater natural reticence, or it may be because Browning pleaded his cause in person while Elizabeth Barrett dared only express herself secretly through the medium of her art, the course of their courtship is not traced in his own poems with the abandon that characterised the " Sonnets from the Portuguese," from which the preceding quotations have been taken. It must be remembered that these were not written for

publication, and were seen by no one but their author until some time after her marriage, when she allowed Browning to read them. To him we owe their publication, for he decided that it would be wrong to deprive the world of her finest work because of its personal application. At first they were published privately, under the supervision of Miss Mitford, and copies of this little book— " Sonnets by E. B. B. Reading, 1847. Not for publication "—should be worth the attention of collectors. In 1850 they were issued to the public under their present name.

> " Man's love is of man's life a thing apart,
> 'Tis woman's whole existence."

So, while Elizabeth Barrett wrote herself into the Sonnets, Robert Browning was analysing the emotions of dead and gone lovers and indulging in metaphysical studies of Renaissance life. The few unmistakable allusions to Elizabeth Barrett are usually so disguised by their setting and altered circumstances that they need to be carefully searched for. Most of these were written by the husband, not the lover, in the calm shelter of the domestic hearth ; where he could watch her, as he wrote in his poem " By the Fireside "—

> " Reading by fire-light, that great brow
> And the spirit-small hand propping it,"—

or seek her approval of a new poem ; in certainty

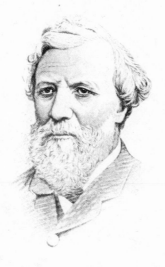

From an engraving after a photograph.
ROBERT BROWNING

p. 150]

that his inmost thoughts would be understood
almost before utterance. When Wordsworth heard
that Miss Barrett and Browning had eloped together,
he is said to have expressed a hope that they under-
stood each other—" nobody else could." Browning
evidently had no doubt on the subject:—

> " Oh I must feel your brain prompt mine,
> Your heart anticipate my heart,
> You must be just before, in fine,
> See and make me see, for your part,
> New depths of the divine !"

What a difference between the marriage stories
of Ruskin and the Brownings ! Yet Ruskin could
never under the most favourable circumstances—
not even to Rose La Touche—have given to a
woman the whole-souled devotion Browning offered
Elizabeth Barrett. He had neither Browning's
depth of affection nor his constancy. What re-
mained of his heart after satisfying the demands of
art and social economics was divided up between a
score of women friends. He would never, in the
first place, have voluntarily visited a sick-room ;
and later would have wearied of attendance on a
delicate wife, instead of, as Browning did, making
all his plans subservient to her comfort. On paper,
Browning was the lover of many imaginary women ;
in reality he was a model husband : faithful in
thought, word, and deed. One may spare pity for
the harsh old father, returning his daughter's letters
with unbroken seals, and dying alienated from

three of his children because they had left his roof
to marry, but it would be wasted on Elizabeth
Barrett Browning, whose only drop of bitterness
was the memory of that father's displeasure, living
and dying encircled by her husband's love.

> "Verse and nothing else have I to give you.
> Other heights in other lives, God willing :
> All the gifts from all the heights, your own, Love !"[1]

Let us envy her rather the romantic devotion
that made him go on pilgrimage to Marylebone
Church, whenever he came to England, that he
might kiss the stones she trod on as a bride.

[1] "One Word More." To E. B. B., by Robert Browning.

CHAPTER X

RUSKIN AS PUBLISHER—GEORGE ALLEN—
THOMAS DIXON

RUSKIN began the practical side of his work as
an art teacher at the Working Men's College
in 1854. It was then under the direction of
Frederick Denison Maurice, that saintly sceptic ;
whose views on the interpretation of the Bible
shocked Ruskin so much that he said Maurice was
" as insolent as any infidel of them all." In after-
years Ruskin might have been more tolerant, but at
this time he still professed the religion taught him
by his mother, rigid and Calvinistic, in which, since
every word in the Bible was inspired, the song of
Deborah stood on the same level as the Magnificat.
Ruskin could never forgive Maurice for denouncing
Deborah's savagery, and putting her song in the same
class as the Norman's sword-song—admirable only
for its rhythmic qualities. So it happened that
Ruskin's first attendance at Maurice's Bible-class
was also his last ; and although he left it on record
that he " loved " Maurice, his affection was for the
man, and did not imply sympathy with the teacher.

Later, he declined to contribute to the Maurice Memorial Fund, on the ground that Maurice was nothing more than the " centre of a group of students " exalted and stimulated by his " amiable sentimentalism."

The management of the Working Men's College displeased Ruskin as much as its Principal's theology. Maurice's dislike to dogma extended to the College regulations. He was content to awaken a desire for knowledge, and provide means to satisfy it, without dictating any special line of study. Ruskin disapproved of the latitude allowed in study, and the freedom of thought encouraged among the students. He bewailed their pride and defiance, saying that there were as many heads as students.

Perhaps it was on account of these differences of opinion that he failed to cultivate the acquaintance of any other master than Rossetti, who also had an art class there. Each clung tenaciously to his own system of teaching. Ruskin believed line-drawing to be all-important, and insisted on keeping his pupils to it ; allowing no colour, except a wash of Prussian blue to teach them how to use a brush. Rossetti, who had never taken kindly to the drudgery of art as a student, was equally impatient as a teacher, and started his class with colour. Ruskin's plodding methods irritated him, and the Prussian blue was his special detestation. Chance one day put Ruskin's stock of it at his mercy, and Rossetti promptly made away with the hated colour.

Ruskin did not interest himself personally in the students, but he made two exceptions to his usual indifference. One of these students disappointed him by developing headstrong qualities; the other, an intelligent and hard-working young joiner named George Allen, learned engraving at the Working Men's College, and afterwards adopted it as his occupation. He wooed Mrs. Ruskin's maid, Hannah, and became Ruskin's right-hand man, engraving all the plates for his books, and, later on, became his publisher.

It has always been the custom of the publishing trade to allow booksellers a discount or percentage, from which the latter take their profit. Ruskin, embarked upon a crusade against commercialism, declined to countenance a middleman between the publisher and purchaser of his books. Messrs. Smith, Elder & Co., who had hitherto published most of his work—a connection dating from the time when cousin Charles introduced the boy writer to Mr. Pringle, of " Friendship's Offering "—would not agree to such strange terms : other publishers took the same view of the question, and as a result Ruskin's books were boycotted.

If the publishers thought that this action would induce Ruskin to alter his convictions, they were mistaken. He made an arrangement with his ex-pupil, Mr. George Allen, whereby Mr. Allen took entire management of all business connected with the publication and sale of his books. The

first number of " Fors Clavigera," in 1871, inaugurated this scheme ; the actual printing being done by Messrs. Smith, Elder & Co., and, later on, by Messrs. Watson & Hazell.[1] Cream-coloured, wide-margined paper was used, and carefully selected type. It was sold in monthly parts at sevenpence a copy ; no abatement being made to booksellers, who were supposed to make their profit by adding openly to the charge for the book : Ruskin's own suggestion was that the price over the counter should be tenpence. This took the trade out of the booksellers' hands : as the pamphlet could be had post free for sevenpence from Mr. Allen, it was hardly likely that the public would go to the local booksellers for it. Even by this arrangement Ruskin did not succeed in abolishing the middleman : there was still Mr. Allen, taking his half-share of the profits, between the public and himself. From this it may be inferred that Ruskin did not find it easy to get rid of the middleman.

Sentiment plays a large part where books are concerned, and a central depôt with postal distribution is as destructive of all the associations connected with a bookseller's shop as the book counter in a drapery store ; a development which is killing the retail book trade of the present day. Never, surely, was middleman more harmless and necessary than the bookseller, and who but Ruskin would have

[1] The style of this firm was changed in 1874 to Messrs. Hazell, Watson & Viney, printers of the present work.

grudged him his modest percentage! It would be a just retribution for the first blow struck at retail bookselling, if his spirit had to haunt the cheap book counter at one of our huge stores, and watch indifferent salesmen make out bills for books at something-and-three-farthings; with a pencil three parts wood or a paper of pins, the produce of sweated labour, thrown in for the odd farthing.

It is difficult to reconcile Ruskin's ideas on the subject of profit with some facts in his own history. He was, by his own confession, the son of " an entirely honest merchant." This merchant, beginning life without capital, acting as middleman between the Spanish vine-grower and the English wine-drinking public, after making provision for his widow of £37,000, was able to leave his son £120,000 —besides house property and pictures. True to his principles, Ruskin expended most of the money, and died comparatively poor, but none of his philanthropic schemes provided for a distribution of their share of the profits to the Spanish peasantry, the fruits of whose toil swelled old Mr. Ruskin's bank balance. Nor do we find any acknowledgment of his indebtedness to trade when he laid lance in rest to fight the windmill of commercialism —nothing beyond a just pride that his father's wine was sound and genuine. Yet the bookseller, like the wine-merchant, exists for the convenience of the public, and the ideal bookseller needs the same knowledge of his wares and discrimination in

placing them before his clients as had been shown
by the elder Ruskin when he traversed the country
in search of orders and gave judgment on this or
that vintage.

Ruskin explained in " Fors," Letter XI., that
he did not mean to forbid profit to the retailer, but
that it must be " quite honestly confessed," and
paid by the purchaser instead of the author. He
announces this with all due gravity, though it seems
absurd to suppose this " quite honest " confession
necessary. Purchasers could hardly be under the
impression that shops were kept by benevolent
individuals from purely philanthropic motives.

In addition to his stand against discount, Ruskin
decided, on principle, against advertising his books.
He would pay for no notices of them in the papers,
and was as scornful of reviewers as a more modern
lady novelist. In his ideal " company of Mont
Rose " reviewers were to have no place—though he
sanctioned an annual book Gazette, in which alpha-
betical lists of books of the previous year were to be
given, briefly noticed by unpaid reviewers.

It is hardly surprising that reviewers, like the
publishers, resented this wholesale condemnation.
For some years there was a press boycott of Ruskin's
books, and newly issued ones were passed over
without comment. In 1887, Mr. E. T. Cook pointed
out that since 1872 the literary journals had been
silent with respect to the writings of " one of the
foremost literary men of the time." An exception

must be made in favour of the *Spectator*, which published an article on Ruskin in the issue of 22nd September 1877; partly reproduced by Ruskin, with caustic comments, in Letter LXXXV. of " Fors."

In an ordinary way certain failure must have attended a venture so opposed to ordinary business methods. Mr. Allen was inexperienced in publishing matters, and hampered by restrictions imposed by a notoriously unbusinesslike principal. He had for his working centre a quiet country village— his warehouse was a shed in the garden—and was debarred from using any of the ordinary methods of advertising, while the prices put upon the books were prohibitive to a large section of the reading public. Yet in spite of all these drawbacks the Orpington publishing firm flourished, and Ruskin was indebted to his copyrights for an income when the fortune left him by his parents had been dissipated in charity and philanthropic schemes. It is said that the profits accruing to Ruskin from his books amounted to an average of £4,000 a year.

To what then can we attribute his success ? Undoubtedly in a great measure to Ruskin's personality. His lectures kept him prominently before the public ; so did the numerous letters he wrote to newspapers ; his philanthropic schemes were of a kind to provoke discussion and draw attention to his books. Ruskin's sense of humour was not strong, or he might have realised what an attractive

advertisement the Hincksey road-mending made, or the still more public appearance of his henchman Downes as foreman of Ruskin's scavengers in the streets between the British Museum and St. Giles, when he began the New Year of 1872 with an object-lesson in municipal cleanliness. As might be expected when his purse-strings were so ready to fly open in support of his theories, Ruskin had a numerous following. The circulation of his books cannot be estimated by sales, as each copy probably passed through many hands. Even the titles of his books played no mean part in popularising them. Ruskin had a peculiar aptitude for choosing titles to arouse desire.

Ruskin's honesty of purpose was never better illustrated than by his bookselling transactions. He took a fierce pride in recanting whenever some once vaunted dogma failed to stand the test of experience or gave way before the evolution of thought. He was not ashamed to proclaim publicly, in later editions of " Modern Painters " and " The Stones of Venice," errors into which he had been led by Protestant bigotry. His art books were suppressed altogether for some years because he feared they might divert public attention from his political work. He condemned the plates from which " Modern Painters " and " The Stones of Venice " had been printed because he believed them too much worn to give good impressions.

The new system had begun with " Fors " in

January of 1871, but " Sesame and Lilies " was
published by Smith, Elder & Co. in May of the
same year, and supplied to the trade at 7s., leaving
the retailer free to fix the price for his customer.
But in the autumn of 1872 " Sesame and Lilies "
was added to the Orpington stock ; the price being
raised on both wholesale and retail orders to 9s. 6d.
carriage paid. This brought it under the same
system as that adopted with " Fors," and it was
suggested that the bookseller should add a shilling
as " honestly confessed profit." This arrangement
roused considerable discontent. After deducting a
penny for postage of the order the profit worked out
to just over a penny in the shilling. By way of
concession the publisher's price was raised to 18s.
carriage paid, with the understanding that the
retailer might ask 20s. for it. This placed the book
out of reach to any but the wealthy, and people
of average means could only read it through the
medium of a circulating library. It is hardly an
exaggeration to say that, for years after publication,
many of his books never reached the class to which
they were addressed.

But Ruskin adhered most conscientiously to his
opinion that if people wanted books they would
find money to buy them, and he was justified so far
as the sales were concerned, though whether the
buyers belonged to the classes or masses must
remain uncertain. After fifteen years the original
" Sesame and Lilies " was in its sixth edition ; and

a cheaper issue, published at 5s., had reached a
fourth edition, with three thousand copies to each
impression.

The five-shilling edition was a concession wrung
from Ruskin when he, somewhat tardily, discovered
that books could be published at a cheap rate with-
out giving illegible type and bad paper. So far as
" Fors " was concerned, though, he remained con-
sistent to his old opinion, for in 1874 the price had
been raised to tenpence a month, and this in spite
of the publication being written for working men.
It cannot be doubted that the high prices retarded
the spread of his teaching ; but as Ruskin wrote in
advance of his time the men who practised some
self-denial to buy his writings were doubtless those
best fitted to prepare the way for a wider acceptance
of his thoughts in later years.

At first joint-publisher with Messrs. Smith &
Elder, Mr. Allen was appointed sole publisher in
1873, and from that date he retained entire control
of Ruskin's books. The conditions of publication
remained unchanged until 1886, when the business
was transferred to premises in Charing Cross Road.
With this removal came a retrogression to the
usual custom of advertising and allowing fixed
discounts to the retailer. Ruskin was then in-
capacitated so far as business matters were con-
cerned ; the result of frequent attacks of brain
trouble : the copyright of his earlier works was
nearing its end. The inference may be drawn that

when the author with his forceful personality was no longer at the helm, such a Utopian bookselling scheme was found inadvisable under pressure of modern competition ; especially as each year brought nearer the end of the monopoly of this popular writer's works.

The adoption of ordinary publishing methods by Messrs. Allen & Sons, and the issue of many of the books in cheaper form, has brought Ruskin's writings within the means of all classes, while the issue of the Library Edition gave a new zest to Ruskinian study by the scholar and the wealthy. With the expiration of copyright it is to be hoped that his political works will be published in the cheapest possible form and scattered broadcast among the people. This is the proper antidote to the poison of disaffection and prejudice resulting from incomplete and garbled versions of his teaching.

By a strange irony of fate Ruskin, the Tory of Tories, has been accepted as the inspired oracle of the Socialist party. As a consequence of this, ten years after his death and a quarter of a century after his retirement from public life, he has a larger following than during the most active period of his working days.

As in the case of Mr. Allen, Ruskin occasionally singled out for special notice some working-man in whom he detected gifts beyond the average of his class. One of these was Thomas Dixon of Sunder-

land, a working cork-cutter, to whom Ruskin wrote a series of letters on various questions affecting the lives and interests of the working-classes. Mr. Dixon, with reason, valued these letters so highly that he used to copy them in order that other thoughtful working-men might share his good fortune. These letters, ranging between the beginning of February and end of April 1867, were published at the end of the same year under the title of " Time and Tide by Weare and Tyne."

We know very little of Thomas Dixon beyond what we learn in a few extracts from his own letters, published in the Appendix to " Time and Tide." These reveal him as shrewd, thoughtful, earnest, far in advance of his time, an idealist, and possessing a keen insight into the lives of his fellow-workers. He evidently spent much of his spare time in solid reading, and his mental capacity is proved by the way he analysed and applied the lessons underlying the books he read. These fragments are sufficient to rouse regret that any letters he wrote on social subjects have not been collected and printed. Without a doubt they would serve a more useful purpose than the theorising indulged in by writers with only a second-hand knowledge of the working-man's thoughts and ideals.

Over forty years have passed since Thomas Dixon wrote : " Now, who will deliver us ? that is the question ; who will help us in these days of *idle or no work*, while our foreign neighbours have plenty

and are actually selling their produce to our men
of capital cheaper than we can make it ? House-
rent getting dearer, taxes getting dearer, rates,
clothing, food, etc. Sad times, my master, do
seem to have fallen upon us." Is not this as applic-
able to the closing days of 1909 as to the beginning
of 1867 ? He was reading Carlyle's " Frederick the
Great " when he wrote that, and finds the cause of
nearly all the national troubles he bewails " em-
bedded in that Frederick." " For our behoof, is
there no one that will take this, that there lies so
woven in with much other stuff so sad to read, to
any man that does not believe man was made to
fight alone, to be a butcher of his fellow-man ? " [1]

In another letter he comments on co-operation,
and on the relations between master and man :
" I myself am not fully satisfied with our co-opera-
tion, and never have been ; it is too much tinged
with the very elements that they complain of in
our present systems of trade—selfishness. I have
for years been trying to direct the attention of the
editor of the *Co-operator* to such evils that I see in it.
Now further, I may state that I find you and
Carlyle seem to agree quite on the idea of the
Masterhood qualification." (Ruskin had written to
him that the master should be " *held responsible,
as a minor king or governor, for the conduct as well as
the comfort of all those under his rule.*") " There
again," continues Mr. Dixon, " I find you both feel

[1] " Time and Tide," Appendix II.

and write as all working-men consider just. I can assure you there is not an honest, noble working-man that would not by far serve under such *master*-hood, than be the employé or workman of a co-operative store. Working-men do not as a rule make good masters ; neither do they treat each other with that courtesy as a noble master treats his working-man. George Fox shadows forth some such treatment that Friends ought to make law and guidance for their working-men and slaves, such as you speak of in your letters. I will look the passage up, as it is quite to the point, so far as I now remember it." [1]

In the same observant fashion he discourses on real kinghood, the limitation of hours of labour, superannuation allowances to employés, Government Savings Banks, Trade Guilds, and the drink traffic. This last-named problem touched him nearly : " It is my mode of living to supply these houses with corks that makes me see so much of the drunkenness ; and that is the cause why I never really cared for *my trade*, seeing the misery that was entailed on my fellow men and women by the use of this stuff." [2]

But the most illuminating passage in his letters is one relating to the home. Self-educated men of Thomas Dixon's class are not always willing to admit the woman to a position of equality : too often each upward step in the working-man's intellectual

[1] " Time and Tide," Appendix II.
[2] *Ibid.*, Appendix IV.

progress tends to remove him from sympathy with women of his own class. " I only wish I could write in some tolerable good style," he says, " so that I could idealize, or rather realize to folks, the life, and love and marriage of a working-man and his wife. It is in my opinion a working-man that really does know what a true wife is, for his every want, his every comfort in life depends on her ; and his children's home, their daily lives and future lives, are shaped by her."[1]

Thomas Dixon was, in effect, the working-man as Ruskin would have him be : temperate, self-respecting, content to improve his condition without leaving his own class ; too proud to make pretence of being a gentleman, and therefore becoming one in the true sense of the word. In 1880 he visited London in company with his friend Joseph Skipsey of Newcastle, a collier since the age of seven, and a poet. They called on Burne-Jones together, and won his liking ; Dixon's delicacy of nature being especially commented on. He is described in the " Memorials of Edward Burne-Jones " as a noble-looking man, with extremely gentle and courteous manners, with wide knowledge of English literature and poetic vision, but the circumstances of his life left him at a disadvantage. During the time of his stay in London Dixon dined with the Burne-Joneses to meet Morris, and so great was the mutual attraction that he lunched with them twice during the

[1] " Time and Tide," Appendix VI.

following week. They never saw him again, for he took to his bed on his return to Sunderland, and died after a little more than a fortnight's illness—from exhaustion. As for Skipsey, he also had much impressed the Burne-Jones family, and the idea of a poet condemned to spend the greater part of his time in a dark colliery so distressed Burne-Jones that he used his influence to procure more congenial work for him. He succeeded in getting him appointed as caretaker of Shakespeare's house at Stratford-on-Avon.

CHAPTER XI

DR. JOHN BROWN—LADY TREVELYAN— LADY MOUNT-TEMPLE

A MOST noteworthy trait in Ruskin was his power of winning friendship. He possessed a magnetic attraction for the best and noblest of his contemporaries. Amongst these Dr. John Brown stands pre-eminent: kindest-hearted, most whimsical, most lovable of physicians, in whom the milk of human kindness was double-creamed.

Ruskin described him as his " best and truest friend "—one of his " frankincense friends "—and Ruskin was not the only bondman to " the greatest slaveholder of his time," as " Mark Twain " affectionately called the author of " Rab and his Friends." Dr. John Brown counted amongst his friends and correspondents—he was a delightful letter-writer— such well-known people as Thackeray, " Mark Twain," Lady Trevelyan, Sir Theodore Martin, and Ruskin. In Edinburgh society, not to know Dr. John Brown argued oneself unknown : he was a centre for literary and artistic as well as medical and social circles.

" Fate tried to conceal him by naming him
Smith," wrote Oliver Wendell Holmes of another
owner of an undistinguished patronymic. Dr.
John Brown of Edinburgh, bearer of a common-
place name, was one of a family of John Browns,
each of whom achieved distinction. His father—
Dr. John Brown of Broughton Place, Edinburgh—
was a noted United Presbyterian minister ;
descended from a still more famous John Brown,
theologian, author, and preacher, who started life
as a shepherd-boy, and educated himself so effi-
ciently during the lonely watches by his flock on the
braes of Abernethy that he fell under suspicion of
having acquired his learning by a Faustian compact
with the Evil One, and was refused a certificate of
church membership on that account by the sapient
elders of his kirk. Their credulity accepted this
report of supernatural agency when the true credit
should have been ascribed to his perseverance and
love of knowledge. Orphaned before he was eleven,
this first John Brown taught himself Greek : " dis-
covering (as true a *discovery* as Dr. Young's of the
characters of the Rosetta stone, or Rawlinson's of
the cuneiform letters) the Greek characters." So
our Dr. John Brown describes with just pride his
ancestor's educational feat.

This first stage in Greek study passed, the Rev.
John Brown's biographer tells how " he had now
acquired so much of Greek as encouraged him to
hope that he might at length be prepared to reap

the richest of all rewards which classical learning could confer on him, the capacity of reading in the original tongue the blessed New Testament of our Lord and Saviour. Full of this hope, he became anxious to possess a copy of the invaluable volume. One night, having committed the charge of his sheep to a companion, he set out on a midnight journey to St. Andrews, a distance of twenty-four miles. He reached his destination in the morning, and went to the bookseller's shop, asking for a copy of the Greek New Testament. The master of the shop, surprised at such a request from a shepherd-boy, was disposed to make game of him. Some of the professors coming into the shop, questioned the lad about his employment and studies. After hearing his tale, one of them desired the bookseller to bring the volume. He did so, and drawing it down, said, ' Boy, read this, and you shall have it for nothing.' The boy did so, acquitted himself to the admiration of his judges, and carried off his Testament, and when the evening arrived, was studying it in the midst of his flock on the braes of Abernethy." [1]

Widely as they were separated by time and social circumstances there was much of resemblance between the youth of this founder of the Brown family and that of Ruskin. Silence, solitude, and hardship alike characterised the shepherd's lot

[1] " Memoir of Rev. John Brown of Haddington," by Rev. J. B. Patterson.

and that of the rich merchant's son in the Hunter Street nursery and the Herne Hill garden.

The Brown family proudly cherished the memory of their ancestor. "He was our king, the founder of our dynasty; we dated from him, and he was 'hedged' accordingly by a certain sacredness or 'divinity,'" wrote Dr. John Brown in "Horæ Subsecivæ." Perhaps it was because dogged determination had helped the first John Brown so much, that the Browns as a family prided themselves on being "firm to obstinacy."

Upward progress in society softened and refined without lessening the mental capacity of the scions from this sturdy self-reliant stock. John Brown, fifth of the name, chose medicine instead of theology as his profession. According to the custom of that time with the medical profession, he was apprenticed to Professor Syme. The choice of Syme as his master he afterwards declared to be "the best blessing of my professional and one of the best of my personal life," describing him as "our greatest clinical teacher and wisest surgeon." Professor Syme had a surgical hospital at Minto House, Edinburgh, and here young John Brown went through the first stages of his professional life. During part of the time he acted as Clerk to the Hospital, a post that gave him special opportunities for learning the histories and studying the characters as well as diseases of the cases under treatment. To know the keen intuition and sympathetic nature

of the man we have only to read that tender, pathetic account of " Ailie," the Howgate carrier's wife, in " Rab and His Friends " :—

" I never saw a more unforgetable face—pale, serious, *lonely*, delicate, sweet, without being at all what we call fine. She looked sixty, and had on a mutch, white as snow, with its black ribbon ; her silvery, smooth hair setting off her dark-grey eyes— eyes such as one sees only twice or thrice in a life-time, full of suffering, full also of the overcoming of it : her eyebrows black and delicate, and her mouth firm, patient, and contented, which few mouths ever are. . . .

" ' Ailie,' said James, ' this is Maister John, the young doctor ; Rab's freend, ye ken. We often speak about you, doctor.' She smiled, and made a movement, but said nothing ; and prepared to come down, putting her plaid aside and rising. Had Solomon, in all his glory, been handing down the Queen of Sheba at his palace gate, he could not have done it more daintily, more tenderly, more like a gentleman, than did James the Howgate carrier, when he lifted down Ailie his wife." [1]

The young doctor's keen sensibilities must have been torture to him when he had to face the grim scenes in Minto House operating-theatre, for, as he tells us, " chloroform—one of God's best gifts to His suffering children—was then unknown." John

[1] " Rab and His Friends," by Dr. John Brown.

Brown was too tender-hearted, too observant, not to have suffered acutely. But if there is any innate nobility in a man's nature the study of medicine brings it out. So it was in the case of John Brown. He was very young when he watched by Ailie's deathbed, yet he grasped the pathos of her delirious fancy as she clasped the rolled-up bedgown in her arms and held it to her breast—" her eyes bright with a surprising tenderness and joy, bending over this bundle of clothes "—thinking it the babe who had been " in the Kingdom forty years and mair." He tells the story with the tenderness of a woman, and although he waxes professional afterwards and explains the action as the result of suggestive pain in the poor maimed breast, this lapse into the scientific relation of cause and effect does not discount from its pathos.

Both Ruskin and Dr. John Brown were dog-lovers, the affection of both for dogs having survived the test of a severe bite in early childhood. Towzer, his Croydon aunt's dog, had been the dumb, sympathetic companion of those childish days when little John Ruskin, standing by the door of the baker's shop, would watch his cousins start for some boyish expedition he was forbidden to share in by his too-prudent mother. " Dash," another of the Croydon dogs, became his own property when that loved aunt died. In manhood there was " Wisie," the faithful little Spitz, and " Bustle," Dr. Acland's dog, to whom Ruskin has ensured a

niche in the temple of Fame as " the chief solace of
my labours in Oxford."

Dr. John Brown had also many dog friends, and
it was à propos of one of them that he wrote :—

" I think every family should have a dog ; it is
like having a perpetual baby ; it is the plaything
and crony of the whole house. It keeps them all
young. All unite upon Dick. And then he tells no
tales, betrays no secrets, never sulks, asks no trouble-
some questions, never gets into debt, never coming
down late for breakfast, or coming in by his Chubb
too early for bed—is always ready for a bit of fun,
lies in wait for it, and you may, if choleric, to your
relief, kick him instead of some one else, who would
not take it so meekly, and, moreover, would certainly
not, as he does, ask your pardon for being kicked." [1]

It is doubtful if Ruskin, who hated ugliness and
mutilations, who confessed that he shrank from his
cousin Margaret in childhood because she was
deformed and an invalid, would have taken " Rab "
to his heart ; much less have made him the central
figure in a character sketch. Poor " Rab "—the
big mastiff, slayer under great provocation of the
" Game Chicken "—was no beauty, but John Brown
looked below the surface in man and beast. " There
are no such dogs now," he wrote of Rab. " He
belonged to a lost tribe. As I have said, he was
brindled, and grey like Rubislaw granite ; his hair
short, hard, and close, like a lion's ; his body thick-

[1] " Horæ Subsecivæ," by Dr. John Brown.

set, like a little bull—a sort of compressed Hercules
of a dog. He must have been ninety pounds'
weight, at the least ; he had a large blunt head ;
his muzzle black as night, his mouth blacker than
any night, a tooth or two—being ·all he had—
gleaming out of his jaws of darkness. His head
was scarred with the records of old wounds, a sort
of series of fields of battle all over it ; one eye out,
one ear cropped as close as was Archbishop Leighton's
father's ; the remaining eye had the power of two ;
and above it, and in constant communication with
it, was a tattered rag of an ear, which was for ever
unfurling itself, like an old flag ; and then that bud
of a tail, about one inch long, if it could in any sense
be said to be long, being as broad as long—the
mobility, the instantaneousness of that bud were
very funny and surprising, and its expressive twink-
lings and winkings, the intercommunications between
the eye, the ear, and it, were of the oddest and
swiftest." [1]

His apprenticeship over, John Brown went as
assistant to a doctor at Chatham. This was in
1831, and during the following year cholera ravaged
the town. The young man and his chief—a Scots-
man like himself—had a hard fight with the epidemic.
They worked almost incessantly in the plague-
stricken districts, and in one instance it is said that
John Brown was found lying in the sleep of
exhaustion across the bed of a dead cholera patient.

[1] " Rab and His Friends," by Dr. John Brown.

In 1833 he returned to Edinburgh to take his degree as M.D., and set up in practice there.

Nature had richly endowed him with all the qualities essential to win hearts, and the cheerful, humorous, sympathetic doctor was soon one of the most popular men in Edinburgh. Tender-hearted as a woman, and with a love of fun and zest for living equal to that of a schoolboy, he was in demand both as a friend and doctor. Fees were a secondary consideration with him, though he was not a rich man. As it was difficult to distinguish between friendly calls and professional visits where so many were friends, he is said to have made a whimsical arrangement that his visits were professional or friendly according to the disposal of his hat when he entered a house— the doctor left his hat in the hall, the friend carried it into the room with him. The story goes that he had sometimes to resist attempts, on the part of friends who sought his advice, to deprive him of his hat in order that the call might be put upon a professional basis.

Little wonder then that in 1874, when the degree of LL.D. was conferred on him by the Senate of Edinburgh University, his objection to the honour —that he was not learned—was met by the suggestion that in his case the letters meant " loved."

To obtain, as Dr. Brown did, a reputation for culture in Edinburgh society, demanded more than average intellectual power. His tastes both in

literature and art were sound and discriminating ;
while he had a special aptitude for detecting rising
genius.

It was at the house of a mutual friend, that of
Lady Trevelyan, the " Pauline " of their letters, that
Ruskin and Dr. Brown first met. Ruskin tells us
that it was on a visit to Wallington en route for
Edinburgh, whither he was going to deliver a course
of lectures. That would be in 1853, but they had
then been corresponding for some years if, as is
stated, their correspondence covered thirty-five
years, since Dr. Brown died in 1882. Writing to
Miss Susanna Beever in 1874, Dr. Brown tells her
that Ruskin first wrote to him thirty years earlier,
which takes it back to 1844 ; the year after the
first volume of " Modern Painters " was published—
a very probable beginning to the acquaintance.

There are several allusions to Ruskin in letters
from Dr. Brown to Lady Trevelyan during 1851 :
candid criticisms of his arrogance and " savagery "
of manner in " The Stones of Venice," which the
doctor had just been reading. Ruskin and his
father were both bitterly opposed to Catholic
Emancipation at the time, and the liberal-minded
doctor stigmatized Ruskin's tirades against it as
" nonsense " — " ridiculous and tiresome." Dr.
Brown had idealized Ruskin, and while he pronounced
" The Stones of Venice " his greatest book " in
some respects," bewails the flaws in his idol. " I
once thought him very nearly a god ; I find we must

cross the River before we get at our gods." [1] Dr. Brown discusses his character also : he shrewdly remarks that Ruskin has too much genius for unfailing good-humour. These early impressions derived from the books and letters of one yet a stranger are all the more valuable because they are unbiassed by the personal estimate. Ruskin, the Enchanter, once met in the flesh, swayed men's minds and captivated their hearts until impartial judgment became almost impossible.

Wallington, near Otterburn, in the Northumbrian borderland renowned for ballad and foray, was described by Ruskin as ugly, square-set, and bare-walled ; but Dr. Brown, after being weather-bound there, wrote that " there could not be imagined a house in which one may less grumblingly pass three days indoors in the country." It was a storehouse of literary, scientific, and artistic treasures, and the host and hostess were as far removed from the commonplace as the interior of their house. Wallington was a favourite stopping-place with Ruskin. He and his friend, Sir Walter Calverley Trevelyan, had much in common. Sir Walter was an antiquarian, geologist, botanist, entomologist, good classical scholar, and a patron of the fine arts. He dabbled in phonetic writing and phrenology ; advocated teetotalism, and supported the Maine Liquor Law. But Ruskin's chief friend at Walling-

[1] " Letters of Dr. John Brown," edited by his Son and D. W. Forrest.

ton was Sir Walter's first wife, Paulina, a clever
woman—artistic and literary—never very strong,
but richly endowed with the mental power and
nervous energy so frequently allied to delicate
health. Dr. Brown wrote to Sheriff Dick that
" Sir Walter and his smallest and briskest and
artisticalest of wives are pleasanter than most people
and easier too." [1] Carlyle described the husband and
wife in one of his gossipy letters to Dr. Carlyle :
" Wife a kind of wit, not unamiable, and with plenty
of sense ; man a strangely silent, placidly solemn
old gentleman in lengthy black wig." [2] Lady
Trevelyan might have felt flattered at being pro-
nounced by Carlyle a woman of sense, for the
philosopher's judgments of women were not always
so favourable.

Her common-sense and coolness in an emergency
was proved on one occasion in a remarkable manner
and to the public benefit, since it saved Holman
Hunt's picture " The Temple " from destruction
by ˙ fire. A canopy, erected over the picture to
improve the effect by preventing reflection of sur-
rounding objects in the glass, caught fire and fell,
blazing, on the gallery floor, close to the picture.
Without hesitation Lady Trevelyan, who happened
to be present, hastily took off a valuable Indian
shawl she was wearing and gave it to the frightened

[1] " Recollections of Dr. John Brown," by Alexander
Peddie.

[2] " New Letters of Thomas Carlyle," edited by A. Carlyle.

attendant, who crushed out the flames. In the confusion, Lady Trevelyan left the gallery un-recognised. The morning was cold, the water supply frozen, and only her prompt action could have saved the picture. She never answered the advertisements asking the owner of the shawl to come forward and claim compensation for the loss of her property, and it was some years before her identity was established.

Lady Trevelyan appears to have been the first of Ruskin's many platonic friends. The mere fact that for many years he maintained a close corre-spondence and personal intercourse with different women of various ages, without giving rise to a breath of scandal, negatives the theory that Ruskin's unhappiness proceeded from disappointments in love. Love with him was diffused and mild; always second to his work. He was one of the few men capable of sustaining a platonic attach-ment, and keeping it free on both sides from gusts of passion.

To do this a man must be pure in life and in ideals, not swayed by strong passions, and should have an instinctive tendency to choose women in whom the maternal dominates the sexual as re-cipients of his friendship. Ruskin liked to take women into his confidence and ask their advice—though he admits in writing of Lady Trevelyan, who probably formed no exception to his rule, that although she was entirely trusted by him as a

" monitress-friend," yet he never took her advice. There was something of the woman in Ruskin. He wanted sympathy, and to be able to tell his sorrows to a patient and willing listener. Men would have no desire for the most part to occupy the rôle of sympathiser : women, in whom the protective and maternal instinct is so strong a motive power, responded freely to his appeal.

Lady Trevelyan wrote art criticisms herself, and papers from her pen appeared in the *Scotsman* and elsewhere. Curiously enough, it was as an art critic that Dr. Brown also made his *début* in literature. He had not thought of writing until Hugh Miller, then editor of the *Witness*, wrote in the spring of 1846 asking him to do a notice of the exhibition of the Scottish Academy ; enclosing with his request four £5 notes as payment for the suggested article. It was Mrs. Brown who persuaded the doctor to accept this offer when he, self-diffident, would have declined. The result was his " Notes on Pictures," afterwards included in " Horæ Subsecivæ." In this he wrote of Ruskin :—

" There is one man amongst us who has done more to breathe the breath of life into the literature and the philosophy of Art, who has ' encouraged ' it ten thousand times more effectually than all our industrious Coles and anxious Art-Unions, and that is the author of ' Modern Painters.' I do not know that there is anything in our literature, or in any literature, to compare with the

effect of this one man's writings. He has by his sheer force of mind, and fervour of nature, the depth and exactness of his knowledge, and his amazing beauty and power of language, raised the subject of Art from being subordinate and technical, to the same level with Poetry and Philosophy. He has lived to see an entire change in the public mind and eye, and, what is better, in the public heart, on all that pertains to the literature and philosophy of representative genius. He combines its body and its soul. Many before him wrote about its body, and some well ; a few, as Charles Lamb and our great ' Titmarsh,' touched its soul : it was left to John Ruskin to do both."

In February of 1847 the *North British Review* published an article by Dr. John Brown on Ruskin's " Modern Painters," and here again he wrote appreciatively of the man who was soon to become his friend ; urging people to trust to his teaching, as thereby they would " find not only that they were richer in true knowledge, and quickened in pure and heavenly affections, but that they would open their eyes upon a new world—walk under an ampler heaven, and breathe a diviner air."

In private letters Dr. Brown was even more enthusiastic, and his descriptions of Ruskin are whimsically humorous. He tells Lady Trevelyan in a letter written in December of 1864 that Ruskin must have wings concealed under his flannel jacket. He insists that he is an angel with singed wings ;

that his " arrogance, insight, unreasonableness, and spiritual ' sheen ' " are proofs of his celestial origin. And the simile seems to have occurred to him more than once, for on another occasion he writes of Ruskin's unhappiness and of his own wish to " cheer" him, quaintly consoling himself with the thought that Ruskin had Heaven in the future for the growth of his wings and the satisfaction of his yearnings.

Dr. Brown suffered a great loss in 1864, when his dearly loved wife died after a long and lingering illness ; doubly painful to him because to the husband's natural anxiety was added the distress of following her illness through its various stages and knowing that with all his professional skill he was powerless to save her. Ruskin's father died in the same year—a link of sympathy between the two friends. It is scarcely to be wondered at that Ruskin, constitutionally prone to fits of depression and morbidly sensitive of conscience, should have suffered in health and spirits after his father's death, especially as they had drifted so far apart during the latter years of the old man's life. It is more surprising that Dr. Brown, so healthy-minded and cheerful, should have failed to regain elasticity after his wife's death. Time failed to bring forgetfulness. He became subject to black hours of melancholy ; the suffering encountered during his professional work became more and more acutely painful ; and the reaction of mind upon body

resulted in failure of general health until in 1876 he decided to retire from general practice. Then it was that he discovered the hold he had on people's hearts. To John Brown of Edinburgh we may apply words written by the author of " Confessio Medici " : " Heaven, not thinking it wise to give him much money, had given him many friends."

Quietly and unostentatiously his friends subscribed to a testimonial as a mark of their affection and esteem. The amount thus privately raised was sufficient, with a Royal Pension grant of £100 a year awarded him in 1874 for " distinguished literary eminence," and the fees proper to his appointment as Medical Officer to the Life Association of Scotland—a post he held from 1864 until he died in 1882—to ensure him a comfortable income.

Lady Trevelyan had a rival in Ruskin's friendship after the mid-fifties. This was Mrs. Cowper-Temple—his " Egeria," as he called her. His first introduction dated from one of the society functions Ruskin disliked so heartily, but many years earlier he had known her by sight and she had been an object of distant worship. In the days when as a love-sick boy he wintered in Rome after Adèle Domecq's marriage, one of the first signs that his heart was not irretrievably broken had been his mute adoration of a stately blonde—the beautiful Miss Tollemache. For her sake he haunted Roman churches on the occasions of musical festivals, happy if he could get a momentary glimpse of her

through the crowd. When, at last, they met, both were married : he to Euphemia Gray, Miss Tollemache to Mr. William Francis Cowper, a son of Lady Palmerston by her first marriage.

Mr. Cowper was adopted by his step-father, and as heir to his property assumed the name of Temple. He was acting as Palmerston's private secretary when Ruskin made their acquaintance, and one of the firstfruits of the new friendship was an introduction to Palmerston and an invitation to Broadlands, where Palmerston treated him with marked courtesy.

" Egeria " pressed her husband into Ruskin's schemes. When the St. George's Guild became a Company it was the Right Hon. W. F. Cowper-Temple who appeared as co-trustee with Sir Thomas Dyke Acland, brother of Dr. Acland ; both of them cautiously disclaiming responsibility for the manner in which the scheme was worked.

Mrs. Cowper-Temple—so Ruskin says—always had her own way, and thought it fitting that he should do the same. This opinion was probably more to Ruskin's mind than Lady Trevelyan's admonitions to regard life as a " spiritual combat," or Carlyle's sermons on filial contentment. But Lady Trevelyan was not in robust health, and self-effacement was easier to her than to the beautiful " Egeria " whom Ruskin found so distractingly pretty that he kept his eyes on the ground while conversing with her lest he should lose his wits.

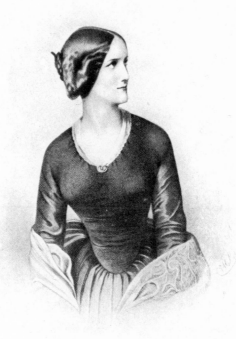

GEORGIANA LADY MOUNT-TEMPLE

Ruskin loved beauty and hated contact with sickness and death, so it was no mean proof of friendship that he was with the Trevelyans on that last sad journey in 1866, when Lady Trevelyan's health was failing so rapidly that they were only able to proceed by easy stages. At Neuchâtel they had to remain, for she could go no farther, and there, on the 13th of May, she died.

CHAPTER XII

UNREST—ROSE LA TOUCHE

MENTAL and spiritual changes, working unseen for years, may suddenly become manifest through some trivial accident; then, in an hour, an unbridged chasm divides the old self from the new. The gathering of a purple orchis during a Sunday walk at Rheinfelden, in the year 1858, seems a trivial thing, but when Ruskin took pencil and paper to draw the flower, he finally broke from Sabbatarianism; completing his severance from the Evangelical party. The repudiation of Calvinism, a natural sequence, did not follow until a few weeks later, when, at Turin, he went into a little roadside chapel to which the few stray Waldensians living in the neighbourhood resorted for worship.

In " Fors " he tells us that the congregation was composed of seventeen or eighteen women " and three louts " : in " Præterita " the total number is given as three- or four-and-twenty, of whom fifteen or sixteen were grey-haired women. This little

handful of Waldensians, their eyes turning to any
stranger in self-righteous questioning—

> "What, you the alien, you have ventured
> To take with us, the elect, your station ?
> A carer for none of it, a Gallio!"—

were there to listen to a preacher who dwelt with
unctuous satisfaction on the sure salvation of his
tiny flock and the equally certain damnation of all
the world outside it. The bare cold chapel, the
long-winded "languid" prayers, the doctrine itself,
must have been familiar to Ruskin from long ex-
perience, but somehow on this occasion the horror
of it came home to him. He left that gloomy chapel
and went out into the warm, kindly sunshine,
converted "inside out" as he puts it. It was not
only the monstrous conception of God as the de-
stroyer of His creatures that repelled him, he
recognised the Puritan's dread of beauty to be a
mistake. Before Veronese's "Queen of Sheba"
he formulated these ideas into a belief that all work
rightly and well done, and all true beauty—whether
appealing to the eye or ear—was of God, and aided
by His Spirit.

But this awakening to wider thought increased
instead of assuaging the doubts and difficulties by
which Ruskin was assailed. He was face to face
with the great problem of human suffering. Pain,
sin, and sorrow—all the accumulated misery of
mankind—weighed him down. He could no longer

drug his consciousness of human woe with pious
reflections that it was God's will ; yet, while re-
pudiating the human conception of God the Avenger,
he was still far from accepting Christ the Consoler.
Ruskin's letters from this time onwards contained
frequent allusions to this vivid realization of the
whole earth groaning in travail, and to the weight
oppressing him because of his belief in man's
mingled responsibility and helplessness.

Ruskin's religious difficulties never took the
form of atheism. His faith in God's existence grew
stronger in times of trouble. He believed that
doubt was a trial of faith sent by God, and that
He was behind all doubt, even when it questioned
His own existence.

Under the circumstances it is not to be won-
dered that Ruskin spent much of his time away
from Denmark Hill. After the close friendship that
had existed between father and son, the former's
pained surprise at all these strange new theories
must have been even more difficult to face than
Mrs. Ruskin's exactions. These were sufficiently
trying. One of the ways by which she showed
her inordinate pride in Ruskin was the habit of
insisting on his most trivial remarks being repeated
to her. So, if she happened to be out of earshot
when he was conversing with a visitor, her im-
perious voice would be heard demanding—

" John ! What was that you said, John Ruskin ? "

A little matter, but surely a sore tax on the

patience of her son. It speaks volumes for his filial reverence that he met these demands upon it with unfailing tolerance and good humour.

Ruskin came back from Italy more despondent than ever, with the cry of the world's pain in his ears, and little interest in life beyond art and the never-failing comfort of the Alps. Even art was not an unmixed pleasure to him now, for this mental and spiritual upheaval altered so many of his earlier views on religious art that he decided not to reprint any of his earlier books unless after careful revision. In a short time he went still farther; declining to reprint any of his art works in order that public attention might be concentrated on his social writings.

But a new influence was coming into his life, bringing him shortlived joy and bitter heartache. By an irony of fate, just as Ruskin had finally abjured Evangelical principles Rose La Touche crossed his path. When he returned to England shortly after that memorable Sunday at Turin, he was asked to give drawing-lessons to three children, two girls and a boy: the younger girl was his " Rosie."

She was Irish, with some French Huguenot blood: a pretty child in her tenth year when Ruskin began to teach her. The La Touches were descended from the Digues de la Touche, Seigneurs of Blois, who were driven to Holland by religious persecutions. The Irish branch of the family issued from

David Digues de la Touche. He came over to Ireland under the banner of William of Orange; remained in Dublin after his regiment was disbanded, and founded the La Touche Bank there. Mrs. La Touche, a very charming and clever woman, was half-sister to the third Earl of Desart. The children came to Denmark Hill for their lessons, under the care of either their mother or the governess, until it was found that perspective and geometry were at a disadvantage where Ruskin's collection of pictures, his minerals, the garden, and the pigs that spoke such excellent Irish, offered so many counter attractions. Ruskin enjoyed these afternoons as much as the children themselves, but when he found their tongues were so much busier than their pencils, he was too conscientious a teacher to allow such waste of time, and thenceforward the lessons were given in their own schoolroom. He was a busy man, but he admits that if he had business in London it somehow always happened to take him past their house; when, by order of the children, he was pledged to visit the nursery.

From the first " Rosie " seems to have been his favourite. She must have been a winsome little girl; her partiality for people she liked being expressed by quaint pet names. Her governess was known as " Bun " because she was " nice " : Ruskin, on the same principle, received the name of " Crumpet "—later, in appreciation of his charity,

it became " St. Crumpet," or, more tersely, St. C.
When the girls had made some progress in drawing
and painting Ruskin gave Rosie lessons in geology :
she learnt enough to find a new name for him, and
he was known as " Archegosaurus."

In 1859 Rose and her family went to live at
Florence. Master and pupil parted with regret
and promised to correspond. Rose's first letter to
Ruskin is given in "Præterita " : the man of forty
treasured this child's letter although he destroyed
hundreds written by the most famous men and
women of their day. It is long, playfully affec-
tionate, observant, and not without a touch of
childish coquetry. He is her " dearest St. Crumpet,"
and she signs herself " ever your rose."

There is one unchildlike remark in this letter :
she wishes so much that he was happy. God can
make him happy, she says—the only phrase fore-
shadowing the Rose of twelve years later. Ruskin
certainly lacked reticence, yet it appears hardly
possible that he should discuss his spiritual and
ethical problems with a child of ten. But later
letters confirm the suspicion that she was entirely
in his confidence as regards these doubts and
difficulties, and met them with childlike faith
and womanly insight. Evidently her nature was
keenly sympathetic at this time, and remained so
until hardened by religious fanaticism.

Disparity of age was no bar to their friendship.
They corresponded regularly while the La Touches

were abroad, and kept up personal intercourse
when at home. Her childish letters to him—all
that survive the holocaust carried out at Brantwood
by Mrs. Severn and Professor C. E. Norton—show
powers of imagination and depth of character
unusual in one so young. Ruskin denied that the
letters were precocious, but he was prejudiced.
Few girls in their early teens would have written
letters so utterly devoid of egotism as those recently
published in the Library Edition of " Præterita."
Rose La Touche evidently possessed all the quali-
fications of an ideal correspondent ; adding to
these a witchery all her own. She was one of
those who, richly dowered by nature, developed
early because doomed to premature decay :
her vital spark burnt itself out when she was
twenty-six.

The La Touches were at their Irish home in
1861, and Ruskin went over there on a visit. Rose
then showed her deeply religious nature, and
talked solemnly when they walked in the woods.
But she was still the playful, affectionate child,
pinning his unread letter into the pocket of her
riding-habit so that it could " talk to her," and
attributing the pony " Swallow's " friskiness to his
glee at having Ruskin's letter to carry. In 1868
Ruskin was in Dublin giving the lecture which, with
the Manchester lectures of 1864, afterwards ap-
peared as " Sesame and Lilies " : dedicated to
Rose La Touche as " φίλη." This must have been

about the time when he took " Paradisaical "
walks with her in " Eden-land "—by the banks of
the little artificial stream running through the
Denmark Hill grounds.

Rosie was a woman now, and in spite of the
difference in their ages Ruskin wished to make
her his wife. His wooing began when she was
eighteen. A probationary period was agreed on ;
her decision being postponed until she was twenty-
one. On Ruskin's side there was evidently a strong
and passionate attachment : he carried one of
her letters constantly about with him, cased
between plates of fine gold. In his letters to
Burne-Jones he called her Proserpine, and in 1865
wrote to him about an appointment for a sitting
(Burne-Jones proposed to paint Ruskin's portrait)
that he would come " Proserpine permitting. Did
you see the gleam of sunshine yesterday afternoon ?
If you had only seen her in it, bareheaded,
between *my* laurels and *my* primrose bank." [1]

On Rosie's side it seems doubtful, however deep
her affection may have been for Ruskin, if passion
had any share in it. She showed no desire to
change the old relationship for a closer tie, and
when at last—in 1873—he asked her to marry him,
she definitely refused on the grounds of religious
differences. She would not yoke herself " with
an unbeliever."

For the third time Ruskin was thwarted in his

[1] " Memorials of Edward Burne-Jones."

love affairs. The man whose teaching came so
near to the Christian ideal of the Sermon on the
Mount was rejected because he refused to pro-
nounce the shibboleth of the Evangelical party.
The Capuchin whose gratitude to Ruskin expressed
itself in the gift of his best-valued relic, a fragment
from the cloak of St. Francis—continuing to urge
its acceptance even when Ruskin, half in sadness,
told him that he was " more a Turk than a Christian
—showed more charity and insight than Rose
La Touche, who had known Ruskin intimately
since her childhood : those wiser days when she
had playfully canonized him as " St. Crumpet."
She could not forgive his sneers at Evangelicals,
nor the way in which he coupled them with
Ritualists as preaching humility without prac-
tising it.

Ruskin moderated his attacks on her religion
but would not conform to it. He described himself
in " Fors " as a Catholic of the Catholics according
to. the Epistle of St. James, but disclaimed any
leaning towards Romanism ; from which he was
as widely separated as from the Evangelicals.
Ruskin was against priestcraft in any form : per-
haps he might have embraced Romanism if he
could have had it with neither Pope nor priest
as intermediary between himself and Heaven. He
went so far as to declare that all beautiful prayers
and all wise interpretations of the Bible were
Catholic. Under the circumstances it is hardly

to be wondered at that Rose La Touche—young,
sincerely pious, at twenty-one the authoress of a
little religious manual—" Clouds of Light "—whose
mind was greatly influenced by the prejudices of
her sect—should have hesitated to marry a man,
old enough to be her father, whose ideas on religion
so widely differed from her own.

Ruskin, who never had sufficient robustness to
bear any severe disappointment without injury
to his health, suffered intensely. He worked with
feverish energy in the hope of deadening thought :
insomnia resulted, alternating with feverish dreams.
His writings altered in tone : his remarks on re-
ligion were softened. The Sacristan's cell at Assisi
was his refuge in 1874, where, amid the semi-
mediæval surroundings of monastic life, he found
a shortlived peace. A dangerous fever seized him
here, and in his sick fancies he thought himself a
brother of the third order of St. Francis. Catholi-
cism undoubtedly had attractions for this renegade
descendant of the old Covenanters.

In the autumn of 1874 Ruskin's troubles were
increased by the news of Rose La Touche's failing
health. He wrote in " Fors " that the woman he
had hoped to make his wife was dying. The
generally accepted story is that he hurried to her
on hearing of her illness, that she refused to see him,
and died obdurate because he would not say that he
loved God better than herself. This is denied.
The version now given to the public restores our

faith in the old Rose, faithful and affectionate, since
it tells us that he not only saw her but was allowed
the consolation of being with her to the last. She
died in May of 1875. Can one say unhappily, since
she was spared the sad knowledge that the mental
powers of her master were failing and his days of
useful work numbered ?

Even now signs were not wanting of mental
disturbance. His writings were becoming dis-
cursive, and in the winter of 1875 his craving for
some assurance of a future life led him to spiritualism.
He attended séances, and believed he had been
shown Rosie's spirit by a medium. A strain of
mysticism showed itself. Carpaccio's " St. Ursula,"
long a favourite picture of his, became almost an
obsession. He carried a photograph of it always
about with him, and made the legendary and fancied
excellences of the sainted princess a standard by
which he judged women. Gradually the picture
acquired almost a living presence. On Christmas
Day, 1876, he had a sudden attack of dangerous
illness ; during this, memories of St. Ursula and
Rose La Touche passed through his disordered
brain until the personalities of his dead love and the
pictured saint became inextricably blended. Rose
now appeared to him as St. Ursula : he became a
happier man because it seemed an augury of a
future life. While Rosie was still alive he had
written to Miss Beever, pettishly flouting the idea
of any happiness to be obtained by a reunion with

his love in heaven. He told her that a talk with
Pythagoras, Socrates, and Valerius Publicola would
be more to his mind there. He wanted Rosie in
this life, not the next. But death altered the
relative values of Pythagoras and Rosie.

CHAPTER XIII

THE SLADE PROFESSORSHIP—HENRY WENTWORTH ACLAND

THE crowd that assembled in the Taylorian on 8th February 1870, to hear Ruskin's first lecture as Slade Professor of Fine Arts, gave evidence to his popularity and the widespread desire to see and hear him. Long before the appointed time the lecture room was packed with a heterogeneous crowd in which grave and reverend heads of colleges and fashionably dressed ladies mingled with the undergraduates for whom the lectures were intended. Others, unable to gain an entrance, stood outside.

A hasty consultation was held. It was decided to hold the lecture in a larger room. Dr. Acland elbowed his way through the audience to the lecturer's table, and announced that Mr. Ruskin would give his lecture in the Sheldonian Theatre. Such unusual enthusiasm over a professor's lecture was a compliment Ruskin appreciated, yet not without misgivings on account of the number of ladies present. By a common failing of human nature, Ruskin valued least what he most excelled in. He took

his mission as a teacher very seriously, though his opinions on Art were sometimes open to controversy, his politics contradictory, and his science unscientific. But although he might be fallible on these points, the prose in which the thoughts were expressed never fell short of perfection. And because Ruskin suspected that these ladies came from a desire to hear his fine-sounding phrases rather than as true disciples, also since his lectures were supposed to be for members of the University only, his usual pleasure in their society was lacking.

Dr. Acland, Regius Professor of Medicine since 1857, had for years been trying to get Ruskin some appointment at Oxford which would give professorial influence and bring him into personal contact with the undergraduates. Acland wished for a wider course of study : one that would ensure a liberal education by giving less exclusive devotion to classics and theology, and allow due honour to literature, history, philosophy, and art. Ruskin was entirely of the same opinion as far as art and literature were concerned. Not so with regard to Acland's inclusion in the scheme of reformation of a proposed medical and scientific school, where young men intended for the medical profession could acquire special knowledge while enjoying all the advantages of a University education.

But Acland was wide-minded enough to disregard Ruskin's unappreciative attitude towards science in view of his undoubted value as an æsthetic and

moral teacher. The first attempt to find him a post in Oxford was made when the Professorship of Poetry became vacant. Acland at once suggested that Ruskin should fill the Chair. This failing, he thought that a Curatorship of the University Art Galleries would be an appropriate post. There was no vacancy, but Acland was himself a Curator, and offered to resign in Ruskin's favour ; an act of self-sacrifice which the latter declined to accept. This was in 1867.

Under the will of Mr. Felix Slade, a Chair of Fine Arts was founded and endowed in 1869—to be called the Slade Professorship. This was just the post for Ruskin. It was offered to him, and accepted. Ruskin threw himself, *con amore*, into the work of his new appointment ; taking up his quarters in Oxford under Acland's hospitable roof in Broad Street. Here he lived during his months of residence in Oxford from February 1870 to April 1871 ; when he moved to rooms in Corpus, to which he had become entitled by election to an honorary fellowship of the college.

The Acland healthy family life, so different from that of the quiet self-centred Ruskin household, grouped itself round gentle Mrs. Acland, whose motherly heart was big enough to contain not only her own family of seven sons and a daughter, but gathered in Ruskin, her husband's pupils, and who would of the lonely, sick and sad, around her. Ruskin's best and truest ideals of womanhood,

and especially wifehood, must owe much to Mrs. Acland.

The Acland Sundays were far different to the gloomy Herne Hill ones that had aroused his boyish hatred. Dr. Acland was a sound Churchman, but his Sunday duties did not end with church. It was no day of rest to him or his wife : their labour was that of love. The afternoons were devoted to little chimney-sweeps, whose hard lot had excited their pity. These met in Dr. Acland's garden during the summer, and in winter indoors with a good fire to cheer them. All the year round they were sure of a well-supplied tea-table, and Mrs. Acland's sympathy. She read to them, talked with them, encouraged them to tell her their troubles, and by every means in her power tried to counteract the brutalizing nature of their calling.

It was the undergraduates' turn in the evening. The University system brings together a large number of young men at an age when the safeguard and refining influence of home-life is most essential. Mrs. Acland did what she could to supply that want by encouraging them to come to Broad Street, where she held open house for undergraduates on Sunday evenings from eight to eleven. These hours were devoted to quiet talk, music, and singing. In order to avoid formality and make them feel at home, Mrs. Acland made one stipulation—no evening dress. At ten o'clock the servants came into the room for prayers and a hymn. Cakes, biscuits, milk, seltzer-

water, and lemonade were provided in the little drawing-room, and at eleven o'clock her guests left.

Besides these regular Sunday gatherings, their life was so bound up with that of the University and town that the house was seldom empty. People who wished to see the Regius Professor " dropped in " at meal-times ; patients called to see him ; during the medical examinations—when, according to the Acland custom, all the examiners were invited to put up at Broad Street—the house overflowed, and some of their guests had to be provided with bedrooms outside. Dr. Pusey, Liddell, Dean of Christ Church, and Jowett, were on terms of intimate friendship there, and visitors to Oxford of every nationality met under the roof of the Regius Professor of Medicine.

Nor was this all. Professor Acland's interest in his students did not end when they left his lecture room. He often arrived home with an overworked or ailing undergraduate in his carriage, and would hand him over to Mrs. Acland with the remark— " Wifie, I have brought So-and-so—he is very unwell and needs your care." [1] Yet, in spite of all this coming and going, the life of the household was so free from restraint that Ruskin, with his room to retire to—looking out on a blank brick wall and with nothing but chimney-pots to divert his attention—always declared that he could write undisturbed in that house.

[1] " Sir Henry Wentworth Acland," by J. B. Atlay.

These Oxford years were among the most strenuous of Ruskin's busy life. His lectures made considerable calls upon his time and thought—not so much in their delivery as in the preparation for them. He said it sometimes took him a week to think of what could be said in a minute, and with his customary thoroughness the prescribed number of lectures was only a starting-point for much outside and voluntary teaching. He published in rapid succession books on art, social economy, botany, and geology—not to mention guide-books and catalogues. All the organising work of the St. George's Guild was his; he planned out a library of standard literature for its members. " Fors Clavigera " appeared at irregular intervals as his health failed, but it was intended to be a monthly, and gave him much work—with no thanks, as he complained in the letter dated 7th November 1872, wherein he says he will no longer call his readers " friends." He founded and arranged the Sheffield Museum, helped Acland with the Oxford Museum, ran a tea-shop on uncommercial lines, took a practical interest in the housing of the working-classes, and wrote frequent letters to the Press. His private correspondence was enormously heavy : to some of his friends he wrote almost daily. This incessant work must have told on a strong man : taking into consideration his delicate health, and the private sorrows and bereavements that undoubtedly lowered his vitality, can it be wondered that Nature rebelled

and sent the poor tired brain wandering in
" Medea's land " ?

He had a severe illness at Matlock in 1871, but
even then was not unmindful of his Oxford work.
All along he had felt dissatisfied with the Kensington
art teaching, and wished to found an independent
Mastership of Drawing in connection with the
Slade Professorship. Permission to have a Master
of Drawing was obtained, and Ruskin's next step
was to endow the post. He wrote a cheque for
£5,000 and put it under his pillow. When Dr.
Acland, hearing of his friend's serious illness, went
to Matlock, Ruskin surprised and embarrassed
him by handing over the cheque with the explana-
tion, " There, Henry, that's to endow the Master."
All suggestions that the matter should be left until
his recovery were scouted, so Dr. Acland had to
take the cheque and invest it in the name of trustees.

If his class came to the Slade Professor to study
art, they could not very well help learning much
besides on various subjects which—to any one but
Ruskin—would appear quite outside his province.
Art sometimes formed but a small portion of the
lecture when Ruskin let loose his eloquence upon
some social evil, or aimed a Parthian dart at Dar-
winism. Such, for instance, was his lecture on
" The Story of the Halcyon," afterwards published
in " The Eagle's Nest." The doctrine of Evolution
irritated Ruskin beyond measure. Was there still
a shrinking from any school of thought that could

not be reconciled with a belief in the verbal inspiration of the Bible, in spite of his long-standing agnosticism ? or was it only the poet's soul shrinking from materialist unveiling of Nature's secrets ? The study of anatomy was also written in his list of things anathema : he railed at it as destructive to art, a degradation as far as the human form was concerned, and a hindrance in painting animals. But it was on Darwinism that he spent himself in choicest invective and withering sarcasm. It taught, so he averred, that it was an act of disrespect to your ancestors if you washed slugs out of a lettuce.

Yet Ruskin's pupils learnt more from him than to scoff at Darwinism and keep clear of anatomy. His lectures were as a trumpet-call to the youth of the University, bidding them to be up and doing in the service of humanity. He pointed out to these future squires and landowners their responsibilities to the tenantry and labourers on their estates. He told them that contentment, pure air, pleasant surroundings, and freedom from grinding mechanical work were essentials in the life of its people if a nation was to produce great art. They were taught the dignity of honest work : he bade them devote some portion of their leisure to sweeten the lot of the poor and helpless. Their enthusiasm quickened at his appeal. There was a bad-surfaced piece on the Hincksey road : no one's business to keep it repaired. Ruskin took lessons in road-mending, bought picks and stone-

breaking hammers, and scandalised Oxford enjoyed
a nine days' wonder over the unaccustomed spectacle
of the Slade Professor and some muscular under-
graduates, with David Downes, the gardener at
Denmark Hill, as foreman, doing navvies' work
on the Hincksey road.

The last thirty years has seen such radical changes
in public opinion, that it is now difficult to under-
stand why such an outcry should have been made
because a few young men spent the time usually
devoted to recreation in handling pick and shovel.
The Oxford Mrs. Grundy of 1874 was zealous for
the University's reputation, jeopardised by such
extraordinary conduct, and relieved her feelings
in letters to the Press. Dr. Acland, broad-minded,
and a knight-errant himself—as witness his labours
during the Oxford cholera epidemic of 1849, when
he and Professor Max Müller devoted themselves
to stamping out the disease, and in 1854, when
he did yeoman's service for the town as Consulting
Physician to the Oxford Board of Health, refusing
remuneration—was indignant at the pettiness
and misrepresentations contained in these letters,
and wrote to the *Times* in defence of Ruskin and
his disciples :—

" OXFORD, *May* 19, 1874.

" SIR,—

" An Oxford correspondent has addressed to
one of your evening contemporaries an attack on

the Undergraduates who have been induced by
Mr. Ruskin to take to ' digging at Hincksey.' Will
you allow a few lines' space to another Oxford
correspondent who feels sure that neither Mr.
Ruskin, who is now in Italy, nor the students
who get their daily exercise at Hincksey, will notice
the sneers. Surely in an age of Liberty and of
Philanthropy, well-meaning men might be allowed
to mend the muddy approaches of some humble
dwellings of the poor without being held up to
the public as persons meet only for the neighbouring
Asylum. Is it so, that the principles on which
Mr. Ruskin and these youths are acting are insane ?

" Mr. Ruskin, a man of no narrow sympathies,
has known Oxford for forty years. He is as inter-
ested in the greatness of the educated youth of
England as he is in the well-doing of the poor.
He is loved by both. To the high-spirited youth
of Oxford he has said, ' Will, then, none of you
out of your abundance, the abundance of your
strength and of your leisure, do anything for the
poor ? The poor ye have always with you. Drain
a single cottage ; repair a single village by-way ;
make good a single garden wall ; make pleasant
with flowers one widow's plot, and your muscles
will be more strong and your hearts more light
than had all your leisure hours been spent in costly
games, or yet more hurtful amusements.' Is he
wrong ? Are the hearty kindly men who obeyed
him wrong ? Are they likely to be worse English-

men for their pleasant love of a respected teacher, and their cheery, almost playful help to agricultural labourers ? Will society be worse that a body of steady students with a kindly enthusiasm left their wonted games to lessen the sadness of the world and make bright some English cottage homes ? To say nothing of the good of humane and hearty occupation to the men themselves, are we sure that some men such as these when wisely directed will not be among the best safeguards in the heaving restless social fabric of modern life ? Is Mr. Ruskin impractical in thus harmlessly evoking the sympathies and energies of the unspoiled minds about him ?

<div style="text-align: right">

" Your obedient servant,

" HENRY W. ACLAND." [1]

</div>

A fortnight after this letter had appeared, Dr. Acland's lead was followed by *Punch*, in the issue dated 6th June 1874, with the following verses (reproduced by kind permission of the proprietors of *Punch*) :—

"HINCKSEY DIGGINGS

"ACLAND writes to defend JOHN RUSKIN,
 Who an undergraduate team hath made, ·
 For once, from May-term morn to dusk, in
 Hincksey soil to set working spade.

[1] "Sir Henry Wentworth Acland," by J. B. Atlay. (Reprinted from the *Times* by kind permission of the Proprietors.)

So very Utopian ! . . . so Quixotic !
Such is the euphemistic phrase,
Equivalent to idiotic,
For Athletes guided to useful ways.

" 'Tis well for snarlers analytic,
 Who the art of the snarl to the sneer have brought,
 To spit their scorn at the eloquent critic,
 Leader of undergraduate thought.
 Heart of the student it will not harden
 If from the bat and the oar he abstain,
 To plant the flowers in a cottage garden,
 And lay the pipes of a cottage drain.

" Why should not sympathy rise above zero ?
 Our ' young barbarians,' toiling thus,
 May bethink them how the unwearied hero
 ODYSSEUS taunted EURYMACHUS :
 ' Give me a yoke of oxen thorough,
 And a keen plough that can cut its way,
 And see who will drive the longest furrow,
 From morn to eve of a summer day.'

" Pity we have for the man who thinks he
 Proves RUSKIN fool for work like this.
 Why shouldn't young Oxford lend hands to Hincksey,
 Though Doctrinaires may take it amiss ?
 Careless wholly of critic's menace,
 Scholars of RUSKIN, to him be true ;
 The truths he has writ in ' The Stones of Venice, '
 May be taught by the Stones of Hincksey too."

The Hincksey people had a dry smooth road,
and Ruskin vindicated his claim to be a practical
social reformer—if, indeed, there had ever been
any doubt on the matter. Wild and chimerical as

some of his schemes might be, no one for a moment doubted the honesty of his teaching, or of his willingness to act on the advice he gave.

Once a week during term-time Ruskin had breakfasts at his rooms in Corpus, open to any of his disciples who cared to attend. One of these was W. H. Mallock. Ruskin said of Mallock that he was the only man who really understood him. Judging by the rather unsatisfactory portrait of Ruskin as " Mr. Herbert " in " The New Republic," this seems doubtful. But Ruskin's character is so baffling that a failure to catch one out of its many phases is pardonable. Arnold Toynbee was another of Ruskin's pupils, and his work in the East End was in a great measure based on Ruskin's teaching. E. T. Cook, the editor of the complete edition of Ruskin's works, and W. G. Collingwood, Ruskin's biographer, were also among them.

Ruskin's lectures continued to be well attended. On 1st December 1877 an audience of six hundred, two-thirds of them members of the University, attended to hear the last lecture for that term—the room full and the door wedged open by those outside who were unable to gain an entrance.

Changes were affecting both his public and private life in Oxford. Mrs. Acland was pining away, dying of the shock she had sustained in the death of her son Herbert in the early summer of 1877. She died in October of 1878, and Ruskin lost another of the good women who had "mothered"

him. Another change was to touch him in one of his vulnerable spots—vivisection. The Oxford Museum had been a hobby of Acland's. Ruskin also had taken great interest in its building and arrangements : he is said to have built one of the brick pillars with his own hands. The story goes, though, that the workmen had to take it down again and rebuild it. A window of his designing was more practical, and still remains. This Museum was, so Ruskin said, the first building in England since the end of the fifteenth century in which the workman had gone to nature for his designs and carried them out unaided.

But Acland's aims went farther than Ruskin's and took a professional bent. He was ambitious to found a Medical School at Oxford, and used all his influence to that intent. At last it appeared as if his wish was to be realized. A new Chair was founded in 1877 by the University Commissioners, to be called the Waynflete Professorship of Physiology. It was charged on the revenues of Magdalen College. At Dr. Acland's persuasion Dr. (afterwards Sir John) Burdon-Sanderson, then Professor of Human Physiology at University College, London, and at the head of his profession as regards that branch of science, accepted the post. He was elected in November 1882. No provision had been made for appliances, and it was found that the accommodation for properly teaching physiology was insufficient. Convocation voted £1,500 for

instruments and apparatus in February 1883.
On 29th May of the same year, due notice was
given that money was required for building pur-
poses, and of an intention to ask Convocation for
authority to expend a sum not exceeding £10,000
in the erection of a Laboratory, Working Rooms,
and a Lecture Room for the Waynflete Professor of
Physiology. Fixtures, warming apparatus, and gas
were also applied for. This notice was met with
considerable opposition, not only from those
who thought the expenditure large and unjustified
or were opposed to the Museum, but also because
Dr. Burdon-Sanderson was licensed under the
Vivisection Act of 1876, and had been a witness
before the Royal Commission on Vivisection.

The decree was submitted on 5th June. Acland
took a prominent part in the debate. He stated
his conviction that experiments on living animals
had resulted in great benefit to mankind, and
expressed his confidence in the humanity of those
who practised vivisection—instancing Brodie as a
type of combined great intellectual power and a
tender gentle nature. But while cruel experiments
might be justifiable, he objected to needless repeti-
tion of them. " Vivisection," he reminded Con-
vocation, " played only a small part in physiological
inquiry." Dr. Burdon-Sanderson attempted to
assuage the storm by announcing that he did not
intend the students to make experiments involving
vivisection ; but as he declined to bind himself to

discontinue using animals for his private investiga-
tions, the anti-vivisectionists were not satisfied.
Out of a house of 173 there were 85 non-placets ;
the decree being carried by a majority of three.

Organization of the Anti-vivisection party fol-
lowed. A memorial to the Hebdomadal Council
asked for the adoption of the following decree :
" That without further order of the University,
buildings and appliances provided by the University
be not used for the performance or exhibition of
experiments involving pain to animals, or of any
operations on domestic animals." One hundred
resident members of Convocation and about forty
non-residents signed the petition accompanying this
decree. Dr. Burdon-Sanderson declined to bind
himself to refrain from " operations on domestic
animals," although he expressed willingness to
agree with the clause forbidding " exhibition of
experiments involving pain to animals." The
memorial was rejected.

But the Waynflete Professor was not yet out
of the wood. In order to raise the £10,000 voted
by Convocation on 5th June, stock had to be sold.
This was standing in the names of the Land Com-
missioners : it having been bought with the money
derived from the sale of lands formerly held in
trust for the Bodleian. A decree of Convocation
was required, and the date was fixed for 5th Feb-
ruary 1884. An appeal was issued to non-resident
members asking them to attend and non-placet the

decree. This pamphlet of ten pages was entitled
" Vivisection in Oxford," and contained copious
extracts relating to Dr. Burdon-Sanderson from
the Report of the Royal Commission.

Acland threw himself into the fray with char-
acteristic ardour. He wrote to the *Times*, begging
members of Convocation to attend and defeat
this attempt to reverse the June decree, as the
success of the agitators would be prejudicial to
the interests of education in the University, as
well as unjust to the distinguished Professor. The
eventful morning came. The Sheldonian Theatre
was crowded. An excited debate ensued, in which
Professor Freeman expressed his dislike to estab-
lishing a " chamber of horrors " in Oxford. Acland
tried to allay the storm by announcing that Dr.
Burdon-Sanderson had written to the Home Office
stating that he did not propose to apply for the
special license needed if experiments were used at
his lectures. But as Regius Professor of Medicine,
Acland insisted on the importance of the researches
on which the vivisectionists had been engaged.
After heated argument the placets scored a victory
with 188 votes, the non-placets having 147.

Nothing daunted, the anti-vivisectionists came
upon the scene again in March 1884, when an
annual grant of £500 for coal, gas, water, and the
general expenses of the Laboratory, was asked
from Convocation. This produced a memorial,
amongst the signatures to which was that of Ruskin,

calling on members of Convocation to refuse sanction to " the performance of physiological experiments on living animals, commonly, but inadequately, described as vivisection." This by reason of a fear that Dr. Burdon-Sanderson's promise to refrain from experiments would not be binding on his successors.

Another memorial from the opposite side followed, laying stress on the precautions taken to prevent the use of objectionable experiments, and calling attention to the impossibility of founding a Medical School in Oxford if the decree was rejected. Among the names appended to it was that of Henry W. Acland.

Again a crowded house met in the Sheldonian ; again Acland's voice was raised on behalf of Medical Science. His vigorous protest against those who had taken " the responsibility of checking the advance of medical knowledge, and the chance of alleviating the suffering of mankind," carried the day. By 412 placets against 214 non-placets the decree was carried, the Laboratory secured its allowance—and Ruskin resigned the Slade Professorship.

Acland and Ruskin belonged to opposite camps, and the fight had been a bitter one, but it is a proof of their mutual respect and affection that their friendship stood the test. Ruskin's approaching brain trouble made frequent intercourse in the future impossible, but the kindly feeling remained.

When Gladstone, in 1892, had to appoint a new
Laureate, it was to Acland that he applied for
information as to the probability of Ruskin being
able to act if he were appointed. The reply was
a foregone conclusion—Ruskin's working days were
over.

The following year (1893) Miss Acland took Sir
Henry—he had been created a baronet in 1890—
to Brantwood. Ruskin was then in his seventy-
fifth year ; Sir Henry seventy-eight. Considerably
more than fifty years had passed since the elder
man came to the rescue of the younger at Christ
Church : several more years of life lay before them,
but this was their last meeting. Sir Henry survived
his friend by a few months and died on 16th October
1900.

CHAPTER XIV

ST. GEORGE'S GUILD

WITH his mind fed from boyhood on Scott, Ruskin's ideal State quite naturally moulded itself on mediæval lines. Strangely enough, the craft and violence of the middle ages never seem to have impressed him. He saw only one side of the shield, and that mirrored a peaceful, happy country, where the cottages clustered round the castle for protection ; where the cessation of toil brought innocent enjoyment—a contented peasantry dancing round the maypole, or sitting round the fire while some wandering harper told his tale. In his ideal the castle had no dungeons : the cowering peasants never watched sullenly from disease and famine-haunted hovels while their lord rode out to the chase, trampling down their crops, which had already paid heavy toll to the pigeons from his cote. Luckily, Ruskin was an idealist : with all his denunciations of human folly and selfishness he retained an undying belief in man's potentialities. Prompted by this childlike faith, he gathered all that was good and noble

from laws made during the best periods of the world's history—the ages when art and civic life were purest and noblest—moulding them into the laws of his modern Utopia, the Guild of St. George.

Ruskin's greatest poem is in prose, and its subject is his dream of an ideal State. Only a poet could have imagined it ; perhaps we may also say only a madman would have tried to put it into practice. And yet, if Ruskin's scheme was madness, it was more deserving of admiration than the sanity of many reformers. He threw a medley of Græco-Florentine-Early English civic laws into the crucible of his brain, and transmuted them into an ideal which is almost identical with the ethics of the Sermon on the Mount.

Other philosophers have attempted to revolutionise society, and have found intellectual satisfaction from the contemplation of an ideal State, but to Ruskin belongs the credit of putting his ideas into practice at the cost of a large proportion of his wealth.

Ruskin's thoughts were directed towards social evils many years before he attempted a cure for them. His first impulse in the direction of reform dated from 1849, when the hardships endured by the Alpine peasant aroused his sympathy. Active political work did not begin until 1860, and then fourteen or fifteen years of theoretical work—writing and lecturing—preceded his practical effort to cope with social problems, the inauguration of

St. George's Guild in 1875. During all these years, although his ideas developed and became modified by a natural evolution, the basis of his teaching in " Fors Clavigera," his final word in political economy, only repeats the keynote of " Unto This Last " : " THERE IS NO WEALTH BUT LIFE." That nation alone was wealthy whose people led happy, healthy, contented lives. Looking round him he saw poverty, dirt, disease, and discontent ; a gulf ever widening between rich and poor ; the decay of agriculture ; the rise of overcrowded manufacturing towns. His answer to all these evils was the establishment of St. George's Guild.

But Ruskin was not a practical man—we cannot expect more of our idealists than a standard to aim at—so while he had an unerring instinct for the symptoms of national decay, his judgment was often warped by prejudice when it came to determining the cause, while the remedies he suggested were unpractical and impossible of realization under modern conditions of life.

The Guild aimed at establishing higher ideals for everyday life, and cultivating in the individual a sense of responsibility towards all the rest of the community. Each was to obey literally the great commandment—to love his neighbour as himself. The upper classes were told to simplify their lives and prepare themselves to act as wise leaders of their inferiors ; the lower classes, to strive for conditions of greater refinement in their homes without

seeking to leave the class to which they belonged by birth and education. Above all the Guild was intended to strike a blow at the modern systems of centralization and over-specialization of labour. Town life was to be avoided as much as possible, and country life fostered by setting the unemployed to reclaim waste lands. As for machine labour, the cause-in-chief of both the draining of the country-side into cities and over-specialized labour, it was forbidden to the members of the Guild except under certain conditions.

The organization of the Guild had a flavour of the knightly-monastic orders about it. At the head was the " Master," Ruskin himself, who kept the " Roll " of the Guild at his rooms in Corpus. It was written—O ye collectors ! heed, and mark the sacrilege !—on the blank leaves of an eleventh-century manuscript of the Gospels. The Master was a " Tyrant," but not a " Despot " : he exercised kingship for the benefit of the State.

Next came the " Companions," chosen from the ranks of the rich and strong, who were to form a band of delivering knights : these were divided into three classes, which were, in order of rank :—

First, the " Comites Ministrantes," whose private affairs must always be held subordinate to the interests of the Guild, and who were bound to devote their best energies to furthering its work. Next came the " Comites Militantes," whose time was devoted to manual labour, on the land or otherwise,

as directed by the " Master." Lastly there were the " Comites Consilii," who formed the main body of the Guild, and who continued their own work as in times past, but were subject to the orders of the " Master " and gave a tithe of their income to the Guild. All alike shared in the common property of the Guild, and had the right of a vote in electing or deposing the " Master." It was proposed to add " Bishops," with jurisdiction over a fixed number of families, but this did not take form.

All the members of the Guild were required to subscribe to a creed of eight articles :—

CREED OF ST. GEORGE'S GUILD

" I.—I trust in the Living God, Father Almighty, Maker of Heaven and Earth, and of all things and creatures, visible and invisible. I trust in the kindness of His law, and the goodness of His work. And I will strive to love Him and to keep His law, and to see His work while I live.

" II.—I trust in the nobleness of human nature, in the majesty of its faculties, the fulness of its mercy, and the joy of its love. And I will strive to love my neighbour as myself, and, even when I cannot, I will act as if I did.

" III.—I will labour, with such strength and opportunity as God gives me, for my own daily bread ; and all that my hand finds to do, I will do it with my might.

" IV.—I will not deceive, or cause to be deceived, any human being for my gain or pleasure ; nor hurt, nor cause to be hurt, any human being for my gain or pleasure ; nor rob, nor cause to be robbed, any human being for my gain or pleasure.

" V.—I will not kill nor hurt any living creature needlessly, nor destroy any beautiful thing ; but will strive to save and to comfort all gentle life, and guard and perfect all natural beauty upon the earth.

" VI.—I will strive to raise my own body and soul daily into higher powers of duty and happiness ; not in rivalship or contention with others, but for the help, delight, and honour of others, and for the joy and peace of my own life.

"VII.—I will obey all the laws of my country faithfully ; and the orders of its monarch, so far as such laws and commands are consistent with what I suppose to be the law of God ; and when they are not so, or seem in any wise to need change, I will oppose them loyally and deliberately—not with malicious, concealed, or disorderly violence.

" VIII.—And with the same faithfulness, and under the limits of the same obedience, which I render to the laws of my country, and the commands of its rulers, I will obey the laws of the Society called of St. George, into which I am this day received, and the orders of its masters, and of all persons appointed to be in authority under its masters, so long as I remain a companion, called of St. George."

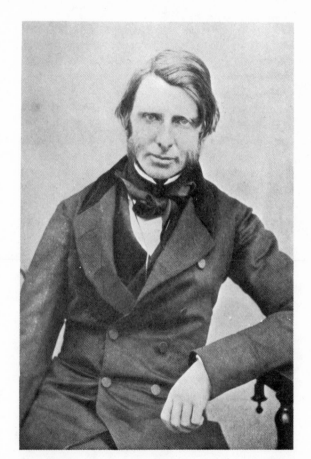

JOHN RUSKIN

It is a creed of noble ideals, and one that would make the world a very different place to live in if men accepted and acted up to it. Only a great-hearted, wise-minded man could have formulated such laws. And Ruskin did more than compile them ; he tried to live up to their level. But what chance had Ruskin's rules of life when nineteen hundred years of Christianity have borne so little fruit that our love for our neighbour is only on our lips, and life is a struggle in which the weakest goes to the wall—an inferno in which men push each other into the mire and climb to wealth and honour over the bodies of their fellow-men ? There is nothing new in the provisions of St. George's articles of faith. They express the aspirations of man at his best in many ages and lands : the instinct for good which is the most reliable proof of man's creation in the image of Infinite Goodness, and our best hope that at last we may rise to the height of ideals we can now only admire without comprehending.

Ruskin found his model in the Free Italian towns of the thirteenth century, when their civilization and prosperity formed such a contrast to the barbarism and poverty of the rest of Europe. In the midst of all the strife resulting from the quarrels and jealousies of noble families, the free towns throve and waxed rich under the wise government of their magistrates. In the open country round these towns the peasantry, a hardy, active, and

industrious race, tilled the ground with so much
care and skill, protecting it from floods by dikes, and
from drought by canals, that the districts they culti-
vated are still distinguishable by traces of scientific
agriculture from neighbouring lands held by vassals
of the feudal nobles. The townsmen owned the
land, paid the land tax, and advanced capital to the
agriculturists ; sharing, in return, in the harvest.
The peasants under their protection dwelt in peace ;
displaying boldly by their dress, cattle, and imple-
ments of husbandry the wealth they possessed,
without fear of exciting the rapacity of their
neighbours. In the towns were fine public buildings,
well-paved streets, comfortable homes, and beautiful
works of art : all surrounded by thick walls and
towers for defence. The signorie ruled with paternal
firmness ; patriotism, the idea of collective action
for the commonweal, had all the force of a religious
principle. Such were Pisa, Florence, and Venice
at the zenith of their power. Their laws were
framed with the same idea—that the magistrates
were responsible for the bodily welfare of the
citizens.

A most excellent model on which to frame a
modern Utopia ; but Ruskin seems, strangely enough,
to have overlooked the fact that the power of these
free cities as well as their wealth was derived from
trade. Their rulers were merchant princes, and the
fall of Pisa came about when, after a war with
Genoa, she gave supreme power to a fighting noble,

Ugolino, who betrayed her fortresses to the Lucchese
and Florentines. The prosperity of the Italian
cities was founded on trade; and usury, Ruskin's
bugbear, filled their coffers. The merchants of
Tuscany and Lombardy travelled far and wide,
lending money on interest to impoverished nobles,
taking their jewels in pawn—as witness the three
balls that hang before our pawnbrokers' shops to
this day. Sismondi says in his "History of the
Italian Republics": "Industry, the employment
of a superabundant capital, the application of
mechanism and science to the production of wealth,
secured the Italians a sort of monopoly through
Europe: they alone offered for sale what all the
rich desired to buy; and, notwithstanding the
various oppressions of the barbarian kings, not-
withstanding the losses occasioned by their own
often-repeated revolutions, their wealth was rapidly
renewed. The wages of workmen, the interest of
capital, and the profit of trade, rose simultaneously,
while every one gained much and spent little;
manners were still simple, luxury was unknown,
and the future was not forestalled by accumulated
debt."

This seems to leave little doubt that the free
cities made use of all the improvements in labour
that came to their hands, and would certainly have
adopted machinery if it had been available. Their
real strength seems to have depended on their
frugality and co-operation for the public welfare

and safety. Success in commerce, and commerce only, gave these cities power to protect the peasants living in the *contado*, or open country, round the city walls.

Florence was governed by the corporation of trades, or *arti*. From the trades six representatives were chosen, *priori delle arti*, to represent the Republic. They were elected for two months, and lived together : these formed the *signoria*. In 1292 a gonfaloner of justice was placed at the head of the signoria. His duty was to display the gonfalon, or standard, round which the citizens were bound to rally when the law required their assistance. One of the first demands he made for civic help was against the nobles, whose arrogance and street brawls disturbed the peaceful citizens. In this year thirty-seven Guelph families were declared by the signoria to be noble and great ; for this reason they were proclaimed incapable of holding office as members of the signoria, and, at the same time, were refused the privilege of renouncing their nobility. Nor was this all : any other disturbers of the public peace were ennobled as a punishment ! This questionable honour added them to the list of persons disqualified for public office. Gilbertian as this punishment appears, it was found so satis-factory in working that Sienna, Pistoia, and Lucca adopted the same plan.

Ruskin, sprung from, and contemptuous of, the merchant class, with ideas of nobility founded

on romance, either failed to recognise or deliberately ignored the enormous constructive and conservative social power wielded by the great middle-class in all ages. He looked on this useful section of society as composed of usurious merchants and litigious lawyers, battening on the peasantry and workmen. In his movement for regenerating society he placed all his reliance on the upper classes ; inspired by a vision of the potentiality in English squiredom if the landed gentry acted up to the duties of their position, resided on their estates, and set an example of regular and temperate living to their tenantry.

The obligatory tithe of the members' incomes was, in the first instance, to be devoted to purchasing land, which was to be cultivated by the agricultural members, who paid rent for it to the Guild. Back to the Land ! was Ruskin's warning cry, anticipating by a generation the demand of the present day. He was almost alone then in his belief that the rapid growth of manufacturing towns, and consequent draining from the country of youth and strength to fill the places of exhausted workers, was a grave national danger. Where other people saw wealth in the ceaseless activity of mills and mines, he foretold national downfall as an inevitable result of the enfeebled physique of the workers, the stunted growth of the children : physical weakness and moral degeneracy going hand in hand. " *There is no Wealth but* LIFE."

Actuated by this belief, Ruskin's main effort
was directed towards promoting agricultural settle-
ments, and in his method of dealing with them he
touched on most of the problems that are baffling
us to-day. Fixity of tenure was one of the in-
ducements offered to St. George's settlers ; and
instead of, as is our enlightened custom, raising
rent and rating where improvements had been
made by the tenant, the rent was to be proportion-
ately lowered : offering a direct inducement to
use the land to the best advantage. All rents
collected from St. George's land, calculated upon
the basis of a tithe of the produce, were paid into
a common fund, and used for the benefit of the
Guild's land where most required : an admirable
way of equalising rich and barren land. This,
Ruskin taught, was the only just application of
rent, which if diverted to other purposes became
" the fatalest form of usury." [1]

The St. George settlers had to pass a probationary
year on the land without a lease, and if during
that period their behaviour and management of
the land satisfied the officials, a three years' lease
was granted. This second period ended, and the
tenant's conduct being still satisfactory, a life
lease was allowed, with power to purchase the
land outright if desired.

On St. George's lands no machinery was to
be used where hand labour would suffice. Ruskin

[1] " Fors Clavigera," vol. iv. p. 281.

had an intense hatred of machinery in any form, and while he did not actually forbid the use of it he restricted it to absolutely necessary forms. Where hand labour could not well be used, as in grinding corn, the natural powers of wind and water were permissible; but steam was only to be resorted to when neither hand labour, wind, nor water could be used. Ruskin's objection to steam was more than mere prejudice. He saw no gain in quickened processes which led to over-production, and this in its turn to glutted markets and paralysed trade.

In addition to the purchase of land the Guild was empowered to purchase mills and factories from its funds ; to be worked by members of the Guild under the healthiest and happiest possible conditions, at a fair wage. In these cases recreation and instruction for the employés were to be provided by the Guild, and, needless to say, steam was only to be resorted to when water-power could not be obtained. So far as the conditions affecting the workpeople are concerned, several large firms now work on a system closely modelled on that of St. George's Guild ; enjoying a success that justifies other employers in following their example.

All mills and factories owned by the Guild were to be conducted in strict accordance with St. George's laws. Any loss resulting from adherence to the ideals laid down for their observance was to be made up from the St. George's fund at starting.

After the first struggle it was hoped that the public would learn to appreciate the honesty of the system and superior quality of the work, and be willing to pay higher prices for it.

Ruskin's rule that all profits should be openly declared was followed by the companions of St. George. Every article made by them bore a ticket marked plainly with the profits and percentages paid through all the stages of its production. In like manner every tradesman who tenanted land under the Guild had to produce his books on the Master's order and make both his financial position and his profits publicly known. The regulation as to usefulness of any goods made or sold was also extended to prohibit the supply of any injurious or disfiguring article, even where there was a demand for it. Freaks of fashion were not to influence their work.

Hampered by so many restrictions, and aiming at such a high ideal of commercial life, it is hardly to be wondered at that the companions of St. George were few in number. The young man who had great possessions turned away sorrowfully. at the command " Sell that thou hast, and give to the poor " : Ruskin's demand that a tithe of every income should go to a fund for the general good met with no response. He declared that a young man starting life with only ten pounds gave up his tithe more cheerfully and willingly than the rich man out of his abundance. Ruskin

started the fund with a thousand pounds in July 1871 ; he gave another thousand in September, and in December of the same year seven thousand more : a fair tenth of all that remained of his fortune. Two or three of his friends " from love of me," as he says, and one " from true love of justice," contributed to the fund, but the first contribution in money from the outside world was not made until June 1872, when thirty pounds came from a stranger at Wells, Somersetshire.

In his report as Master, dated January 1886, Ruskin withdrew the rule that a tithe of the income should be contributed, and accepted members who promised to subscribe £5 a year or upwards.

Some land was given : two acres of rocky ground, and about a dozen cottages, at Barmouth, by Mrs. G. T. Talbot in 1875, the conditions of her gift being that the rents should not be raised nor the existing tenants disturbed, but that they should be given every encouragement to improve their dwellings both as regarded sanitation and comfort. There was also an understanding that repairs were not to be regarded as a return of rent but as part of the general policy of the Guild. Twenty acres of woodland at Bewdley was given in 1877 : this also, like the rocky ground at Barmouth, was not much use for agricultural purposes at a time when the cultivation of small holdings was in an experimental stage.

Ruskin's most active adherents were the Yorkshire

operatives, and in 1876 he announced in "Fors" that throughout the year his letters would be chiefly addressed to them. Two out of the many rules of life he gave the Sheffield men deserve careful notice : one forbade them to sell food to strangers while a hungry mouth remained in their own district, the other commanded them to put their wages into a common fund until not a single cold or hungry person remained in the district. When sufficient food and clothing had been provided for the whole community, money might be saved by the thrifty, and women could beautify their dress, but until the poor were decently and gracefully clad Ruskin bade the women wear simple blouses and aprons. Would that this rule could be applied to-day—not only in Sheffield, but throughout the land—so that the reproach might be removed from our women that they clothe themselves sumptuously and vie with each other in extravagance while at the other end of the social scale their sisters starve with cold and hunger.

The rule as to exporting food-stuff seems hardly necessary while we produce such a small proportion of what is consumed that even the poorest depend for daily bread on imported food, but it might with advantage be applied to our coal supply at the present day : all export of coal to be forbidden until every hearth in England was warm, and at a cost within the means of the poorest.

Objections to these rules for mutual support were met by Ruskin's assertion that we need not fear to clothe the naked and feed the hungry lest thereby we encouraged idleness and thriftlessness, since idleness would soon be dealt with as a social offence.

In March 1876, at the request of a few of these Sheffield working-men, Ruskin, as Master of the Guild, authorised the purchase of thirteen acres of land at Abbeydale, near Sheffield; this forming the nearest approach to his ideal settlement. As tenants of this land the men became subject to the Guild laws, one of which was framed to prevent over-production. They were to work each day on whatever useful articles they were capable of making—" an earnest day's labour," well and honestly done. All the articles were to be sold at fixed prices, for cash. At the end of each year, after putting aside what was needed for the next, the surplus unsold stock was to be given away by proper officials appointed by the Guild.

The unskilled labourer has long been a perennial source of anxiety and embarrassment to the country. His position is always precarious, and in times of depression he drifts too often into the ranks of loafers and vagrants. Ruskin endeavoured to find a cure for this evil by ruling that every workman must be examined in his craft on coming of age, and if certified as proficient his name was then entered in a register, after which he received a fixed and unalterable wage to the day of his death;

paid so far as was possible in kind, not money. Those unable to pass their examination in one trade must try a lower one until they found their level. Ruskin went still farther : he was of opinion that every male child of English birth should be taught some craft by which he could, if necessary, earn his daily bread.

It is a foregone conclusion that the proper training, examination, and registration of skilled craftsmen would lessen the worst features of unemployment by reducing the ranks of unskilled workers to those absolutely unable, by means of bodily or mental incapacity, to learn a trade. How permanent employment could be guaranteed for all is not so clear, since even under the most ideal conditions no preventive has yet been found for the inevitable ebb and flow of trade. It may be that Ruskin did not intend to guarantee permanent employment, but only to ensure that the able and honest workman should not be liable to periods of want and distress through circumstances over which he could have no control. Ruskin's aim throughout was to equalise the standard of living rather than to raise it, and this fixed wage was a guarantee for daily bread—a safeguard against fear of the future, instead of possibly higher, but fluctuating, earnings under existing conditions.

Would a dead level of life be such a benefit as Ruskin and other idealists believed ? Would men long remain content to live without hope of change ?

with no scope for ambition, no fear of falling?
Would not the weak and shiftless rely upon their
certainty of creature comforts, and shirk or evade
the toil demanded of them? Would not the
stronger first chafe under the restraining laws and
then, if unable to rise, sink into a condition of dull,
animal contentment? Ambition has always been
the lever by which mankind has progressed : human
nature must change completely before the mere
certainty of daily bread will satisfy it. And where
would Art be in a state of existence with nothing
to hope for, nothing to fear?

Payment in kind of this fixed and permanent
wage consisted of such necessaries of life as the
worker required ; but if desired he could have
instead an order on the government stores for the
value—cash payment, in fact—in either gold, silver,
or paper currency. How a return to the cumbrous
system of barter would work remains unproved,
for St. George's Guild does not seem to have ever
advanced to the practical stage with this part of
the scheme. But a special coinage was designed
for the Guild : of pure gold or silver, absolutely
free from alloy.

The gold coins were to be called the ducat and
half-ducat. These were to be made of pure beaten
gold ; the ducat being of the same size as our
sovereign, or, as Ruskin says in another letter of
"Fors," the diameter of the old English "angel."
The "angel" varied in value from six shillings and

eightpence in the reign of Edward IV., by whom it was introduced into England, to ten shillings in the time of Charles I., who last coined it. Ruskin announced that the ducat would be worth, in metal, twenty-five shillings at least of our present coinage.

The design was evidently inspired by that of the " angel," so far as the figure of St. Michael was concerned. On the obverse of the ducat St. Michael was represented, standing on the dragon. Above him were the words " Fiat voluntas " ; below him " et in terra," and the year of coining. The reverse bore a branch of Alpine roses under the words " sit splendor," and beneath the roses " sicut in cælo." Around the edge of the coin the word " Domini " appeared. The half-ducat bore the same design, except that the figure of the dragon was omitted, and the armed figure of St. Michael carried a St. George's shield.

Their silver currency consisted of the florin, twenty of which were worth a ducat ; the penny, value one-tenth of a florin ; the halfpenny, and another coin worth one-fifth of a penny. The use of this last coin seems questionable where drapers had to mark their goods honestly, and there was no odd farthing lurking in an inconspicuous position on the ticket.

These smaller silver coins were to be beaten thin and pierced with holes differing in number according to their value : a halfpenny would have

two holes, and a fifth, five. Their special use was
to educate people into appreciating fineness of
touch. During the process of education, these
small thin coins must have proved embarrassing.
The idea of a nervous disciple of St. George fumbling
in his pocket with frost-benumbed fingers for two
halfpennies with which to pay a 'bus fare, con-
scious that the attention of all the other passengers
was riveted on his efforts to secure the elusive
coins, and anxious to appease the growing irritation
of the conductor, calls up a vision at once humorous
and painful. Perhaps the objection may be raised
that a disciple of St. George would not make use
of such modern innovations, but the simile holds
good in any other transaction involving the pay-
ment of small sums.

The florin of St. George bore as a device the
shield only on one side, and the Alpine rose on the
other. In the penny an English daisy was sub-
stituted for the Alpine rose, and in the half and
fifth of a penny the design was simply a " chased
wreathen fillet."

A demand for absolute purity of gold in the
coinage was an instance in which Ruskin's zeal
for commercial honesty outran his discretion.
He seems to have overlooked the fact that alloy in
gold coinage is not added to deceive or for purposes
of adulteration, but in order that the soft metal
may acquire sufficient hardness to allow of working,
and to give permanence to the design stamped on

it. After the trouble he took over the design, and remembering his railing at the banality of English coinage, it is strange that he should have overlooked the short life of any coin, no matter how clear the die, if made in such a malleable metal. The *honesty* of pure gold coinage might well lead to *dishonesty*, through the added difficulty of deciding if lightness was due to fair wear and tear or to illegal attrition, and so the result would be a temptation to revive the old thievish practice of sweating gold coin.

When it came to the question of comparative usefulness in work, Ruskin again showed his curious retrogressive tendency. He started by explaining that the first object of work was to provide primitive necessaries of life—food, clothing, shelter, and warmth. The only true St. George's work ministered to physical needs : " Fishing, fowling, digging, sowing, watering, reaping, milling, shepherding, shearing, spinning, weaving, building, carpentering, slating, coal-carrying, cooking, costermongering," and so forth. In all these it was understood that only hand labour should be used, so his scheme aimed at reorganising a land of patriarchal simplicity. All other work than this was to be done as play or for devotion. Brain work, or any occupations followed by educated people, came under the heading of " competitive play," and every brainworker was urged to complete the day by devoting some portion of his time to manual labour.

The home-life of a companion of St. George was as carefully regulated as his working day. Every household had to be provided with a library at the expense of the common fund, the books being carefully selected and divided into two classes : permanent possessions—the Bibliotheca Pastorum— and exchangeable books chosen by each family from an authorised annual list. Newspapers were not allowed in a St. George's household, until, in course of time, one should be published in accordance with the principles of the Guild ; containing no unconfirmed statements, and excluding all but really important home and foreign news. Nor were the companions allowed to choose any books that did not appear in the official list. All very excellent rules for young people, or for those who felt the need for guidance, but irksome to stronger minds. Such dogmatic ruling does not commend itself to Englishmen.

Obedience to parents being all important in Ruskin's eyes, it was only to be expected that it would be specially enjoined on St. George's children. No one could be received into the Guild under age. Girls were ordered to give implicit obedience to their parents, and set an example of sweet and gracious humility. Even where the home-life was not all that could be desired, they were not to adopt a self-righteous attitude. The law of God, they were told to remember, was that they should be " spirits of Peace and Humility " while remaining

16

under the home roof. Ruskin always had in mind
the possibility of introducing a distinctive dress for
the women ; becoming, useful, and modest. But
it went no farther than a few tentative suggestions,
and some regulations as to the wearing of ornaments.
If carried out it would, in a modified fashion, have
revived some of the sumptuary laws. Stones of
the agate class were allowed to be cut, but not
jewels, which, if worn, must be used in their natural
state.

Sir Thomas Dyke Acland and the Right Hon.
William Cowper-Temple, Egeria's husband, had
accepted the trusteeship of the fund when it was
started ; but without committing themselves to
any opinion with regard to the Guild's principles,
and accepting no responsibility for the scheme.
In 1877 it was thought advisable to register the
Guild under the Companies Act, 1867. St. George's
Guild became St. George's Company, and the
original trustees having resigned, they were re-
placed by Mr. George Baker, of Birmingham, and
Mr. Q. Talbot.

Part of the fund was spent in acquiring objects
for the Guild Museum, which was started in
September 1875 in a cottage at Walkley, near
Sheffield. Mr. Henry Swan, formerly a pupil of
Ruskin at the Working-men's College, was ap-
pointed Curator with a salary of £40 a year. Ruskin
gave largely both in time and objects, hoping to
make it a working-man's Bodleian. He fixed on

Walkley as a site for the Museum in one of his dogmatic moods. It was intended for the Sheffield working-men, but he would not put it in the town. Country walks were wholesome for them ; to get to the Museum they would have to take one : therefore the Museum should be at Walkley. Argued that it would be more frequented in closer proximity to the town, he took the same grounds as in his bookselling arrangement : if people wanted to use the Museum they would walk there ; if they did not want it they could stop away. The Museum became one of Ruskin's hobbies : he presented it with a valuable collection of minerals, photographs illustrative of Italian Architecture, and objects from his private collections. Large sums of money from the Guild fund were also expended on pictures, coins, minerals, and books, with a view to making it an educational centre for the Sheffield artisans. In his zeal for its improvement he spent so freely on the interior that when it came to a question of building more commodious premises there was no money for the purpose. The Corporation of Sheffield came forward with an offer to find a building if the Guild would give the Museum to the town. This suggestion was refused. The Corporation then proposed to take the collection as a loan, and house it in a suitable manner if the Guild would continue to pay the Curator's salary. This was agreed to, and Meersbrook Park, a finely situated old hall standing amidst trees, was selected as the

new quarters of the Museum, and opened on 15th April 1890 by the Earl of Carlisle.

The failure of St. George's Company to establish a hold on the people was undoubtedly a contributory cause of Ruskin's brain disorder. He said himself that he went mad because nothing came of his work, and it can be easily understood that lukewarm adherence on the part of his followers, and absolute indifference as far as the outside world was concerned, would be enough to throw a man of such extreme sensitiveness off his balance. Now, thought is moving in the direction he pointed out, and it may be that some day the vital principles of St. George's Guild, divested of the fantastic and unpractical elements, will enter into our national life. But even if this is not so, and we are never able to " stretch the octave 'twixt the dream and deed," the world must always be the better for its glimpse of Ruskin's Utopia.

CHAPTER XV

WHISTLER AND HIS LAWSUIT

N O account of Ruskin would be complete without some notice of " our friend the enemy "— James McNeill Whistler. This strange, mocking, cynical genius, with a tongue like a two-edged sword, and a pen dipped in vitriol, was a well-known frequenter of the social and artistic world during the seventies and eighties of the nineteenth century ; noticeable by reason of his strange attire, the long cane he affected, and the careful poise of his hat over the cherished white lock. These and other eccentricities served both to single him out from the crowd and secure him the notice he coveted.

The stories, true and false, told about Whistler and his oddities, would fill volumes. He claimed to be abnormally sensitive to colour, and his colour harmonies and schemes amounted to a craze. It was said that he had insisted upon the removal of a visitor's red tie before commencing conversation, because he thought it disturbed the colour harmony

of his studio. He collected blue china—was, in fact, the originator of that fashion—and, to complete the colour scheme of his blue ware, was credited with tinting his butter a delicate shade of apple-green.

Undoubtedly Whistler was a poseur of the first water, and the very seriousness with which he took himself minimised contemporary estimate of the man and his genius. England likes modesty in her great men. Whistler called himself " the Master," and frankly placed himself in the first rank of the world's great artists ; even in that position demanding to be *primus inter pares*. With Ruskin as the acknowledged authority on art constantly re-iterating praises of conscientious elaboration of detail, and the Pre-Raphaelite school in the ascendancy, it is not to be wondered at that Whistler's enigmatic Nocturnes and Harmonies should be received with puzzled bewilderment and even derision. To complete the misunderstanding, he was a wit—and one whose pleasantries were flavoured with wormwood. His epigrams, or those attributed to him—for like most wits he had to father many a strange *bon mot*—had always a caustic point to them. It was difficult to appreciate a man whose tongue lashed out at the slightest provocation in scathing sarcasm. As far as the public could judge he was a vain egotist who painted incomprehensible daubs and called them pictures.

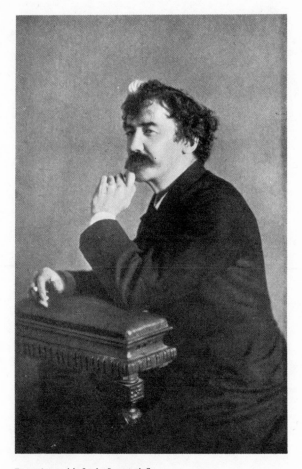

From a photograph by London Stereoscopic Co.

JAMES McNEILL WHISTLER

But what manner of man lay hidden behind this apparently impenetrable crust of egotism and vanity? That can only be guessed at. Whistler kept all but a few sycophants at arm's length. He boasted that he could not keep a friend : " I cannot afford it," he explained with frank cynicism. Yet we know that his life was pure, and that children did not fear him, so it seems probable that all this was only defensive armour, behind which the real Whistler, abnormally sensitive, quivering at every buffet dealt by an unsympathising world, sheltered himself ; repaying scorn for scorn,, railing for railing, and taking pleasure in the swiftness of his parry and ripost.

The critics reviled him : he turned the tables upon them by carefully collecting their remarks— if self-contradictory so much the better—and printing them in his next catalogue. " Out of their own mouths ye shall judge them," he added as a motto on the title-page. Purchasers of his pictures naturally imagined that they had permanent rights of possession in the property they had acquired. Whistler would not see this : " Small collection kindly lent their owners," was the audacious state-ment printed on the catalogue of one of his loan exhibitions. He was a typical megalomaniac, but he was also a genius—the world, which for so many years derided him as a charlatan, has conceded that. Judging from his lecture—" Ten o'Clock "— delivered in London in February 1885, and after-

wards repeated at Cambridge, he might have achieved success with his pen also, had he devoted himself to literature instead of art. This is confirmed by his book, " The Gentle Art of Making Enemies," though not so satisfactorily. Whistler had no sense of humour : he laughed at, not with his fellow-men. That, and the wearisome reiteration of the all-important *I*, spoils the literary effect.

This was the man of whose " Nocturne in Black and Gold—The Falling Rocket," Ruskin incautiously wrote in " Fors " : " I have seen and heard much of cockney impudence before now, but never expected to hear a coxcomb ask two hundred guineas for flinging a pot of paint in the public's face."

It was not the first time Ruskin had meted out scant praise or unmixed censure to hapless artists, with no worse result than private discontent or discouragement and the woeful wail of an Academician recorded in *Punch* :—

> "I paints and paints,
> Hears no complaints,
> And sells before I'm dry,
> Till savage Ruskin
> Sticks his tusk in,
> And nobody will buy."

But Whistler was of another stamp. He saw in the criticism an opportunity to fling a dart at the

popular critic and secure some notoriety for himself
at the same time. He brought an action for libel
against Ruskin.

The case Whistler *v.* Ruskin came on for hearing
before Baron Huddleston and a special jury on
15th November 1878. The plaintiff claimed £1,000
damages.

During 1867, Ruskin had declared in " Time and
Tide " that there would be no lawyers in his ideal
State. But by the time the first " Fors " letter
was written (January 1871), moved by the
picturesque side of the profession, he had relented
and so far modified his views that, " for the sake of
their wigs," he was willing to keep a few lawyers—
presumably in the "dignified almshouse" designed for
them and their clerks in a later "Fors" (Letter XVI.),
where they were to be supplied with " parchment
unlimited," and have their " ink turned on at a
tap " ; security of free maintenance for life in this
legal paradise being assured them on one condition
—that they troubled humanity no more ! Perhaps
it was fortunate for Ruskin that his ideal common-
wealth was slow in coming to fruition, so that when
Whistler launched his legal thunderbolt, there
were still lawyers in plenty, from amongst whom
he chose the Attorney-General and Mr. Bowen to
defend him.

Whistler had retained Mr. Sergeant Parry and
Mr. Petheram. The case caused a great sensation
in artistic circles, and the interest was not lessened

by the knowledge that Ruskin was seriously ill and would not be able to attend. The over-wrought brain had given way at last. An attack of brain fever prostrated him in the spring of 1878 for about two months, and it was autumn before he thoroughly recovered. In Ruskin's unavoidable absence his friend Burne-Jones accepted the task of giving expert evidence for the defence.

The libelled picture was produced as evidence for the defence, and considerable amusement was caused by a skirmish between counsel as to the right way up. Said the counsel for the defence :—

" You are holding it upside down."

Counsel for Plaintiff (indignantly) : " No I'm not."

Counsel for Defendant : " I tell you, you *are*."

Counsel for Plaintiff : " How do you know which is the top and which is the bottom ? "

Counsel for Defendant (amiably) : " I don't know ; only when I saw it at the Grosvenor Gallery it was the other side up."

After this, and kindred passages of arms, the Attorney-General certainly had some excuse for remarking, in his address to the jury, that he " did not know when so much amusement had been offered to the British public as by Mr. Whistler's pictures."

Night scenes are, as was stated by expert witnesses, seldom successful. Night is a subject for the poet, not the painter. The Cremorne Nocturne, a vague expanse of bluish-black, with gold splashes to show the flight of fireworks, was as unsatisfactory as most of its kind : unsatisfying to those capable of seeing and appreciating the beauty and mystery of night ; a meaningless daub to the crowd. Whistler had carried out his dictum, " The work of the Master . . . is finished from its beginning " : Burne-Jones in his evidence pointed out that though the picture had colour and " atmosphere " it lacked detail and composition, being more a sketch than a finished picture. Whistler was cross-examined by the Attorney-General, who facetiously asked him how long it had taken to " knock off " the picture. When the artist gave two days as a rough estimate of the time employed, the Attorney-General wished to know if he asked two hundred guineas for two days' work. The retort came swiftly :—

" No ; I ask it for the knowledge of a lifetime," and Whistler scored, for the British love of fair play secured the little man the Court's applause.

" Now," said the Attorney-General in further cross-examination of the plaintiff, " do you think that anybody looking at that picture might come to the conclusion that it had no peculiar beauty ?."

" I have strong evidence that Mr. Ruskin did come to that conclusion," replied Whistler.

" Do you think it fair that Mr. Ruskin should come to that conclusion ? " the Attorney-General asked.

" What might be fair to Mr. Ruskin I cannot answer."

The next question must have been prompted by some malicious sprite who wished to make mock of the dignified majesty of the law as represented by the Attorney-General. " Do you think now," that legal luminary asked ingratiatingly, " that you could make me see the beauty of that picture ? "

Whistler made a deliberate pause and gazed meditatively at his tormentor, then at the picture, and back again to the waiting lawyer :—

" No ! Do you know I fear it would be as hopeless as for the musician to pour his notes into the ear of a deaf man." And the laughter in court showed that Whistler had scored another point.

Whistler was doubly at a disadvantage in the case as an American and an impressionist against a man who was immensely popular and accepted as an authority on all artistic matters. That the verdict was given in his favour was a proof of the impartiality of the Court. The damages were assessed at a farthing, and Ruskin's costs amounted to £386 12s. 4d. This was raised by sub-

scription amongst Ruskin's friends and admirers, one hundred and twenty in number. Whistler wore the historic farthing as a trophy attached to his watch-chain, and revenged himself on Ruskin by calling him " the Peter Parley of Painting." At different times Ruskin drew forth some of Whistler's choicest sarcasm. He described Ruskin as having a " flow of language that would, could he hear it, give Titian the same shock of surprise that was Balaam's when the first great critic proffered his opinion."

This was not allowed to pass without challenge.

" The ass was right," wrote one of Ruskin's supporters.

Whistler was equal to the occasion. " But I fancy you will admit that this is the only ass on record who ever did see the Angel of the Lord, and that we are past the age of miracles," he retorted.

Punch contributed his share to the Whistler libel suit by publishing a cartoon by Linley Sambourne in which Baron Huddleston solemnly presents the farthing to Whistler while Ruskin, depicted as an " old Pelican in the Art wilderness," stands dejectedly by, and the costs writhe as serpents with legal wigs between them. This appeared on 7th December 1878, and as Whistler declared, was " sufficient to satisfy even my craving for curious ' combinations.' "

Ruskin, convinced against his will, was of the

same opinion still, but with the fear of the law of libel before him, refused to be drawn into

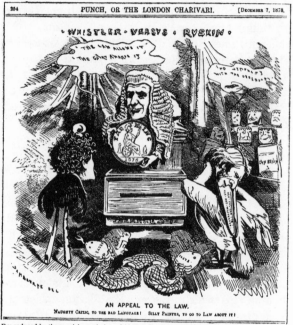

Reproduced by the special permission of Messrs. Bradbury, Agnew & Co., Ltd., the proprietors of *Punch*.

RUSKIN AS AN "OLD PELICAN IN THE ART WILDERNESS."

any discussion with respect to the case. He preferred to keep silence unless he could say what he liked, and thought. One libel action was enough.

A critic more or less made little difference to Whistler. There were always enough to keep his tongue and pen busy. Most likely he would have missed the excitement of retaliation if their attacks had ceased. One of his most active enemies took the " White House," formerly Whistler's residence, and at once started various alterations to adapt it to his own taste. This roused Whistler's wrath.

" Shall the birthplace of art become the tomb of its parasite ? " he asked, with tragic emphasis.

Pity would have been wasted on Whistler where the critics were concerned. He was fully able to look after himself, and woe betide the unlucky critic who made some technical blunder. One hapless man described Whistler's " Notes " as " reproductions of Indian ink and crayon sketches," smartly remarking of them that they were " masterly so far as they go—but then they go such a little way." This was an occasion for Whistler's celebrated laugh—so fiendish in its timbre that Irving imitated it in his representation of Mephistopheles—for the " reproductions " turned out to be original lithographs. Whistler's sarcastic comments on the misapprehension, and his innuendo with regard to the value of criticism by one who could fall into such an error, were only equalled by those he favoured another critic with when Herkomer's water-colour portrait of Ruskin had been described as an oil-painting.

Ruskin and Whistler could never have met on common ground, so it is scarcely to be wondered at that the former treated the latter as a charlatan, while, reciprocally, Whistler was willing to acknowledge Ruskin as a master of literature but denied his mission to interpret art. According to Whistler, only artists should attempt to criticise art ; in which case, so the art critic of the *World* said, " it would be a case of vivisection all round." It seems strange that Whistler should have suggested it, for he was on no better terms with the majority of his brother-artists than with the professional critics. His Presidency of the Society of British Artists lasted two years, and then ended in a rebellion against efforts to run it on his own lines. " The Artists come out, the British remain," was his own explanation of the situation when the Whistlerians followed their " Master " out of the Society. As for the Royal Academy, between Whistler and that august body there was no communication. " It is my rare good fortune to be able to send you an unsolicited, official, and final certificate of character," he wrote to the Press, enclosing a circular addressed to him at " The Academy, England," which had finally reached him bearing the endorsement " Not known at the R.A."

A fundamental difference between Ruskin and Whistler was the latter's belief that artistic periods did not occur, that the artist was entirely inde-

pendent of external influences, and remained
unaffected by the life around him. Ruskin, on the
other hand, held that no true art could flourish
in a debased state of society, and that the moral
life of a nation determined whether its artistic
ideals were true or false. He wrote his " Stones
of Venice " to show the close connection between
civic and artistic life. Their appreciation of artistic
subjects was diametrically opposed. Colour was
everything to Whistler and he made all else sub-
ordinate to it. He devoted himself to producing
harmonies in blue and gold, black and gold, black
and grey, and so forth. Even his exhibitions were
" arrangements "—in yellow and white, or flesh-
colour and grey ; everything in the rooms, including
the uniforms of the attendants, being of the selected
colours. His subjects were invariably chosen for
their adaptability to some colour scheme, and his
aim was a sensuous study of line and colour, not
the reproduction of nature. Now, with Ruskin,
colour was a secondary consideration. Whistler's
careless, impressionist sketches were far removed
from the careful delineation of natural scenery that
Ruskin admired, and, indeed, held to be essential
in art. But perhaps the widest divergence of all
was in their ideals of beauty. Imagine Ruskin,
who would willingly have swept away every factory
on the face of the earth, being called upon to admire
a study of Price's Patent Candle Factory ! Or,
with his horror of Cook's tourists and the hurry

of modern life, making a sketch of the steel frame-work of one of our huge caravanserais—as Whistler did of the unfinished Savoy Hotel. Each had his appointed place. Ruskin was a man of sentiment ; Whistler was absolutely wanting in that quality. Oil and water might mix easier than men of such different types. There were limits to Ruskin's greatness : so also to Whistler's, for genius always flows in a narrow channel.

It is impossible to resist Whistler's delightful egotism. In relation to the spread of education it was said that the lower classes were frequenting picture galleries, and " that 'Arry had taken to going to the Grosvenor." Whistler confirmed this statement : " To have seen him . . . was my privilege and my misery ; for he stood under one of my own ' harmonies '—already with difficulty gasping its gentle breath—himself an amazing ' arrangement ' in strong mustard-and-cress, with bird's-eye belcher of Reckitt's blue, and then and there destroyed absolutely, unintentionally, and once for all, my year's work ! " [1]

Peace to his Manes ! He survived Ruskin by three years. Whistler's critics had fallen off one by one. " I have hardly a warm personal enemy left," he said, on hearing that one of the most active was dead.

[1] " The Gentle Art of Making Enemies," by J. McN. Whistler.

CHAPTER XVI

AFTERMATH

MISS KATE GREENAWAY—MISS ALEX-ANDER—MISS SUSANNA BEEVER

AS time rolled on Ruskin took full advantage of the privilege claimed by age to cultivate the friendship of many charming women and carry on mild flirtations with young girls. His gentle philandering was so innocent and paternal that Mrs. Grundy in her sternest mood never seems to have taken exception to it. Ruskin had suffered much through women : his youth was embittered by Adèle's indifference, his manhood shadowed by his wife's desertion, his whole nature warped by his mother's injudicious fondness. But instead of developing into a misogynist, Ruskin found his greatest solace in their friendship ; receiving in return a heaped measure of the semi-maternal affection good women delight to bestow.

Ruskin dearly loved to have pretty women about him, but with Miss Kate Greenaway the attraction was due to no transient beauty. The homely little artist fixed his attention first by the charm of her

sketches. Ruskin, a child-lover, could appreciate
the witchery of her children, and a correspondence,
begun in January 1880, resulted in a friendship
only ended by death.

With almost boyish eagerness Ruskin opened the
correspondence by a string of questions as to her
methods of work and beliefs. He wanted to know
if she drew her winsome little lads and lassies out
of her own head, or could she adapt them from
nature ? Then followed exhaustive cross-examina-
tion on her belief, or disbelief, in " Fairies,"
" Ghosts," " Principalities," " Powers," " Heaven,"
and, euphemistically, " anywhere else." The rele-
vancy of some of these queries to " Kate Greenaway "
babies is not evident, but her answers must have
satisfied him, as the letters soon came thick and
fast ; those on her side usually accompanied by a
tiny sketch, sometimes in colour ; for it was a
charming habit of Miss Greenaway's to head her
letters with an appropriate drawing.

Ruskin's enthusiasm for her work waxed apace.
He begged her to try glass-painting, and of his
own accord had a sketch of a little girl with a doll
reproduced on glass for a nursery window. As had
been the case with the general public, Kate Greena-
way's spontaneity, the breeze and movement of
her children, their pensiveness and graceful abandon,
took Ruskin's heart by storm.

His lavish eulogy of her work was misunderstood
by the critics, who remembered her errors of draw-

ing. But it was Ruskin's way to give unqualified praise or blame, and Miss Greenaway's pure line-drawing, the happy way in which she caught the innocence and grace of childhood, her unvarying devotion to beauty and avoidance of ugliness and meanness, far outweighed in his eyes her faults of draughtsmanship. It is certain that he was not blind to her weak points. Witty criticisms of her perspective, her children's shoes, the absence of limbs under their dainty frocks, and of her colouring —which he declared was done in camomile tea and starch—abound in his letters to her.

He quizzed her accessories ; told her that her leaves had been in curl-papers all night, and begged her to draw a different chair. He was specially urgent on the point of her need to study from the nude, and whimsically eager to get rid of the impossible shoes her children wore ; to have her draw arms instead of mittens. All his criticisms were received with perfect good-humour : even when he sent to tell her that the figures in her Almanack for 1884 might be divided into two classes—the hobblers and the kickers ; with a separate variety, the straddler, for October. By way of amends he added that Baxter, his valet, thought it beautiful. To please him she deepened the tones of her colour washes, and tried to amend her perspective.

Perspective was one of Miss Greenaway's stumbling-blocks, for her short-sighted eyes had to peer into details too closely to get the whole into its

proper relationship as to distance. She evaded
the difficulty as much as possible, but Ruskin was
bent on conquering her weaknesses, and in 1887 he
gave her lessons in perspective. She made a restive
pupil, seizing on his remark that Giovanni Bellini
defied perspective by demanding why, if he defied
it, she might not do the same.

But in 1883 she designed a headpiece for Letter
XCIII. of " Fors," and this delighted Ruskin so
much that he seems to have realised the wisdom of
allowing her originality to follow its own bent;
accepting its limitations rather than risk the loss
of some distinctive charm by confining it within
academic channels. He told her that he trembled
to ask her to draw in any other way.

Besides this headpiece, she designed the head- and
tailpieces for " Fors " Letter XCIV., a headpiece
for Letter XCV., and for Letter XCVI. a full-page
sketch as frontispiece—in which, alas ! two out of
the three figures are disguised in mittens, and shoes
a size too large for them ; while the third—out of
deference to Ruskin's prejudices perhaps—goes
barefoot. " Feet—feet—and arms," urged Ruskin.
" No more shoes, come what will of it." She also
did some illustrations for Ruskin's edition of " Dame
Wiggins of Lee."

Ruskin described Miss Greenaway as " mixed
child and woman." No one who has studied her
sketches can fail to understand this. She looked
at childhood with a woman's eyes and interpreted

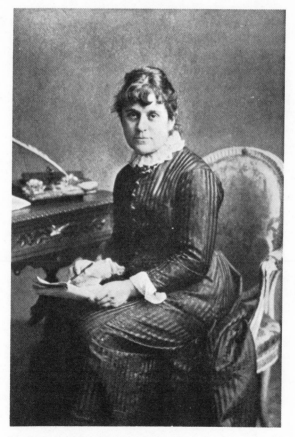

From a photograph by Elliott & Fry.

KATE GREENAWAY

the result by the wisdom of a child's heart. Imitators of her style were legion, but there is an unmistakable breeziness about her dancing maidens, a peculiar pensiveness and gravity in the children, that stamps the genuine sketch and makes the gazer oblivious for the moment of anatomical defects.

During the time of his Slade Professorship Ruskin mounted twenty-five of her "Mother Goose" drawings in glazed, sliding frames, as examples of line-drawing for the Oxford loan collection. He also took great interest in the reproduction of her sketches. His idea was that better results would be obtained if only the outlines were printed, and these afterwards coloured by hand, as the colour-printing frequently spoiled the picture. With his customary love of detail he even went into such points as the necessity for payment on a scale that would allow colours to be applied leisurely, and the importance of limiting the colourist's hours of work.

Miss Greenaway visited at Brantwood; the friendship being extended to Mrs. Severn, Ruskin's adopted daughter. When in London, Ruskin would call at Miss Greenaway's studio at Frognal. Letters passed freely between them: during three years there was hardly a day without a letter from Ruskin. He sent her his early drawings, begging her to criticise them and choose for herself one out of every ten. Then came his serious illness, and after May 1889 there were no more letters from him.

A month later the last Letter of " Fors " was published. The once busy pen had been laid aside, and from this time Ruskin was numbered amongst those " who only stand and wait." But although he was unable to answer her letters, Miss Greenaway found that the receipt of them gave pleasure when he was well enough to see them, so, with touching fidelity to her old friend, a one-sided correspondence was kept up for the remainder of his life.

During Ruskin's frequent wanderings in Italy he made the acquaintance of many English and American artists. Amongst these one—Miss Francesca Alexander—interested him greatly because of her ability to understand and faithfully depict Italian life. She was living at Florence with her mother when Ruskin first knew them—two refined, clever gentlewomen, well able to enter into his social ideals. Miss Alexander made her studio an audience chamber for the Tuscan peasants, and pursued her work while they talked to her of their affairs or watched the progress of her sketch. She was their adviser and sympathiser, winning their confidence to such an extent that she was able to collect from their lips the legends of the countryside, and illustrated them with her own sketches. The result was published as " Roadside Songs of Tuscany," to which Ruskin wrote a preface. Ruskin ardently admired her work, and counted mother and daughter among his friends.

In March 1883 he referred to Miss Alexander's

work in his Slade Lecture, praising both her life and drawing. The following June he gave a private lecture, taking for his subject the art of Miss Greenaway and Miss Alexander—his eulogies of these two artists to the exclusion of so many other names provoking much criticism. It must be admitted that Ruskin's judgments were no longer indisputable. He had already suffered from two attacks of brain fever (1878 and 1882), and although no one questioned the artistic ability of the two ladies, it was felt that he did them no service by over-extravagant praise.

Ruskin bought a hundred of Miss Alexander's sketches illustrating the " Roadside Songs of Tuscany." " All ' chiaro ' and no ' oscuro ' " he described her work. He wrote a preface to her " Story of Ida," and also edited some of her letters to him. These were published under the title " Christ's Folk in the Apennine." After Ruskin's remarks on handwriting in " Fors," and his insistence that slowness and legibility were the two great points to be aimed at, it will easily be understood that Miss Alexander's clear and beautiful handwriting was no small recommendation to her in Ruskin's eyes.

But of all Ruskin's platonic friendships none bears such a delicate, old-world bloom as that between the owner of Brantwood and the ladies of " the Thwaite." A perfume of lavender and potpourri seems to hang about the letters published as

" Hortus Inclusus " : powder and patches, and
courtly play over snuff-box and fan, seem more in
keeping with this middle-aged friendship than the
utilitarian costume and abrupt manners of to-day.

There were two maiden ladies at " the Thwaite "
when Ruskin went first to Brantwood : a third
sister, Miss Margaret, was dead. Miss Mary, the
elder, made politics and science her special interests
in life. Miss Susanna was of gentler mould, and
chiefly delighted in the simple pleasures obtainable
through the care of flowers, birds, and animals.
Literature, especially poetry, was also a great
resource in leisure moments : she was well read,
and wrote a little herself. Ruskin's first published
letter to her contains a scolding because she had
burnt her little story of " The Bee and Narcissus "
instead of sending it to Assisi for his approval.
Later, she made the selection from " Modern
Painters " known as " Frondes Agrestes."

" The Thwaite " was on the other side of Conis-
ton Lake ; near enough in a country neighbourhood
to make the advance from a first formal acquaint-
ance to friendship an easy one, especially when the
inmates of both houses were well disposed to closer
intimacy. Having made Miss Susanna Beever's
acquaintance in the autumn of 1873, by the middle
of April in the following year Ruskin was writing
to her as " Susie," and signing himself " your
loving J. R."

A month later she confided her age to him. She

was sixty-eight ; thirteen years Ruskin's senior. Sixty-eight years *young*, we may say, for she seems to have been one of those rare, sweet natures in whom the charm of youth lingers to extreme old age. She asked Ruskin to let her be a second mother to him, and he protested that there was not sufficient difference in their ages : she must be his elder sister. But except when the dark mood was upon him, and he poured out his longings and yearnings as if certain of understanding and sympathy, his letters to her were in a playful strain. They indulged in the children's game " Let's pretend," and Susie was " ten years old," admonished to " be a good child " while he was away, told that she has been " a careless little thing " or " a dear good little girl."

As time went on she advanced to thirteen, and Ruskin begged her to begin being serious. He declares that it has been hinted that she ought to be sent to school, but that he declines to notice such remarks as he knows she will be good and do her lessons at home. For her " thirteenth " birthday he sent her presents of a crystal and pieces of native gold and silver. These were followed by many other specimens from his collection when he found what pleasure their beauty gave her.

There is less exaggeration in these playful allusions to her age than would appear. Miss Susie Beever overflowed with interest in simple things and pleasures. There was no affectation of youth ; it

was the genuine and spontaneous expression of a
beautiful nature, ripened and mellowed by pain
and sorrow until it had lost all taint of selfishness.
Dr. John Brown was one of Miss Susie's corre-
spondents, and described her as prattling away
" like a girl, and yet with the sad knowledge of
years." " Our Susie " he calls her when writing to
Ruskin, and compares her to a lamb with respect
to her blitheness and playfulness, and yet less selfish
than a lamb. His knowledge of her was entirely
drawn from letters, for they never met, but she had
" the rare gift of talking on paper."

Ruskin was in the thick of his troubles about
Rose La Touche when he began writing to Miss
Susie, and his letters contain frequent allusions to
his heart-sickness : outpourings which were met by
delicate sympathy and tactful efforts to divert his
thoughts from the clouds obscuring his path. She
had sorrows of her own, and they sometimes lent a
touch of sadness to her letters. Blindness threat-
ened her, and Ruskin, in gratitude to Dr. Kendall for
successfully treating her eyes, gave him a crystal
from his collection.

Ruskin's minerals were a great source of pleasure
to Miss Susie, and choice or beautiful specimens of
these, and also of his agates, were frequently sent
for her admiration. Her quickness of perception
made it natural that Ruskin should discuss his
work with her. " Deucalion," his book on stones,
and " Proserpina," in which he rearranged flowers

on a system of his own, each in turn gave excuse for endless letters. Ruskin always needed human sympathy, especially the sympathy of women. The personal character of his letters, their slightly egotistic tendency, and the self-betrayal resulting from an almost exaggerated truthfulness, make his letters more than usually interesting. And of all his correspondence, these to Miss Susie Beever stand out pre-eminent in their revelation of the man, because of the quickness with which she responded to every changing mood.

In these letters Ruskin touches on one of his peculiar weaknesses—his dislike of all scientific explanations and systems. He had just seen a paper by Sir John Lubbock, giving the results of investigations on flowers and insects, in which it was stated that scent, colour, and form were all due to the influence of bees. The Lubbock theory that flowers unvisited by insects had neither scent, colour, nor honey, provoked his retort that it was more likely these flowers got no attention from bees—hardly a logical argument. He confesses to being " made miserable " by reading these things because the author showed such evident knowledge of his subject. Again, he tells Miss Susie that the scientists (at Oxford) slink out of his way as if he were a mad dog, because he lets them " have it hot and heavy whenever I've a chance at them."

This shrinking from the advance of science is

one of the strangest contradictions in Ruskin's mental development. It was not merely indifference to science : he positively hated it, and his dislike was not unmixed with fear. He seemed to dread being compelled to readjust all his conceptions of the universe if he once admitted the claims of science. Yet—inconsistent mortal that he was—he took pleasure in a book on wasps, and even suggested teaching children to keep wasps' nests as a remedy for the August plague of flies.

"Love's Meinie," his book on birds, is full of protests against scientific classification and nomenclature. He appealed against the use of dead languages which ought to be laid at rest, and urged the use of Old-English and Norman-French names for birds in preference to those compounded from Greek or Latin roots—"skin and bones holding our living tumuli together." Strange that his own books so often bore Latin titles !

Ruskin's distaste for science committed him to the sweeping assertion that a few lines of Milton on the Creation was the only piece of Natural History worth the name in the English language, and White's "Selborne" the only proper model for such writings. In spite of Mazzini's compliment— that Ruskin's was "the most analytical mind in Europe"—he looked upon Nature only with the eyes of an æsthete, giving the reins to his imagination instead of patiently striving to get to the heart of things like Darwin and Huxley. He

believed Science and Commercialism were two
giants devastating the land : science depriving the
workman of his belief in angels and the efficacy
of prayer ; commercialism confining him within
the crowded and dismal streets of a great town,
too saddened for song, and with neither birds,
trees, nor flowers to cheer him and stimulate his
higher faculties. Under such conditions how were
workmen to derive profit or entertainment from
the Fine Arts ?

" Proserpina " was his attempt to poetise botany.
All the dry, ugly, botanic names were to be spiritua-
lized. He said the Devil himself had contrived
that proper names of flowers were often founded
on unclean or debasing associations, and any
interpretation of them would defile the reader's
mind. In lieu of these he proposed to give all
the pretty flowers feminine names, since if he
only renamed those with objectionable associations,
the curious would be tempted to translate the
very terms he was anxious to do away with. So
Dianthus became Clarissa, and Polygala was re-
named Giulietta. Mints and lavenders were put
in an order he called " Vestales," or " vestals,"
and the entire order Caryophylaceæ took the
name of " Artemides," from Artemis ; while
Proserpine gave her name to an order in which
were placed snapdragons (draconids), anemones,
hellebores, ivies, and forget-me-nots.

Mythology was largely drawn on to supply

suitable names. Calypso was chosen to rule over the calyx, and Proserpine had the corolla under her protection. In such wise Ruskin's botany wandered off into mythology or the realms of poetry, pausing a while at times to give a slap at Darwin and his "vespertilian treatise on the ocelli of the Argus pheasant," and indulging in symbolism until botany is lost sight of; yet, through all these discursive ramblings, remaining so entirely Ruskinian and charming that criticism is disarmed. The cream of the whole is his delightful dissertation on the names and personalities of Shakespeare's women.

Poppies furnished him with the theme of an ethical discourse. The petals, so tightly packed within the sepals, reminded him of unwilling submission to too severe restraint in the nursery; the fallen sepals in the open flower, of youth breaking away from all restraints; and the ineffaceable creases in the petals showed traces of this youthful submission to "laws of pain, not instruction." In contrast to this, primroses were flowers of gracious breeding: sweet, submissive childhood contented with its lot; the little yellow petal peeping out from the calyx nursery was the obedient child growing out to the light but content to remain in the old home all its days.

Bright colour in sky and sea and flowers was the portion of noble men living under healthy conditions. Such people, country dwellers, loved

colour. The ignoble and sensual, town-dwellers, had a taste for mud-colour and black. Unhealthy places, Ruskin declared, proclaimed themselves by the ghastly colour in earth, air, and flowers.

With whimsical pettishness Ruskin protests against calling a plant an " aceous " thing. It must be either one thing or another—Poppy or not a poppy, but poppaceous never, he vows.

A few general rules were laid down as to his system of naming orders and families. No woman's name ending in " a " was to be attached to a plant unless it was both good and pretty. The terminations " is " and " e " in feminine names were also marks of honour : only flowers of great beauty and having noble historic associations were deemed worthy to bear them. So it was that the daisy was dedicated to Alcestis because of its connection with Chaucer. But names with these terminations were ·not always those of women : if not, they denoted special sensitiveness or their association with legend.

Ruskin's classification is as follows :—

HIGHER ORDERS.

ORDER I.—CHARITES. (*Graces.*)

GENERA (or Gentes). (1) Rosa. (2) Persica. (3) Pomum. (4) Rubra. (5) Fragaria.

ORDER II.—URANIDES.

GENERA. (1) Lucia. (2) Campanula. (3) Convoluta.
[Lucia or Lucy was formerly gentian, but Ruskin de-

cided that Gentius, king of Macedon (query Illyricum), was not a fit person to have floral honours.]

ORDER III.—CYLLENIDES.

GENERA. (1) Stella. (2) Francesca. (3) Primula.
[The sedums are disguised under the name of " Stella," and " Francesca " is known in daily life as saxifrage.]

ORDER IV.—OREIADES.

GENERA. (1) Erica. (2) Myrtilla. (3) Aurora.

ORDER V.—PLEIADES.

GENERA. (1) Silvia. (2) Anemone.

ORDER VI.—ARTEMIDES.

GENERA. (1) Clarissa. (2) Lychnis. (3) Scintilla. (4) Mica.

ORDER VII.—VESTALES.

GENERA. (1) Mentha. (2) Melitta. (3) Basil. (4) Salvia. (5) Lavendula. (6) Thymus.

ORDER VIII.—CYTHERIDES.

GENERA. (1) Viola. (2) Veronica. (3) Giulietta.

ORDER IX.—HELIADES.

GENERA. (1) Clytia. (2) Margarita. (3) Alcestis. (4) Falconia. (5) Carduus.
[Clytia included all true sunflowers, and Falconia the hawkweeds.]

ORDER X.—DELPHIDES.

GENERA. (1) Laurus. (2) Granata. (3) Myrtus.

ORDER XI.—HESPERIDES.

GENERA. (1) Aurantia. (2) Aglee.

ORDER XII.—ATHENAIDES.

GENERA. (1) Olia. (2) Fraxinus.

Then followed the water-plants :—

ORDER I.—DROSIDÆ.

GENERA. (1) Juncus. (2) Jacinthus. (3) Amaryllis
(4) Iris. (5) Lilium.

ORDER II.—TRITONIDES.

GENERA. (1) Trefoil.

ORDER III.—NERIADES.

GENERA. (1) Quatrefoil.

ORDER IV.—BATRACHIDES.

GENERA. (1) Cinquefoil.

ORDER V.—DEMETRIDÆ.

GENERA. (1) Grasses. (2) Sedges. (3) Mosses. (4) Lichens.
 [Included with the mosses were drosera, ophryds, and
agarics.]

LOWER ORDERS.

ORDER I.—DIONYSIDÆ.

GENERA. (1) Hedera, (2) Vitis. (3) Liana.

ORDER II.—DRACONIDÆ.

GENERA. (1) Atropa. (2) Digitalis. (3) Linaria.

ORDER III.—MOIRIDÆ.

GENERA. (1) Conium. (2) Papaver. (3) Solanum. (4) Arum. (5) Nerium.

The names run smoothly off the tongue, calling up memories of the plains of Sicily and the Elysian fields, or the garden of the Hesperides : yet these only to the initiated. Ruskin intended to supply dainty names in the vulgar tongue, but his task was never finished. Up to the present no one else seems to have undertaken its completion, and systematic botany has never been dethroned. " Proserpina " will have its use : not as a text-book, but as a fount of pleasant fancies and dainty names for those who love flowers for their own sakes and reck little of systematic botany.

This spiritualized botany, the outcome of a love of flowers for their own sakes and a poet's desire to individualize them, evidently appealed strongly to gentle Miss Susie, whose encouragement undoubtedly stimulated Ruskin's imagination in devising names for his flower-women. If Mrs. Cowper-Temple was

his " Egeria " in early manhood, Miss Beever seems
to have earned that distinction in later life. Like
all good women, she did a little mild preaching at
times : half-shy exhortations to faith, and such
wise counsel and encouragement as a true Egeria
should give.

Above all a large-hearted woman, the pleasure
of giving was paramount with Miss Beever. She
delighted in making little gifts to her friends. Dr.
John Brown had a penwiper made of feathers from
her peacock. She made another like it for Ruskin
—to his great embarrassment, for he had to confess
that he always wiped his pen upon his coat-tail.
Cranberry roots to be planted out in the bog on the
moor above Brantwood, flowers for his " Proser-
pina " work, and feathers from which he could
make observations on colour and the arrangement
of filaments for " Love's Meinie " ; not to mention
such creature comforts as oysters, cheese, and brown
bread of " the Thwaite " baking, came over the
lake to Brantwood ; while Ruskin, never to be
outdone in generosity, lavished books, drawings,
photographs, and champagne on his neighbours.

Miss Mary Beever died in December 1883, and
henceforward Miss Susie was left alone at " the
Thwaite," her solitary lot being ameliorated by
the warm interests she took in all living creatures.
Ruskin, to whom mourning was especially dis-
tasteful, thanked her for not sending the news
to him on black-edged paper. " Why," he asked,

" should we ever wear black for the guests of
God ? "

Miss Susie's pets were at the same time the pride
and sorrow of her life. She feared to let them creep
too closely into her heart because of the inevitable
parting when they died. She kept peacocks for
the æsthetic delight of their plumage ; five cats
warmed themselves by " the Thwaite " fire ; she
proudly claimed the title of " lady " because a
squirrel came to her for his daily loaf. Birds came
regularly for their moistened crusts of bread ; they
nested unafraid in the garden, well aware that the
kind and curious eyes watching their ways were
friendly. She was a feminine St. Francis, and ex-
tended her love of God to the least of His creatures.
Even a stray dog who made his way to her window
understood that a finger pointed in the direction of
the kitchen meant an invitation to dinner, and a
blackbird rescued, unfledged, from a nest blown
out of the ivy, welcomed her step on the stair with
a shriek of joy, and would sit chirping on her finger
or peck gently at her hair. Miss Susie grew to love
her blackbird, but she understood the longings of
wild creatures too well to keep him in captivity.
At the first signs of restlessness he was carried down
the garden, in raspberry time, and there let free
—even though " my eyes filled with tears when he
left."

In 1886, when, his working days over, simple
pleasures alone remained to him, Ruskin devised

a method by which his old friend could take her choice of all his sketches, and at the same time spread out the pleasure of selection over many weeks. Twenty-four sketches were sent to her to begin with, to be kept for a week. At the end of that time she selected twelve, and exchanged those remaining for another dozen. When the next week ended the process of selection was gone through again, and this was repeated each week, twelve always being in her possession, until his stock was exhausted. Out of the last dozen, the " creamiest cream " of the lot, as he told her, she was to choose one to keep. In whimsical allusion to his habit of describing himself as her " poor cat," her " curled-up old cat," and as purring acknowledgments of her kindness, he asked her if this arrangement was not " a nice amusing categorical, cataloguizical, catechismic, catcataceous plan."

Reading the few stray fragments at the end of " Hortus Inclusus "—" Susie's Letters "—it is impossible to keep from wondering how such a sweet, loving, *lovable* woman remained Miss Beever to the end of the chapter. And a regret arises for those thirteen years of seniority and the lateness of their meeting. What might Ruskin's life have been had there been a Miss Susie by his side in the days when he first buckled on his armour to fight the world ? All the bitterness of slighted affection removed ; tactful sympathy always ready when he needed it ; her quiet common-sense to act as

a rudder when his genius rushed headlong into absurdities.

Better for him, perhaps, but for her—no. Ruskin was not the man for matrimonial life. He would have frittered away his heart in weak sentimentalities if he had been wedded to an angel. The gentle châtelaine of "the Thwaite" was better off with her poor, and her friends—not to mention the birds and beasts that looked to her for food—than she would have been with Mrs. Ruskin to crush her bright spirits into a dull uniformity and a hundredth share in Ruskin's heart.

On the 29th October 1893 Miss Susie Beever died, and was buried in Coniston churchyard.

CHAPTER XVII

RUSKIN'S TEACHING. I.

POSITION OF WOMEN—MARRIAGE—EDUCATION OF CHILDREN

WOMEN occupied a very high position in Ruskin's scheme of the universe. It is not quite in accordance with modern ideas, for the woman of the present day is too apt to believe that nothing but self-assertion and a demand for nominal equality can raise her from the position of a household drudge. Ruskin gave her queenly honours : she was to be the guide, counsellor, and inspiration of man. Strife between the sexes on questions of equality was absurd : there could be no need to demand shadowy rights when the woman only had to stretch out her hand to grasp the sceptre—hers inalienably, if she chose to claim it, by divine right of womanhood.

" And whether consciously or not, you must be, in many a heart, enthroned : there is no putting by that crown ; queens you must always be : queens to your lovers ; queens to your husbands and your sons ; queens of higher mystery to the

world beyond, which bows itself, and will for ever bow, before the myrtle crown and the stainless sceptre of womanhood. But, alas! you are too often idle and careless queens, grasping at majesty in the least things, while you abdicate it in the greatest; and leaving misrule and violence to work their will among men, in defiance of the power which, holding straight in gift from the Prince of all Peace, the wicked among you betray, and the good forget." [1]

" Grasping at majesty in the least things : " stepping down from her throne and casting aside crown and sceptre to clamour in our streets for the right to make a cross on a bit of paper, when from her throne she could have decreed with queenly calm, " It is our pleasure to have the franchise." Not content with having cheapened womanhood in the man's eyes, but taunting her sisters who understand the secret of their own power, and the relative unimportance of such outward signs of rule, as traitresses to their sex.

There are those who say that Ruskin taught the subjection of women and masculine superiority. Quite otherwise : and those who assert this are either ignorant of the actual power behind the throne of womanhood, or decline to recognise it. The best example of woman's influence is not found in the blustering, loud, selfish, and self-assertive woman, but in the wise, gentle, far-seeing, and

[1] " Sesame and Lilies."

dignified wife and mother; holding undisputed
sway over the hearts and lives of husband and sons,
and, quite unconsciously, radiating peace and re-
finement far and wide. Ruskin himself disclaimed
such views :—

" We hear of the ' mission ' and of the ' rights '
of Woman, as if these could ever be separate from
the mission and the rights of Man—as if she and
her lord were creatures of independent kind, and of
irreconcilable claim. This, at least, is wrong. And
not less wrong—perhaps even more foolishly wrong
(for I will anticipate thus far what I hope to prove)
—is the idea that woman is only the shadow and
attendant image of her lord, owing him a thought-
less and servile obedience, and supported altogether
in her weakness by the pre-eminence of his fortitude.

" *This, I say, is the most foolish of all errors re-
specting her who was made to be the helpmate of man.
As if he could be helped effectively by a shadow, or
worthily by a slave !* " The italics are mine. Surely
this passage from " Sesame and Lilies " proves
conclusively that Ruskin had no wish to lower
women to a condition of mute subjection.

Ruskin taught that a woman's first claims were
those arising out of her relationships as daughter,
wife, and mother, and it was in view of her duties—
and privileges—as wife and mother that her educa-
tion was planned : on broader lines and less special-
ized than that of a man. But if her life was ordered
for the placidity of the fireside, Ruskin did not

intend her influence to stop there. He expressly
warns women of their responsibility with regard
to the world-pain ; bidding them enlarge their
sympathies and use their power to cleanse the
dark places from sin and its attendant suffering.
" But, chiefly of all, she is to be taught to extend
the limits of her sympathy with respect to that
history which is being for ever determined as the
moments pass in which she draws her peaceful
breath ; and to the contemporary calamity, which,
were it but rightly mourned by her, would recur no
more hereafter. She is to exercise herself in imagin-
ing what would be the effects upon her mind and
conduct, if she were daily brought into the presence
of the suffering which is not the less real because
shut from her sight. She is to be taught somewhat
to understand the nothingness of the proportion
which that little world in which she lives and loves,
bears to the world in which God lives and loves ;—
and solemnly she is to be taught to strive that her
thoughts of piety may not be feeble in proportion
to the number they embrace, nor her prayer more
languid than it is for the momentary relief from
pain of her husband or her child, when it is uttered
for the multitudes of those who have none to love
them,—and is ' for all who are desolate and
oppressed.' " [1]

Far from refusing them a part in public concerns,
Ruskin urged women to use their influence to put an

[1] " Sesame and Lilies."

end to war. " Let every lady in the upper classes of
civilized Europe simply vow that, while any cruel
war proceeds, she will wear *black* ; a mute's black,—
with no jewel, no ornament, no excuse for, or
evasion into, prettiness—I tell you again, no war
would last a week." [1]

Ruskin taught that it was in motherhood, and
in motherhood alone, that woman's power centred.
As a mother she held the future of the Empire in
her hands. Home-life was so important a factor
in national progress that Ruskin suggested, in
" Time and Tide," having " bishops " appointed,
with jurisdiction over one hundred families, to
record all that was " inevitably known of its publicly
visible conduct, and the results of that conduct,"
and forward these reports annually to an officer
provided by the State for the purpose ; in order
that the families noted for their virtues should be
honoured, rewarded, or advanced in position. " And
in a little while it would come to be felt that the
true history of a nation was indeed not of its wars,
but of its households." [2]

One study was taboo to women. Ruskin's private
history supplies the explanation for this restriction.
When " Sesame and Lilies " appeared, Rose La
Touche, for whom it was written, had not yet
become the bigoted religieuse who rejected his love
a few years later, but Ruskin had already suffered

[1] " The Crown of Wild Olive."
[2] " Time and Tide."

much at the hands of Evangelical women. And his own experiences were doubtless in his mind when he wrote : " There *is* one dangerous science for women—one which they must indeed beware how they profanely touch—that of theology. Strange, and miserably strange, that while they are modest enough to doubt their powers, and pause at the threshold of sciences where every step is demonstrable and sure, they will plunge headlong, and without one thought of incompetency, into that science in which the greatest men have trembled, and the wisest erred. Strange, that they will complacently and pridefully bind up whatever vice or folly there is in them, whatever arrogance, petulance, or blind incomprehensiveness, into one bitter bundle of consecrated myrrh. Strange, in creatures born to be Love visible, that where they can know least, they will condemn first, and think to recommend themselves to their Master, by crawling up the steps of His judgment-throne to divide it with Him. Strangest of all, that they should think they were led by the Spirit of the Comforter into habits of mind which have become in them the unmixed elements of home discomfort ; and that they dare to turn the Household Gods of Christianity into ugly idols of their own ;—spiritual dolls, for them to dress according to their caprice ; and from which their husbands must turn away in grieved contempt, lest they should be shrieked at for breaking them." [1]

[1] " Sesame and Lilies."

Even more sternly are they rebuked in " The Crown of Wild Olive." " If you choose to obey your Bibles, you will never care who attacks them. It is just because you never fulfil a single downright precept of the Book, that you are so careful for its credit : and just because you don't care to obey its whole words, that you are so particular about the letters of them. The Bible tells you to dress plainly, —and you are mad for finery ; the Bible tells you to have pity on the poor,—and you crush them under your carriage-wheels ; the Bible tells you to do judgment and justice,—and you do not know, nor care to know, so much as what the Bible word ' justice ' means. Do but learn so much of God's truth as that comes to ; know what He means when He tells you to be just ; and teach your sons, that their bravery is but a fool's boast and their deeds but a firebrand's tossing, unless they are indeed Just men, and Perfect in the Fear of God :— and you will soon have no more war, unless it be indeed such as is willed by Him, of whom, though Prince of Peace, it is also written, ' In Righteousness He doth judge, and make war.' "

It was because Ruskin was an idealist and realized the capabilities of women that he lashed their shortcomings and little vanities so severely. He argued that the greatest writers—Homer, Æschylus, Chaucer, Shakespeare, Spenser, Dante, Scott—had agreed in depicting women as the counsellors and guides of men. " In all Christian ages which have

been remarkable for their purity or progress, there
has been absolute yielding of obedient devotion,
by the lover, to his mistress. I say *obedient*;—not
merely enthusiastic and worshipping in imagination,
but entirely subject, receiving from the beloved
woman, however young, not only the encourage-
ment, the praise, and the reward of all toil, but, so
far as any choice is open, or any question difficult
of decision, the *direction* of all toil. . . . And this,
not because such obedience would be safe, or
honourable, were it ever rendered to the unworthy;
but because it ought to be impossible for every
noble youth—it *is* impossible for every one rightly
trained—to love any one whose gentle counsel he
cannot trust, or whose prayerful command he can
hesitate to obey. . . .

"You cannot think that the buckling on of the
knight's armour by his lady's hand was a mere
caprice of romantic fashion. It is the type of
an eternal truth—that the soul's armour is never
well set to the heart unless a woman's hand has
braced it; and it is only when she braces it loosely
that the honour of manhood fails." [1]

With such exalted ideals of womanhood it was
only to be expected that Ruskin's views on marriage
would be on the same plane. There is a peculiar
pathos in the following passage from "Sesame and
Lilies" on home and the wife's place in it, read in
conjunction with our knowledge of Ruskin's own

[1] "Sesame and Lilies."

experience of married life. Probably, when he wrote it, he had already in his mind the possibilities of such a home, with Rose La Touche by the fireside :—

" This is the true nature of home—it is the place of Peace ; the shelter, not only from all injury, but from all terror, doubt, and division. In so far as it is not this, it is not home; so far as the anxieties of the outer life penetrate into it, and the inconsistently-minded, unknown, unloved, or hostile society of the outer world is allowed by either husband or wife to cross the threshold, it ceases to be home ; it is then only a part of that outer world which you have roofed over, and lighted fire in. But so far as it is a sacred place, a vestal temple, a temple of the hearth watched over by Household Gods, before whose faces none may come but those whom they can receive with love,—so far as it is this, and roof and fire are types only of a nobler shade and light,—shade as of the rock in a weary land, and light as of the Pharos in the stormy sea ;—so far it vindicates the name, and fulfils the praise, of Home.

" And wherever a true wife comes, this home is always round her. The stars only may be over her head ; the glowworm in the night-cold grass may be the only fire at her foot ; but home is yet wherever she is ; and for a noble woman it stretches far round her, better than ceiled with cedar, or

painted with vermilion, shedding its quiet light far, for those who else were homeless." [1]

Ruskin favoured early marriage for the working-classes because it induced morality, but not hurried, improvident unions. One of his grave indictments of modern life was that its strenuousness retarded marriage in the case of the wise and provident until the best of their youth had passed ; while the idle, thriftless, and incontinent, unrestrained by any thought of the future, hurried into marriage and brought into the world children weak in character, like themselves, and then trusted to outside help in educating them. Ruskin taught that the beginning of all sanitary and moral law must be in State regulation of marriages. The reward for youth should be permission to marry, and this permission should be given as a public testimony that the youth and maiden were good and virtuous in character, the one skilled in his handicraft, and the other in domestic economy. He suggested that those who had obtained this permission to marry should have, if necessary, a State allowance of a fixed sum according to their position in life, payable for seven years from their wedding day, in order that they might be free from care during their first years of child-rearing. On the other hand the rich were to be allowed only a certain income, in proportion to their rank, from their wealth, during the same period after marriage ; to accustom them

[1] " Sesame and Lilies."

to live on moderate incomes before they had control of larger ones. The marriageable age was never to be earlier than seventeen for girls, and twenty-one for youths. Those who gained permission to marry in their eighteenth and twenty-second years, respectively, were to be counted honourable, and it was to be thought disgraceful if the woman's twenty-first year and the man's twenty-fourth ended without having satisfied the authorities that they were fitted for married life.

Twice a year, on May Day and at harvest home, a festival was to be held, with innocent revelry and feasting, at which the names of those who had qualified for matrimony during the past six months were to be publicly announced, and the candidates crowned; after which these (the maidens as " Rosières " and the bachelors called by some name derived from the laurel fruit) led the procession, with music and singing, through the streets. The result of this regulation of marriages, and enforced sanitary laws, would be, Ruskin believed, the development within a few generations of a very high type of beauty in face and form, together with superior intelligence.

But in order to continue this upward progress of the race, education must play its part. Ruskin approved of compulsory education for children of the working-classes, but thought that discretionary powers should be given certain officials to excuse attendance at the State schools in the case of

children whose parents were sick and needed their care, or where from any cause home-life would be of more benefit to them than that of the school. By education alone, and that not only of the intellect but of the heart, could crime be lessened : for moral education prevented crime by taking away from the young " the *will* to commit sin."

" Educate, or govern, they are one and the same word. Education does not mean teaching people to know what they do not know. It means teaching them to behave as they do not behave. And the true ' compulsory education ' which the people now ask of you is not catechism, but drill. It is not teaching the youth of England the shapes of letters and the tricks of numbers ; and then leaving them to turn their arithmetic to roguery, and their literature to lust. It is, on the contrary, training them into the perfect exercise and kingly continence of their bodies and souls. It is a painful, continual, and difficult work ; to be done by kindness, by watching, by warning, by precept, and by praise,—but above all—by example.

" Compulsory ! Yes, by all means ! ' Go ye out into the highways and hedges, and *compel* them to come in.' Compulsory ! Yes, and gratis also. *Dei Gratia*, they must be taught, as *Dei Gratia*, you are set to teach them. . . . For that is another of our grand popular mistakes—people are always thinking of education as a means of livelihood. Education is not a profitable business but a costly

one ; nay, even the best attainments of it are always unprofitable, in any terms of coin. . . . You are to spend on National Education, and to be spent for it, and to make by it, not more money, but better men ; to get into this British Island the greatest possible number of good and brave Englishmen. *They* are to be your ' money's worth.' " [1]

After this, it will be easily understood that Ruskin's system of education depended first of all on moral training and the cultivation of a child's powers of observation. " The three R's " filled a very subordinate place in his school syllabus. A child could do very well without reading and writing, but not without definite instruction in Honour, Truth, Humility, Love ; not to mention Obedience and Reverence, which were included in Humility. As the conditions under which a child was taught largely influenced its future life, Ruskin emphasised the need for beautiful objects and " gentle human faces " around it. Nothing ugly, depressing, or base should ever be allowed in the neighbourhood of children.

Obedience was the foundation-stone on which the whole superstructure of education rested. Then came training in :—

" (*a*) the laws of health, and the exercises enjoined by them ;

" (*b*) habits of gentleness and justice ; and

" (*c*) the calling by which he is to live." [2]

[1] " The Crown of Wild Olive."

[2] Preface to " Unto This Last,"

Riding, running, the management of a boat in the case of children living on the coast, the art of self-defence, dancing and music, were included in the first section. Reverence and Compassion came under the second heading ; so did the strictest regard for truth, a branch of truthfulness being the careful study of words and their exact meanings. For the third section, the schools were divided into groups, according to the district. Children dwelling in cities learned mathematics and the fine arts ; country children acquired a practical knowledge of agriculture, and studied the natural history of birds, insects, and plants ; while those living near the sea had their special needs consulted by being taught " physical geography, astronomy, and the natural history of sea-fish and sea-birds." Technical education was not to be overlooked : the carpenter's workshop was always to form part of a boys' school buildings, and, where possible, a potter's shed.

Reading and writing were omitted because, as he explains, few people got any good from either. The reading done by foolish people was harmful to themselves, and their writing harmed others. As for arithmetic, a visit paid to Coniston school, where the master put his class through a brilliant display of feats of agility in mental arithmetic, convinced him of its practical uselessness when the chief aim was to teach self-reliance. A few general and unexpected questions put by himself to the scholars

showed that as far as everyday objects were con-
cerned their intelligence remained quite undeveloped.
Ruskin's whole idea was based on a gradual un-
folding of the child's natural powers ; on putting
it in the way of acquiring knowledge for itself and
training its powers of observation rather than
teaching set subjects by rote. So the " three
R's " were consigned to the background, and
as a total ignorance of these subjects might be
awkward, he conceded home instruction in them
during the child's earliest years : grudgingly,
because he thought they confused and encumbered
the memory.

School subjects were to be divided into two
classes—those taught to all alike, and those limited
to children who showed some aptitude for them.
Vocal music came under the first heading, and class-
singing formed part of the daily programme. For
all alike, too, were such subjects as geometry, and
astronomy taught from plainly printed daily charts
showing the positions of all visible stars and planets ;
supplemented by exercises, at least weekly, in draw-
ing the arcs described by sun and stars. Botany
taught through the medium of gardens cultivated
by the children, and zoology, in studying which the
care of pets had a part, were also general subjects ;
though Ruskin seems to have wavered on this point,
as he states elsewhere in " Fors " that botany need
not be taught to the children of fishermen. Both
boys and girls learned Latin.

Drawing and history may be described as extras, since they were to be taught only to those who had a special gift for either. Nor was any pupil to be worried with geography, unless his memory and idea of locality proved good enough to carry him successfully through the ordeal of supplying the names left blank in maps engraved, after photographs, from models to scale. These maps were to show plainly all the natural features of the country, as well as its geological formation, but, as a memory-test, rivers, mountains, towns, and so forth had no names affixed. These were contained in a key, which also served as the elementary text-book. Railways were never to be shown on maps used in schools.

History, not a dry list of dates, but as the medium for conveying great moral lessons, was to be taught with practical illustrations in the way of maps, explanations of the quarterings in our Royal Standard and how they came there, lives of great history-makers, and the customs of the people. The histories of five great cities—Athens, Rome, Venice, Florence, and London—were marked for special attention. Older people were advised to add to the history of these cities a knowledge of the works of five people connected with them—Plato, Virgil, Carpaccio, Dante, and Shakespeare.

Daily, for at least an hour, a well-trained reader was to entertain the children by reading aloud from some interesting story or book of adventure. Chil-

dren of the upper classes might thus hear Chaucer, Spenser, and Scott ; for the lower classes ballads and fables could be substituted. True history or travels and fairy tales were also allowable, but he vetoed the use of didactic or descriptive books for this purpose. Shakespeare was forbidden, either for reading aloud or as a school book : his works were to be read privately and thought over. During the time occupied by this daily reading, children who were able to do so might sew or draw while they listened, and any who were not interested might go on with their work without being blamed for inattention to the reader : they were however liable to censure if the work they were engaged upon suffered from inattention. Rather hard on children of normal restlessness, surely !

The school library was for the children's use alone. Ruskin believed in freedom of choice, and the child's power to assimilate the best if its tastes had not been perverted. " The chance and scattered evil that may here and there haunt, or hide itself in, a powerful book, never does any harm to a noble girl ; but the emptiness of an author oppresses her, and his amiable folly degrades her. And if she can have access to a good library of old and classical books, there need be no choosing at all. Keep the modern magazine and novel out of your girl's way : turn her loose into the old library every wet day, and let her alone. She will find what is good for her ; you cannot : for there is just

this difference between the making of a girl's character and a boy's—you may chisel a boy into shape, as you would a rock, or hammer him into it, if he be of a better kind, as you would a piece of bronze. But you cannot hammer a girl into anything. She grows as a flower does,—she will wither without sun ; she will decay in her sheath, as a narcissus will, if you do not give her air enough ; she may fall, and defile her head in dust, if you leave her without help at some moments of her life ; but you cannot fetter her ; she must take her own fair form and way, if she take any, and in mind as in body, must have always

> ' Her household motions light and free,
> And steps of virgin liberty.'

Let her loose in the library, I say, as you do a fawn in a field. It knows the bad weeds twenty times better than you ; and the good ones too, and will eat some bitter and prickly ones, good for it, which you had not the slightest thought would have been so." [1]

Bridget Elia, it will be remembered, " was tumbled early, by accident or design, into a spacious closet of good old English reading, without much selection or prohibition, and browsed at will upon that fair and wholesome pasturage. Had I twenty girls," says wise, simple Charles Lamb, " they should

[1] " Sesame and Lilies."

be brought up exactly in this fashion." So if
Ruskin's theory was not quite original he found
himself in good company.

Ruskin would have the girls taught sewing,
spinning, weaving, and cooking; dressmaking
being also allowed them, so far as it was in
compliance with the feminine instinct for " self-
decoration in all worthy and graceful ways." As
her mission was home-life, as guide and directress
rather than as an active worker in the world, her
education in all things was to be wide rather than
deep. He sought to quicken her responsiveness in
general company, not to make a clever or brilliant
woman of her. Ruskin, clear-eyed and far-seeing,
recognised that, whether she liked it or not, a
woman's power depended upon her muliebrity.
She could not change her nature, nor the direction
of her influence in the world; therefore all ad-
vancement must be on natural lines. The foolish
woman may rail at Ruskin's ideal as a poor-
spirited creature; the wise one knows that in
such women rest our hopes for the future of the
race.

It will be seen that the whole of Ruskin's educa-
tional teaching is directed to the cultivation of
individuality, self-reliance, self-control, contentment,
and reverence. Competitive examinations were
absolutely prohibited. The cramming system, with
all its resulting evils, was to be abolished, and
emulation discouraged. The time usually wasted

on subjects for which a child had no natural gift
was to be more profitably employed in developing
his talents. Instead of, as under our present system
of education, cramping individuality by compelling
all children to take the same course of study,
originality was to be cultivated to the utmost
possible extent. Mediocrity stood less chance of
distinction, but the wings of genius were not
clipped.

Above all, Ruskin's system aimed at developing
strength of character and making good citizens.
The early lessons in Obedience, Reverence, Truth-
fulness, and other moral virtues fitted them to live
with contentment and self-respect in their own class.
Education, Ruskin explained in " Time and Tide,"
was not a leveller : on the contrary it was the most
fatal way of proving distinctions. He gave as an
instance a handful of pebbles from the sea-shore ;
alike to the untrained eye until the lapidary had
polished them, when the value of each stone was
shown by the fineness of its marking and the degree
of polish it had taken. There could be no real
equality. He instanced two children, going to
school hand in hand, and spelling together from
the same page for the first half-hour, equals for the
first and last time ; the gulf ever widening—" at
birth nothing, at death, infinite." Ruskin always
taught the dignity of contentment : the wisdom
of a man raising the standard of living in his own
class, instead of struggling to attain a higher level

at the cost of separation from his family; with no other result than the loneliness resulting from living in company with those who are aliens in thought and custom to the caste he was born in. " My continual aim has been to show the eternal superiority of some men to others, sometimes even of one man to all others; and to show also the advisability of appointing such persons or person to guide, to lead, or on occasion even to compel and subdue, their inferiors, according to their own better knowledge and wiser will." [1]

Ruskin had no wish to imply that education did not alter a man's level. " The man who likes what you like," he says in " The Crown of Wild Olive," " belongs to the same class with you, I think. Inevitably so. You may put him to other work if you choose; but, by the condition you have brought him into, he will dislike the work as much as you would yourself. You get hold of a scavenger or costermonger, who enjoyed the ' Newgate Calendar ' for literature, and ' Pop goes the Weasel ' for music. You think you can make him like Dante and Beethoven? I wish you joy of your lessons; but if you do, you have made a gentleman of him :—he won't like to go back to his costermongering." The ineffaceable distinctions Ruskin had in mind were not due to education but to the thousand-and-one social observances that mark the barriers

[1] " Unto This Last."

between class and class. There will always be a majority to whom nothing is possible but mechanical and servile labour.

.Nowadays, when there is so little true self-respect among the working-classes that they grudge giving any outward signs of respect to their masters ; when schoolmasters dare not chastise an insolent pupil without fear of a summons for assault ; when parents are not ashamed to appear before a magistrate and declare their own children beyond control (the mother of a six-year-old boy made this disgraceful excuse at Highgate Police Court on 24th September 1908) ; when child-suicide is not uncommon, and occurs with increasing frequency,— it is just as well to think over Ruskin's teaching and ask ourselves if we might not do better by following his wise counsel : inculcating habits of obedience, reverence, and patience on our children, rather than allowing them to grow up with neither the fear of God nor man before their eyes. It is neither kindness nor love that allows them to grow thus unchecked, but rather a weak sentimentality— due in a great measure to indolence and indifference —which shrinks from the idea of enforcing disciplinary measures. We are sowing the wind, and shall reap the whirlwind : for into the hands of these spoilt, neurotic children we shall, sooner or later, have to commit the fortunes of the world's greatest empire, and the destinies of hundreds of millions of their fellow-creatures. How shall they,

who have never learnt to control themselves, be able to govern others ?

" Are we not of a race first among the strong ones of the earth ; the blood in us incapable of weariness, unconquerable by grief ? Have we not a history of which we can hardly think without becoming insolent in our just pride of it ? Can we dare, without passing every limit of courtesy to other nations, to say how much more we have to be proud of in our ancestors than they ? Among our ancient monarchs, great crimes stand out as monstrous and strange. But their valour, and, according to their understanding, their benevolence, are constant. The Wars of the Roses, which are as a fearful crimson shadow on our land, represent the normal condition of other nations ; while from the days of the Heptarchy downwards we have had examples given us, in all ranks, of the most varied and exalted virtue ; a heap of treasure that no moth can corrupt, and which even our traitorship, if we are to become traitors to it, cannot sully.

" And this is the race, then, that we know not any more how to govern ! and this is the history which we are to behold broken off by sedition ! and this is the country, of all others, where life is to become difficult to the honest, and ridiculous to the wise ! And the catastrophe, forsooth, is to come just when we have been making swiftest progress beyond the wisdom and wealth of the past." [1]

[1] " The Crown of Wild Olive."

Ruskin was thinking of the economic condition of the country when he wrote thus ; but does it not come with terrible force applied to the race of moral weaklings for which our modern system of education and home-training is responsible ?

CHAPTER XVIII

RUSKIN'S TEACHING. II.

COMMERCIALISM—CO-OPERATION—VARIOUS

RUSKIN'S ideas on social reform cover such a wide range of subjects that it is difficult to compress even those most characteristic of the man into the limits of this chapter. No question was too deep for him to attempt a solution, no detail so small that he neglected to touch upon it. But there are certain broad aspects which claim attention as revealing his personal bias, and for this reason specially interesting to us at the present moment.

By reason of early education and inherited beliefs on the one hand, and of sympathy for the weak and oppressed on the other, Ruskin became that strange anomaly, an aristophile-democrat. The position seems irreconcilable at first glance, but a little thought and careful piecing together of his political writings will explain the paradox.

All Ruskin's teaching is based on his axiom " THERE IS NO WEALTH BUT LIFE. Life, including all its powers of love, of joy, and of admiration.

That country is the richest which nourishes the greatest number of noble and happy human beings ; that man is richest who, having perfected the functions of his own life to the utmost, has also the widest helpful influence, both personal, and by means of his possessions, over the lives of others." [1]

Acting on this belief, he next proceeded to investigate the causes underlying various evils which weakened or destroyed life—greed on the one side, causing poverty on the other ; ignorance, and its attendant, crime. So far there was nothing in his belief that had not been advanced by other writers, but in his application of these elementary facts Ruskin's prejudices influenced his logic. He agreed with other political economists in attributing the poverty of the workman to the greed of the capitalist, but his remedy was a return to the old system of hand labour and the abolition of machinery.

Ruskin's objections to machinery chiefly rested on the soul-deadening influence of subdivided labour. The constant repetition of a dull monotonous task killed all individuality in the worker. There could be none of the old craftsman's pride where the workman's share in making an article was limited to the mechanical action of controlling a machine. Ruskin loved the country. The introduction of machinery had blackened it with smoke and drawn off the rural population to dwell in crowded cities, under conditions that

[1] " Unto This Last."

rendered them anæmic and stunted the growth of
their children. All this made a strong indictment
against machinery to Ruskin, æsthete and nature-
lover. He thought of the sordid squalor of the
towns ; their ugliness, and the debasing effects of
all this on the tastes and characters of those who
dwelt in them. He said a great cry went up from
these towns " that we manufacture everything
there except men."

Ruskin failed to see the other side of the question
—that machinery lightened the toil of many a
hard-working drudge whose task could now be per-
formed mechanically : failed also to realise the
added comforts and higher standard of life rendered
possible by the cheaper production through machine
labour of articles for domestic use or luxury.

Now, although at first sight any attempt to put
back the hands of the world's clock and return to
the slow laborious method of working may seem
foolish, a return to his axiom will enable us to see the
question from his point of view. To Ruskin, Life—
the life of the factory worker or miner—was Wealth :
the only true national wealth ; countable in souls,
not specie. " It matters little, ultimately, how
much a labourer is paid for making anything ; but
it matters fearfully what the thing is, which he is
compelled to make. If his labour is so ordered as
to produce food, and fresh air, and fresh water, no
matter that his wages are low ;—the food and fresh
air and water will be at last there ; and he will at

last get them. But if he is paid to *destroy* food and fresh air, or to produce iron bars instead of them,—the food and air will finally *not* be there, and he will *not* get them, to his great and final inconvenience." [1] Later on in the same book—in the lecture on Work —he says :—

" Of all wastes, the greatest waste that you can commit is the waste of labour. If you went down in the morning into your dairy, and found that your youngest child had got down before you ; and that he and the cat were at play together, and that he had poured out all the cream on the floor for the cat to lap up, you would scold the child, and be sorry the cream was wasted. But if, instead of wooden bowls with milk in them, there are golden bowls with human life in them, and instead of the cat to play with,—the devil to play with : and you yourself the player ; and instead of leaving that golden bowl to be broken by God at the fountain, you break it in the dust yourself, and pour the human life out on the ground for the fiend to lick up—that is no waste !

" What ! you perhaps think, ' to waste the labour of men is not to kill them.' Is it not ? I should like to know how you could kill them more utterly, —kill them with second deaths, seventh deaths, hundredfold deaths ? It is the slightest way of killing to stop a man's breath. Nay, the hunger, and the cold, and the whistling bullets—our love

[1] " The Crown of Wild Olive."

messengers between nation and nation,—have brought pleasant messages to many a man before now : orders of sweet release, and leave at last to go where he will be most welcome and most happy. At the worst you do but shorten his life, you do not corrupt his life. But if you put him to base labour, if you bind his thoughts, if you blind his eyes, if you blunt his hopes, if you steal his joys, if you stunt his body, and blast his soul, and at last leave him not so much as strength to reap the poor fruit of his degradation, but gather that for yourself, and dismiss him to the grave, when you have done with him, having, so far as in you lay, made the walls of that grave everlasting : . . . this you think is no waste, and no sin." [1]

Ruskin taught that healthful, honest work was essential to the happiness of all classes. The brain-worker was told by Ruskin that his day was not complete unless he had done his share of manual labour, and helped to lighten the lot of the hewers of wood and drawers of water whose heavy manual toil was yet an essential part of the nation's life. " It may be proved, with much certainty, that God intends no man to live in this world without working, but it seems to me no less evident that He intends every man to be happy in his work. It is written ' in the sweat of thy brow,' but it was never written ' in the breaking of thy heart,' thou shalt eat bread." [2]

[1] " The Crown of Wild Olive."
[2] " Pre-Raphaelitism."

As there was much necessary work in the world that was dangerous, Ruskin suggested that all this should be done by criminals.

Gambling in food-stuffs, or the destruction of any article of food—fish or fruit, for instance—in order that a glutted market should not result in lower prices, roused, and justly, Ruskin's wrath. The great American trusts and combines were yet to arise and batten on the people when Ruskin wrote, but he had to hear of fish carted away for manure while the poor starved, and fruit rotting on the trees when the children might have enjoyed an unwonted feast. This was the aspect of commercialism that led him to condemn trade, and suggest that the duty of bringing together the producer and consumer should be undertaken by gentlemen, and not by those whose sole aim was to squeeze the highest possible profit out of the transaction.

Ruskin's views with regard to interest on capital differed widely at various periods. When he wrote "Munera Pulveris," that is, at the time when his judgment was soundest, he allowed the justness of moderate interest on invested capital. Both then and for some years later, part of his own money was invested in Consols : one of his first acts after his father's death was the reinvestment of £50,000 in mortgages at five per cent instead of three per cent stock. As time went on interest and usury became almost synonymous terms with him. In

April 1871 he said in " Fors " (Letter IV.) that he
was not " comfortable " about a sum of £7,000 he
had invested in " Funds or Founded things," the
only point on which he appeared clear being that he
drew a dividend of two hundred a year for it—a
matter which exercised his conscience sorely,
though in July 1877 he still held Consols, and de-
fended himself in " Fors " (Letter LXXX.) on the
grounds that as long as there was a National Debt
he might as well use the system he had condemned,
since his abstention would not abolish it.

By this time he had completely confused the
terms interest and usury ; so that he looked upon
the shopkeeper or manufacturer who developed his
business with the help of borrowed capital as only
a degree less culpable than the moneylender who
took advantage of a borrower's dire necessity to
exact usurious interest on a loan. Nothing would
satisfy Ruskin but the abolition of all forms of
invested capital—or rather of any interest, or return,
for the use of capital. It was allowable to save—
though, strangely enough, Ruskin laid little stress on
the necessity for thrift—for he said in his " Crown
of Wild Olive " : " An industrious man work-
ing daily, and laying by daily, attains at last the
possession of an accumulated sum of wealth, to
which he has absolute right. The idle person who
will not work, and the wasteful person who lays
nothing by, at the end of the same time will be
doubly poor—poor in possession and dissolute in

moral habit; and he will then naturally covet the money which the other has saved. And if he is then allowed to attack the other, and rob him of his well-earned wealth, there is no more any motive for saving, or any reward for good conduct; and all society is thereupon dissolved, or exists only in systems of rapine. Therefore the first necessity of social life is the clearness of national conscience in enforcing the law—that he should keep who has JUSTLY EARNED." A man might save, but if he did not wish to spend his savings " he must either hoard it or lend it, and the worst thing he can generally do is to lend it; for borrowers are nearly always ill-spenders, and it is with lent money that all evil is mainly done, and all unjust war protracted." [1] Ruskin seems here to overlook the loss to the community where wealth is hoarded, and the benefit accruing to it when a poor inventor is able to command capital at low interest with which to develop a new idea.

Rent came under Ruskin's condemnation even more decisively than interest. It was usury—" the fatallest form " of it—yet he sold his Marylebone house property to Miss Octavia Hill, who carried out in practice his theories on the subject of the housing of the working-classes. Miss Octavia Hill, who still remains with us—linking the philanthropy of to-day with that awakening interest in the lives of the poor aroused by the teaching of Carlyle,

[1] " The Crown of Wild Olive."

Ruskin, and Kingsley during the mid years of the last century—began her splendid work for the better housing of the poor with some houses in Marylebone left to Ruskin by his father. Three more houses were bought with money advanced by Ruskin, and these paid him five per cent interest, with an additional sum of £48 written off the principal after only eighteen months of Miss Octavia Hill's careful management.

Miss Hill collected the rents herself, using the opportunities this gave her to become acquainted with the tenants and encourage them to improve their condition. Out of the rents collected she set aside a certain proportion for repairs ; any interest on purchase money was deducted, and out of the balance she defrayed the expense of any improvements suggested by the tenants themselves. Gradually, the houses were put in thorough repair, sanitary defects remedied, playgrounds provided for the children, and the tenants of what had been some of the worst houses in Marylebone became self-respecting and humanised. Other property was acquired ; ladies were trained to work with her as " visitors," each having charge of a court or block of buildings, and performing such duties as rent-collecting and school-board visiting.

In 1902 Miss Hill had 1,268 families under her own control ; the Ecclesiastical Commissioners and other owners of slum property either entrusted her with the management of their houses or con-

sulted her on the subject, and her system had been adopted in many large towns of both England and Scotland. Miss Hill did a higher service than merely providing better dwellings for the poor : she educated them to the point of desiring healthier surroundings, and made them active agents in carrying out improvements in their own homes. Ruskin's ideas on the subject of humanising the poor by giving them healthier homes were sound in principle, but it needed Miss Hill's practical common-sense to reduce his theories to practice.

Ruskin's little inconsistencies were in a great measure due to his lack of business talents. When it came to a question of rent, for instance, while in his teaching he denounced it as unnatural, he was in his private capacity receiving both rent and interest—not from any dishonesty, but because his lavish generosity left him with an ever-empty purse, and he took whatever came to fill it with the unquestioning simplicity of a child. It is impossible to follow Ruskin's life without realizing that as far as money was concerned, in spite of all his political writing, he was absolutely ignorant of its value.

The tea-shop at 19 Paddington Street was one of Ruskin's efforts to carry out his ideas of honest commercialism. Commerce, as we have seen in the chapter on St. George's Guild, was chief amongst Ruskin's bugbears. Advertisement in any shape or form was anathema to him, so of course nothing of

the kind was allowable in his model shop. But there
are advertisements and advertisements. Perhaps the
" fine old china," from the collection of an Italian
Cavaliere, displayed in the window was not without
its influence in attracting the notice of the cultured
passers-by, who were also most likely to be dis-
criminating purchasers of tea. Mr. Arthur Severn
painted the sign for this shop, and an old servant
of the Ruskins had charge of it, but with many
restrictions as to the method of conducting the
business. Tea of the best quality was sold at a
fair profit : later, coffee and sugar were added to
the stock. On the death of Ruskin's old servant
Miss Hill took over the management of this in
addition to his other property in the neighbourhood.
Mr. Collingwood tells us that the shop returned
" legitimate profits."

Of all Ruskin's disciples Arnold Toynbee came
nearest to carrying out his plans for the elevation
of the masses. This young reformer, who died,
worn out, at the age of thirty-one, threw himself
with all the zeal of his delicate yet forceful tempera-
ment into the work of developing Friendly Societies
and Trades Unions. In solitude he prepared for his
work : at the age of eighteen he went alone to the
quiet country village of Bracknell, in Berkshire, to
study history and its philosophy. From thence
he went to East Lulworth, on the Dorset coast,
another quiet spot, and in strict retirement between
these two places spent a year in the " pursuit of

truth for its own sake." Constitutionally delicate, his Oxford life, which followed on this term of contemplation, was broken by ill-health. A serious breakdown followed on his attempt to win a scholarship at Balliol, and an enforced year's rest; after which he returned to Oxford as a commoner of Balliol, but with only strength for two or three hours' study a day. After this it is not surprising that he had to be content with a pass degree, which he took in the summer of 1878.

But Arnold Toynbee was an example of a strong personality in a frail body. Jowett, T. H. Green, and Nettleship were among his intimate friends, and he was a frequent guest of Ruskin at the breakfasts instituted during the latter's Slade Professorship. " The Apostle Arnold " was his name amongst those who admired his pure and lofty ideals and were carried away by his eloquence : Mrs. Humphry Ward drew her character " Robert Elsmere " from Arnold Toynbee. His influence was so strong for good over all with whom he came into contact that, in spite of his delicate health and lack of University honours, he was appointed tutor and lecturer to Indian Civil Service candidates at Balliol immediately after taking his degree. In connection with this he gave his lectures on "The Industrial Revolution in England," with special application to the decline of the yeomanry.

But before this (in 1875) Toynbee had commenced his mission as a social worker. He spent part of

his vacations during this year in barely furnished rooms in Commercial Road, working in conjunction with Canon Barnett of St. Jude's, Whitechapel ; acting also as a visitor for the Charity Organisation Society. His evenings were often spent at the Tower Hamlets Radical Club, where he sometimes lectured on religious subjects—for Toynbee took a keen interest in Church affairs, and advocated local Church government by parochial councils, the union of Churchmen and Dissenters, and Church and State : "real religious freedom," he taught, was not possible except in a National Church, which could not be independent of the State. But Toynbee's connection with Whitechapel is chiefly noteworthy because it led to the founding of Toynbee Hall, for he soon had to give up his personal work there on account of ill-health.

Toynbee's ideas followed on much the same lines as Ruskin's. From his more practical knowledge of how the poor lived, he was sometimes able to carry Ruskin's teaching a step farther than his master. Toynbee's schemes for improving the conditions of the working-classes were based on better housing, open spaces, and the establishment of free libraries. Alas, that such a promising career should have been cut short ! Ruskin had many a keen follower, but of all the eager, earnest youths who attended his lectures and tried to carry out his ideas, few had better natural chances of success than Arnold Toynbee, whose personal influence was

the motive power in the lives of some of our most active philanthropists.

Both Ruskin and Toynbee are sometimes claimed as Socialists. In reality they differed widely from the bona-fide Socialist. Ruskin, as we have seen, firmly believed in kingship and government by the aristocracy, whose hereditary privileges and advantages of birth and early training rendered them peculiarly fitted to assume the control of men. Instead of levelling class, he wished to awaken the nobility and country gentlemen to a sense of their duties and responsibilities.

In a footnote to the fourth chapter of "Unto This Last," Ruskin makes his position clear with regard to Socialism : . . . "I am not taking up, nor countenancing one whit, the common socialist idea of division of property ; division of property is its destruction ; and with it the destruction of all hope, all industry, and all justice : it is simply chaos—a chaos towards which the believers in modern political economy are fast tending, and from which I am striving to save them. The rich man does not keep back meat from the poor by retaining his riches ; but by basely using them. Riches are a form of strength ; and a strong man does not injure others by keeping his strength, but by using it injuriously. The socialist, seeing a strong man oppress a weak one, cries out : ' Break the strong man's arms ' ; but I say, ' Teach him to use them to better purpose.'

The fortitude and intelligence which acquire riches are intended, by the Giver of both, not to scatter, nor to give away, but to employ those riches in the service of mankind ; in other words, in the redemption of the erring and aid of the weak—that is to say, there is first to be the work to gain money ; then the Sabbath of use for it—the Sabbath, whose law is, not to lose life, but to save. It is continually the fault or the folly of the poor that they are poor, as it is usually a child's fault if it falls into a pond, and a cripple's weakness that slips at a crossing ; nevertheless, most passers-by would pull the child out, or help up the cripple. Put it at the worst, that all the poor of the world are but disobedient children, or careless cripples, and that all rich people are wise and strong, and you will see at once that neither is the socialist right in desiring to make everybody poor, powerless, and foolish as he is himself, nor the rich man right in leaving the children in the mire."

The upper classes, according to Ruskin, must, in the interests of the nation, continue to hold the administrative power. It must however be understood that he had no intention of entrusting the lives of the people to a mushroom nobility. The class he had in mind were fitted by the accumulated experience of hundreds of years to take command of their fellow-men. These old families were to be secured possession of land proportionate to their rank. Ruskin suggested that their

incomes should not be derived from this land but paid directly by the State ; all rents from the land itself being paid into a common fund, and returned to the land in the shape of improvements. How the incomes of his aristocracy were to be secured is not quite clear.

Many of the schemes we pride ourselves on to-day as representing the latest efforts of modern philanthropy were originated by Ruskin. State education was one of his pet projects ; to his teaching we owe the efforts that have been made—all too slowly, but still growing and spreading—for raising the tone of our poor by providing them with better homes. Technical schools, the revival of skilled crafts and exhibitions, societies for the encouragement of home industries and hand labour, are all largely due to his example. More directly, his teaching resulted in the establishment of a watermill for weaving homespun, built at Laxey, in the Isle of Man (1876), and the revival of spinning and hand-loom weaving at Langdale—with so much success that work was provided for many otherwise idle hands, and the produce of these looms became greatly in demand by embroideresses and laceworkers. Keswick also entered the field with the Ruskin Linen Industry. The unemployed question —that riddle of the Sphinx—and old-age pensions both taxed Ruskin's ingenuity, as they do ours to-day. Nor can the advocates for small holdings claim originality with regard to their panacea for

all social ills, for Ruskin was before them in his efforts to repopulate the countryside with a sturdy race of yeomen.

As we pass from one page to another of his political writings and note the fearless way in which Ruskin wrestled with problems, any one of them enough to baffle the ingenuity of statesmen, criticism gives place to admiration. And remembering how much of what he taught has now become a truism, it is not rash to hope that he was prophetic when he wrote the last few stirring pages of " Unto This Last " :—

" All England may, if it so chooses, become one manufacturing town ; and Englishmen, sacrificing themselves to the good of general humanity, may live diminished lives in the midst of noise, of darkness, and of deadly exhalation. But the world cannot become a factory, nor a mine. . . . Neither the avarice nor the rage of men will ever feed them, and however the apple of Sodom and the grape of Gomorrah may spread their table for a time with dainties of ashes, and nectar of asps—so long as men live by bread, the faraway valleys must laugh as they are covered with the gold of God, and the shouts of His happy multitudes ring round the winepress and the well. . . .

" Raise the veil boldly ; face the light ; and if, as yet, the light of the eye can only be through tears, and the light of the body through

sackcloth, go thou forth weeping, bearing precious seed, until the time come, and the kingdom, when Christ's gift of bread, and bequest of Peace shall be Unto this Last as unto thee ; and when, for earth's severed multitudes of the wicked and the weary, there shall be holier reconciliation than that of the narrow home, and calm economy, where the Wicked cease—not from trouble, but from troubling —and the Weary are at rest." [1]

[1] " Unto This Last."

CHAPTER XIX

AT BRANTWOOD

WHEN old Mr. Ruskin died, in 1864, affection for his son was found to have outweighed any little differences of opinion that had arisen between them in politics or by reason of Ruskin's abandonment of art criticism in favour of social reform. The bulk of his fortune was left to Ruskin, who found himself in possession of £120,000, leasehold property at Herne Hill and Denmark Hill, and a freehold pottery at Greenwich. This was leased to a maker of chimney-pots, who brought Ruskin his rent of fifteen pounds a quarter, receiving in return a glass of wine and his landlord's sympathetic interest in high winds as conducive to brisker business. In addition to all this, his inheritance included pictures valued at £10,000.

Mr. Ruskin had not been a miser : he had spent freely but judiciously on the comfort of himself and his family ; generously, as concerned gifts and charities. His fortune—made, it will be remem-

bered, entirely by his own exertions—was the result of careful business management and Scotch frugality : systematic living below his actual income, and avoidance of expensive society. Under these circumstances, having lived as long as his memory went back in solid comfort, having also no vices, it might have been supposed that Ruskin would have proved an exception to a fact that has almost the regular force of a natural law— the alternation of saving and spending by two successive generations. Probably owing to the restrictions imposed by his mother in earlier years, Ruskin proved no more able to take care of his money than the veriest spendthrift who ever dissipated his patrimony ; but with this difference, that it was spent on others and not on himself.

He began his career as a prodigal son by distributing £17,000 amongst those of his father's relations who had, in his opinion, reason to complain of neglect in Mr. Ruskin's will. Fifteen thousand more went as a loan to set a cousin up in business, and this was written off as a gift in accordance with his " message " from St. Ursula on Christmas Day, 1876. An unlucky change of investments from stocks to " entirely safe " mortgages accounted for the loss of another £20,000 ; gifts to St. George's Fund and the endowment of a mastership of drawing at Oxford took £14,000. Here we have a slice of £66,000

taken from his fortune—more than half the invested money.

But this was a mere trifle. Ruskin, generous to a fault, took no precautions against imposture. He employed as secretary a plausible scamp who took advantage of his easy-going good nature ; appropriated large sums of money entrusted to him for the benefit of needy artists and other cases of real or supposed distress, and exploited Ruskin to his own advantage. How large a proportion of the money Ruskin believed to be spent in charity was thus misappropriated can never be estimated : Ruskin was not the man to investigate cases himself, nor to keep accounts of the money so spent.

Absolutely unbusinesslike, Ruskin fell an easy prey to the unscrupulous. It may be that his personal experiences of the unjust advantage taken where a purchaser was ignorant or credulous, led to the crusade against commercialism he entered upon in his latter years. Some of his pictures, too large for Brantwood, were sold, and others purchased—the sales always to his disadvantage, and the purchases made at fancy prices. The dealer's explanation was flattering to his vanity : that a picture's market value was lowered by Ruskin's rejection of it, and his wish to buy another sufficient to enhance its price. Another of his bad bargains is frankly confessed to in " Fors." He bought a collection of minerals ; gave three thousand pounds

for it, and found it not worth five hundred. A lawsuit followed, but after two years' litigation a thousand pounds ordered to be returned him on the price was swallowed up in costs; the only satisfaction he obtained being the judge's decision that the defendants should give him another five hundred pounds' worth of minerals.

Brantwood was his next purchase; bought without examination, and found afterwards to be in a ruinous condition. The purchase money was fifteen hundred pounds, but the amount became four thousand before it was habitable: two thousand more was spent on improvements.

Mr. Ruskin left as provision for his widow £37,000 and a life interest in the house at Denmark Hill. When she died, in 1871, this also came to Ruskin. Yet in March 1877, when he published an account of his expenditure in "Fors" (Letter LXXVI.) of £157,000 left him between 1864 and that date, only stock to the value of £15,000 was left; though he added to this pictures insured for £30,000, and estimated to be worth double that amount. He said that his average expenses during the period since his father's death had been £5,500 a year, and now, of what remained he proposed to spend three thousand on amusing himself that year; investing the balance of twelve thousand in Consols, so that he might be assured a yearly income of £360 for the remainder of his life. Probably Ruskin himself never knew what proportion of this yearly

expenditure went in gifts and what was spent on his personal comforts. He liked to live well, in a solid, old-fashioned way, but it may be suspected that the larger portion was expended on others.

Old Mr. Ruskin's death introduced a new member into the family circle, whose tact added much to Ruskin's home comfort. Miss Joanna Agnew, a young cousin, came to Denmark Hill on a short visit, and remained with Mrs. Ruskin until April 1871, when she married Mr. Arthur Severn, son of their old friend the British Consul at Rome. In the following December Mrs.' Ruskin died; having survived her old servant, Anne, some months. In accordance with her son's dislike of black and funeral display, Mrs. Ruskin's coffin was painted blue. Ruskin, who had reproached himself bitterly for his frequent absences from home during the closing years of his father's life, mourned his mother no less sincerely. The autocratic old lady's power had waned slightly with age (she never seems to have had quite so much influence with her son after the annulment of his marriage), but habit, and the natural docility of Ruskin's character, left her at any rate the semblance of authority to the end. Years after her death, Ruskin, himself grown old, still lamented the loss of his mother and Anne.

Death had removed the last restriction on Ruskin's movements. Brantwood, which he had recently

purchased from Mr. W. J. Linton, the engraver, husband of Mrs. Lynn Linton, the novelist, became his future home : the secluded situation lending itself to his desire for retirement, now become morbid by reason of his disappointment in love, and the events leading to his retirement from the Slade Profesorship.

Brantwood had many associations with literary and political life. It had once been in the occupation of the father of the Rev. Charles Hudson, tragically killed, in 1865, during the first ascent of the Matterhorn. At different times, Gerald Massey, the poet, and Dean Kitchin, resided at Brantwood. Linton, from whom Ruskin bought the house, was not only a poet and engraver but also a Chartist. There had been mysteries, and plots whispered of : secret correspondence with Mazzini, and revolutionary propaganda, emanating from the dilapidated house by Coniston Lake.

Ruskin's Oxford life kept him away from Brantwood for much of his time during the first years of possession. In spite of all his complaints of unhappiness, these were probably among the best, because the most active, years of his life. But the dark days were near at hand. The illness at Matlock in July 1871 ended favourably, though his obstinacy in eating beef with a plentiful sprinkling of pepper as a remedy for internal inflammation can hardly be commended. His writings and lectures were growing more and more discursive.

Ideas seemed to chase each other with bewildering
rapidity through his overtaxed brain. His " Fors "
articles treated such questions as rent and interest
with increasing inconsistency, and the criticism
provoked by these opinions preyed upon his ultra-
sensitive mind. Spiritualism engaged his attention :
he began to see visions and dream dreams. Letter
LXXXVII. of " Fors," " The Snow Manger,"
dated March 1878, possesses a painful interest, for
in its Delphic utterances there is ample evidence
of his unbalanced mind. It was coincident with
the commencement of a serious attack of brain
trouble, attended by delirium and visions ; attri-
buted by the doctors to overwork, though Ruskin
himself declared that it was not overwork but the
absence of results that made him mad. Friends
and foes were united now in sympathy. On
the 24th April, speaking in Convocation, the
Oxford Proctor told how, in Italy, prayers had
been offered up for Mr. Ruskin's recovery. With
his life and reason hanging in the balance, even
his critics could only remember the purity and
beauty of his teaching, his generosity and
truthfulness.

It was the middle of May before he was able to
take up the threads of his work again, and then
only so far as to finish the Turner Catalogue. All
exciting work was forbidden him. Early in 1879
he resigned the Slade Professorship, and lived the
greater part of his time in retirement at Brantwood.

In the spring of 1882 he had a second attack of brain fever, when he voyaged to "Medea's land"—went "Argonauting"—or, as is so often the case, found his world peopled again with faces from the past : his father, mother, and Anne, for whom he so persistently longed.

In 1883 he was at work again as Slade Professor ; as we have seen in a previous chapter, in which his violent antagonism to the scientific party is recorded. This mental stress ended in another brain attack after his resignation in 1884, which marks the conclusion of his public life, for the attacks now recurred from time to time until his once brilliant intellect was brought low. Shorthouse, in " John Inglesant," wrote : " Nothing but the Infinite pity is sufficient for the infinite pathos of human life." Ruskin, the man who had had no childhood, came in his latter years into the heritage of simple pleasures which had been denied him in his youth. The company of children, simple delights, quiet restfulness, even the company of his old favourites—Scott, and Carlyle's " French Revolution "—were all his in his better hours, but there was no more active work for him. Yet, for there is always compensation for a lost gift, he was hemmed round at Brantwood with a loving band of friends, and had a daughter's care from Mrs. Severn. In the quiet shelter of Brantwood no disturbing influences of modern life could annoy him, no reminder come of the commercialism that

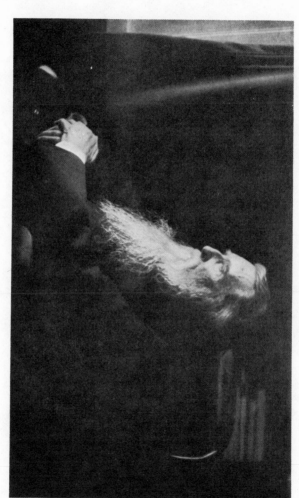

From a photograph by permission of Fredk. Hollyer.
P. 330]

JOHN RUSKIN

still reigned in the outer world, undisturbed by his wild efforts to overturn its throne. When he died on the 20th January 1900, after only a few days' illness—influenza—his work may have been deemed ended, but later years proved that it was only begun. In the future, it may be years hence, will come the reaping of the harvest from seed sown by John Ruskin.

" Swift is very like me," wrote Ruskin, in one of his introspective moods. How like, and yet unlike, may be seen from the comparison drawn by Frederic Harrison.[1] " Strange parallel, singular coincidences ! The most drab-coloured with the most purple of all great masters of English ; the most cynical with the most idealist maker of Utopias; the most foul with the most prudish of writers ; the keenest politician with the most unpractical of dreamers ; the bitterest hater with the most loving sentimentalist—and yet analogies in mind and in circumstance—they two so lonely in spirit, so like in their genius for sarcasm, so boiling with indignation for the people's wrong, so brave, so defiant, each gifted with such burning speech, both such platonic lovers, yet so continually petted by good women, both once so much sought, often so hotly reviled, both ending in such a wreck, in something so like despair. John Ruskin too, in his last years of decayed power, could have said, more reverently and less arrogantly, as he turned

[1] " John Ruskin " (English Men of Letters).

over the pages of his earlier books, ' My God !
what a genius I had when I wrote that ! ' He
too might have truly written as his own epitaph
sæva indignatio cor lacerabat—yea, and could have
added *et mentem conturbabat*."

BRANTWOOD, CONISTON.